Griselda Pollock
Professor of Social and Critical Histories at
the University of Leeds, is internationally known as a leading
feminist art historian and cultural theorist. Her many publications
include the pathbreaking study *Old Mistresses: Women, Art and Ideology*
with Roszika Parker. Her major areas of research and publication
range from nineteenth-century European and Amerian modernism
to contemporary art and cinema. She is currently working on
*Differencing the Canon: Feminist Desire and the Writing of
Art's Histories,* to be published in 1999.

WORLD OF ART

This famous series
provides the widest available
range of illustrated books on art in all its aspects.
If you would like to receive a complete list
of titles in print please write to:
THAMES AND HUDSON
30 Bloomsbury Street, London WC1B 3QP
In the United States please write to:
THAMES AND HUDSON INC.
500 Fifth Avenue, New York, New York 10110

Printed in Singapore

GRISELDA POLLOCK

Mary Cassatt
Painter of Modern Women

184 illustrations, 55 in color

THAMES AND HUDSON

For Andra
my dearest sister

Designed by Liz Rudderham

First published in the United States of America in 1998 by
Thames and Hudson Inc., 500 Fifth Avenue, New York,
New York 10110

Library of Congress Catalog Card Number 98-60039
ISBN 0-500-20317-2

Printed and bound in Singapore

Contents

Preface

For many people, this book will be their first introduction to the art of Mary Cassatt. For others it may provide more information about "the American Impressionist from Pennsylvania." For yet another group who have led the rediscovery of women artists erased from the pages of twentieth-century art history, this study opens a new chapter in the interpretations of women's contributions to the making of modern art.

I have been working on Mary Cassatt since I published my first book in 1978. Some of her paintings have been constant intellectual companions in rethinking the intersections of the histories of art and of women in modernity. Each time I return to her work, I am challenged anew by images that are complexly intellectual, formally innovative, yet shot through with fantasy and desire. Cassatt's work needs to be read through the double perspective of nineteenth-century art theory and the articulation of feminist self-consciousness in that period. She painted at a significant historical moment, when the New Woman emerged, desiring to travel, to be educated and make her own way into culture; when feminism became a political and, at times, a militant force for social change; when the beginnings of psychoanalysis, the "talking cure" for young women suffering from a seeming epidemic of hysteria, coincided with the semiotic revolution of modern art whose focus was the spaces and social relations of the new metropolis.

This book argues that Mary Cassatt, the American "aristocrat" from Pittsburgh, became a leading figure in the group of Independent artists in Paris after 1877, while playing an equally influential role in both the development of American modernism and the formation of American collections of modern French art. In her art, she grappled with some of the critical issues of her cultural moment—that spanned the decades from 1844 to her death in 1926—examining women across their life-cycles from infancy to adulthood and old age. She painted, drew and etched women as daughters, mothers, sisters, elderly matrons, and as participants in the remaking of culture. In dealing with what made women "new" and art "modern," Cassatt made herself the "painter of modern women."

Cassatt has been absorbed into twentieth-century art history as a painter of "mothers and children." This book both challenges and reassesses that judgment by paying careful attention to her long apprenticeship to art in the cities and museums of Europe from Paris, to Parma, Rome, Madrid, Seville, and Antwerp. I argue that Cassatt, more often linked with Degas, was, in the 1860s, also an astute student of both Courbet and Manet. Her profound comprehension of their role in modernism can be read in the collections of the Metropolitan Museum of Art, New York—a collection formed by Louisine Havemeyer under Cassatt's direct tutelage. Cassatt's encounter with Degas in the 1870s was decisive and productive, for in him she found an artistic alter ego who, by introducing her to experimental printmaking, prepared the way for her radical modernization of a challenging subject: women and children. Unafraid of proximity to these major artistic intellects, Cassatt's strategies reveal her ambition to be part of the most important artistic project of her moment.

Much of Cassatt's early work was destroyed by the artist, leaving the record skewed in favour of the work after 1877. This new analysis carefully reconstructs her early choices about where to study and what to paint that were made over the important ten years of her initial studies and professional career. It then asks: "What was it about the subjects and styles of the Independents—the Impressionists—that gave the artist the new direction her studies had anticipated, making it possible for her to integrate her engagement with the Old Masters from Correggio to Velázquez and Vermeer, and her awareness of the deconstructive moves by Manet and Courbet with the ambitions and experiences of a New Woman in Paris?"

Cassatt exhibited her work consistently during her career, both in Paris and throughout the United States. Focusing on major exhibitions of Cassatt's paintings, color prints and her one mural for the Woman's Building at the World's Columbian Exposition in Chicago in 1893, the book tracks the reception of her works on both sides of the Atlantic, paying careful attention to the range of aesthetic positions to which her increasingly distilled and psychologically focused studies of children and attendant adults appealed in the early twentieth century. It concludes with the exhibition of works by Cassatt and Degas organized by the great collector Louisine Havemeyer as a benefit for the cause of Women's Suffrage in New York in 1915 when the twin themes of this book—modern women and modern art—came together in a space where feminism and artistic radicalism were logical partners. It has taken almost another century for art historians to be able once again to realign them. The work of this "American in Paris," Mary Cassatt, testifies to their creative partnership.

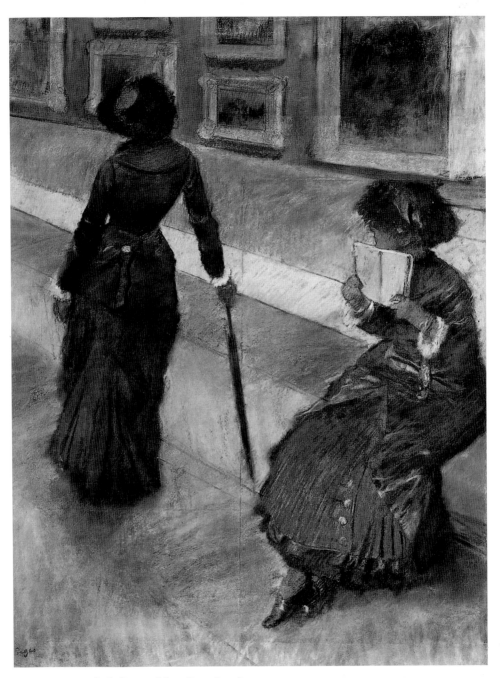

1 EDGAR DEGAS *At the Louvre (Mary Cassatt)* c. 1879

Chronology

1844 Mary Stevenson Cassatt born in Allegheny City in Pennsylvania.

1850–55 Family travels in Europe, living in Paris, Heidelberg, and Darmstadt.

1855 Brother Robert dies. Family returns to Pennsylvania.

1860–62 Cassatt studies in the Antique Class at Pennsylvania Academy of Fine Arts (PAFA) in Philadephia.

1863–65 During American Civil War (1860–65) family leaves Philadelphia.

1865 Dec: Cassatt to Paris. Private instruction from Gérôme while copying paintings in the Louvre.

1866–67 Eliza Haldeman joins Cassatt to study in Chaplin's studio. They settle at Ecouen to study under Frère and Soyer. Cassatt visits Barbizon to see Millet. The 1867 Salon refuses Cassatt's first submission.

1868 Cassatt's *The Mandolin Player* accepted at Salon under name Mary Stevenson. She moves to Villiers-le-Bel to work with Manet's teacher Couture.

1870 Winter: travels with mother to Rome and studies under Bellay. Exhibits *A Peasant Woman of Fobello* at Salon. Aug: Franco-Prussian War. Cassatt back to USA.

1871 Meets Emily Sartain in Philadelphia. Fall: to Chicago, where several of her paintings destroyed in the Great Fire. Dec: Cassatt and Sartain travel to Parma, via Liverpool, London, and Paris.

1872 In Parma, copies Correggio, and paints *Two Women Throwing Flowers During the Carnival,* accepted at Paris Salon. Fall: travels alone to Madrid, visits Prado, and settles in Seville.

1873 *Offering the Panal,* one of Cassatt's Spanish subjects, exhibited at Paris Salon. Summer: with mother to Holland and Belgium; Fall: to Paris and Parma en route to Rome.

1874 Working in Rome, returning in June to Villiers-le-Bel. Degas sees *Ida* under name of "Mary Cassatt" at Salon. First exhibition of Independent exhibiting society (Impressionists). Cassatt meets Louisine Elder (later Havemeyer) in Paris. Fall: moves to Paris, and sister Lydia visits. *Offering the Panal* and *On the Balcony* exhibited at National Academy of Design, New York.

1875 Cassatt's portrait of Lydia rejected for Salon, but *Mlle. E. C.* (untraced) accepted. Summer: to Philadelphia. Aug: back in Paris, where Lydia visits.

1876 Working in Paris. Second Independent group exhibition. Exhibits family portraits and *The Musical Party* at PAFA.

1877 Meets Degas who invites her to join Independents. Parents and Lydia come to Paris to set up home with her. Cassatt rents separate studio. *Bacchante* shown at PAFA.

1878 Third Independent exhibition falls through. Cassatt's *Head of a Woman* (unidentified) shown at Paris Exposition Universelle. Paints *Reading "Le Figaro,"* which is exhibited in Paris before being shipped to Philadelphia. *Toreador Smoking* shown at PAFA. *At the Opera* shown in Boston.

1879 April: exhibits 11 works in fourth Independent Exhibition. Joins Degas in planned journal *Le Jour et la nuit,* experimenting with etching techniques.

1880 April: shows 8 paintings and pastels, 8 etchings at fifth Independent exhibition. Takes summer house at Marly-le-Roi, near Morisot and Manet's houses. Paints brother's children.

1881 Shows 11 pastels and paintings at sixth Independent exhibition.Durand-Ruel becomes her dealer. *At the Opera* shown at Society of American Artists, New York (US independents).

1882 Withdraws from seventh Independent exhibition. Illnesses of mother and sister. Nov: Lydia dies. Louisine Elder visits Cassatt in Paris.

1883–85 Exhibits paintings at Society of American Artists in New York and at Dowdeswell's first Impressionist exhibition in London. Work severely disrupted by caring for mother.

1886 Exhibits with eighth and last Independent exhibition.

1887–88 Shown by Durand-Ruel in New York in first major exhibition of Paris modernism. Families visit from USA. *Mrs. Cassatt Reading to her Grandchildren* shown in London and Pittsburgh.

1889 Joins Société des Peintres-Graveurs with annual exhibitions at Durand-Ruel's. Louisine Havemeyer to Paris.

1890 Exhibits with Peintres-Graveurs. Exhibition of Japanese prints at the Ecole des Beaux Arts.

1891 Solo exhibition of suite of 10 color prints, with paintings and pastels at Durand-Ruel's, Paris. Dec: father dies.

1892 Commission for *Modern Woman* mural for Women's Building at World's Columbian Exhibition, Chicago.

1893 *Modern Woman* mural shipped to and shown in Chicago. Major retrospective of 100 Cassatt works since 1878 at Durand-Ruel's, Paris.

1894 Buys Château Beaufresne north of Paris. Berthe Morisot dies.

1895 April: First solo show at Durand-Ruel's in New York. Oct: mother dies.

1895–97 Works on new printing processes, and images of mothers and daughters.

1898 First trip to USA since 1875. Receives portrait commissions there.

1901 Travels to Spain and Italy with Havemeyers as their art adviser. Exhibits continuously throughout USA for next two decades.

1904 Made Chevalier of the Légion d'Honneur.

1906 Burns many early works. Brother Alexander dies.

1908 Trip to USA. Visits Matisse exhibition in Paris, and meets Gertrude and Leo Stein. Durand-Ruel organizes exhibition in Paris which then travels to New York, Washington, and Pittsburgh.

1910–11 To Egypt with brother Gardner and family. Gardner dies. Cassatt unable to work for two years.

1912–13 Achille Segard begins interviews for book *Mary Cassatt: Un Peintre des enfants et des mères*. Cassatt renews friendship with Renoir while living in Grasse.

1913–14 Resumes work, focusing on children and mothers, and children. Outbreak of WWI forces move south to Grasse. Eye cataracts diagnosed.

1915 Works by Cassatt and Degas shown in Suffrage Benefit Exhibition, organized by Louisine Havemeyer, at Knoedler's Galleries in New York.

1917 Degas dies. At the sale of his studio, Cassatt's *Girl Arranging her Hair* (1886) is catalogued as a Degas. Cassatt has the first operation in several unsuccessful attempts to save her eyesight.

1920 Lois Cassatt, sister-in-law, dies; her collection of Impressionist works sold, and many early Cassatt works disappear. Angered, Cassatt starts to sell or donate to public collections works she would have willed to the family. Louisine Havemeyer lectures on Cassatt to National Association of Women Painters and Sculptors.

1926 14 June: Mary Cassatt dies. Estate willed to her maid, Mathilde Valet, who holds two sales in 1930.

1927 Memorial exhibition in Philadelphia.

1928 Memorial exhibitions in Pittsburgh and at Smith College.

Who is Mary Cassatt? What is She?

A tall, slender very aristocratic figure dressed in black, leaning on a cane and advancing carefully down the graveled paths of her park, with its magnificent trees...thus did Mary Cassatt appear to me. I helped her up the front steps. A smile of great goodness illuminated her sober countenance; below curls threaded with silver, her gray-blue eyes, the cool of still waters, animated her strong features. She held out to me an energetic, delicate hand, long, thin, hard-working, and lively, a vibrating extension of her sensitivity....

"I am American," she said, "definitely and frankly American. My family was, however, originally from France."

<div align="right">

Achille Segard, *Mary Cassatt,*
Un Peintre des enfants and des mères, 1913

</div>

Mary Cassatt (1844–1926) was an American painter who, after 1875 lived and worked permanently in France. Mary Cassatt was a painter who was a woman. Both these facts have made a difference to her reputation and recognition in the course of the twentieth century.

She is not easily slotted into an art history based on national schools—does she belong with the Americans or the French Impressionists with whom she exhibited from 1879 to 1886? Her work is not defined by one style: was she a Realist, an Impressionist, a Post-Impressionist, a Symbolist? Cassatt balked at being thought a *woman* painter. This distinction is hers, not mine. In January 1898, Mary Cassatt wrote to her French dealer, Paul Durand-Ruel:

I have just received a letter from a lady secretary of the Ladies Art League [in the United States], telling her that you promised her a choice of my pictures belonging to you to show in the exhibition that these ladies are going to have, subject to my consent. *I refuse absolutely.*

Careful to protect her considerable status as a progressive and professional artist, Cassatt insisted on significant distinctions: between professional and amateur; between being a woman taking her place in the international art world and being a "lady" painter showing in provincial American exhibitions; between being at the forefront of Parisian cultural

2 Mary Cassatt after 1900

modernism and being part of the local development of American art markets. But let there be no mistake—such a stance did not make her any less committed to the representation of the experience of women or of what she took to be the telling themes of her moment from the point of view of an intelligent, ambitious, professional woman from the American "aristocracy."

This book coincides with the first major retrospective of Mary Cassatt's work in the United States since 1970. In 1970, Adelyn Breeskin, a long-time Cassatt scholar, published a catalogue raisonné of the paintings, pastels and watercolors. Over the last two decades, new biographies and monographs have appeared, notably by the leading Cassatt scholar, Nancy Mowll Mathews (1994), who also edited the artist's correspondence (1984), wrote an illustrated monograph (1987), curated an exhibition of Cassatt's graphic work (1989) and collated a collection of documents (1996).

When I wrote my first study of Cassatt in 1978, I could begin with the conjecture, "You may never have heard of Mary Cassatt." It would be almost inconceivable to say this twenty years later. Even if some are still not familiar with the debates about the interpretation of her work, many would recognize her art from the numerous bookcovers, calendars, and greetings cards that are part of the world of art merchandizing in a period that has witnessed the rocketing of prices for Impressionist painters. In 1983, even Mary Cassatt's *Reading "Le Figaro"* breached the million-dollar price tag.

CASSATT THE ARTIST

The first monograph on Mary Cassatt appeared in her life-time when, in 1913, the French Symbolist critic, Achille Segard presented the artist to the French-speaking world in *Mary Cassatt: Un Peintre des enfants et des mères (Mary Cassatt: Painter of Children and of Mothers)*. The title is significant. Mary Cassatt has become thoroughly identified with images of "motherhood"—a phrase which binds both woman and child into a single expressive identity, symbolizing not so much a moment in a woman's life-cycle of experiences, but a function, or a destiny. By not calling her a painter of "mothers and children," Segard offered an insight that was often subsequently ignored: that Mary Cassatt was an acute observer of the subtle relationships between the young person coming into being, and the adult, in whose own personhood this infant Other intervenes, to solicit a new range of emotions, experiences, apprehensions, and conflicts. Segard wrote:

14

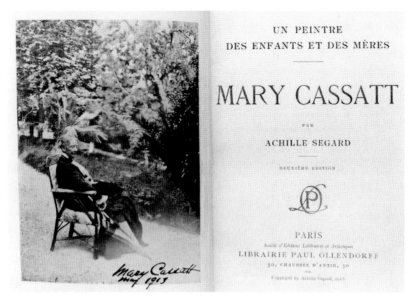

UN PEINTRE
DES ENFANTS ET DES MÈRES

MARY CASSATT

PAR

ACHILLE SEGARD

DEUXIÈME ÉDITION

PARIS
Société d'Éditions Littéraires et Artistiques
LIBRAIRIE PAUL OLLENDORFF
50, CHAUSSÉE D'ANTIN, 50

Copyright by Achille Segard, 1913

3 Frontispiece and titlepage from Achille Segard *Mary Cassatt: Un Peintre des enfants et des mères* 1913

Her conception of life and art is profound and touching. One perceives that she has a strong feeling that the place of the child in human life is of limitless importance, hence he [the child] represents at one time both the present and the future, is the gage of immortality, the necessary medium for the continuation of the race and its perpetuation.

Segard's emphasis on childhood echoes a similar stress by other French critics: in 1904 Gustave Geffroy, Monet's apologist, titled his essay "Femmes Artistes: Un Peintre d'enfance—Mary Cassatt" ("A Painter of Childhood"), and two years earlier the same title was given to his article on the painter by Camille Mauclair, who concluded: "that she is perhaps the first painter of children to exist for many a year is a result of [her] exquisite tact."

As a Symbolist writer, seeking for deeper meaning beyond the surface of the everyday, Segard appreciated Cassatt as a painter of "emotional lyricism." Comparing her with the "Impressionists," Segard argues that she stands apart because they were "strangers to the painting of individual expressions of the human soul."

Such is her place among the Impressionists. She agrees with all the others when it comes to the use of lively and brilliant tones; new and unpredictable harmonies of color; certain peculiarities of composition, or, more properly speaking, *mis en toile*; the need to allow neither anecdote

nor any conventional subject; the belief that realism is indispensable; a scrupulous conception of artistic conscience, which demands that one transcribe only emotions that one has experienced sincerely; the obligation to work directly from nature. But Mary Cassatt is set apart from the others by the intellectual quality of her feelings, and by a sort of emotional lyricism that is revealed in her work, through faces, gestures, and movements alone.

In contrast to those contemporaries for whom the beautiful appearance, or the fashionable surface of woman, coupled with suggestively enigmatic sexual danger was the substance of a mythic femininity, Cassatt specifically selected models of all classes who did not attract an eroticizing gaze, precisely so that the viewer must encounter the painted figure as a subject, not an object, or a myth. Whether child or adult, figures are represented in her pictures to convey a *psychological interiority*—a combination of thoughts and feelings that intimate an "inner life," which is perhaps what Segard could only express through the now dated term "soul."

Equally Cassatt's images of children with mothers and nurses are not emblems of some ideology about Nature, Tradition, Timelessness, or Home. Her figure compositions discover both the tension in, and pleasure of, interactions between children and adults who are emotionally bonded, while being at radically different moments of psychological development and life-cycle. As a mature woman, and especially after her own mother died in 1895, Cassatt spent two decades exploring the artistic challenge and intellectual possibilities of this subject, redefining it through formal experimentation in several media. She selected her models and set up situations in her studio so that she could examine and paint a representation, a *mise en toile*, a composition in the old academic sense, and not just a casually observed or spontaneously formed scene.

Cassatt's works bring into visibility, and cultural attention, an awareness of psychological processes that take place in the ordinary transactions of the child's relations with adults and vice-versa. Contemporary with Freud's theories of the psyche and the unconscious, with the special interest in the child as a complex formation rather than an idealized *tabula rasa* associated with Rousseau and Romanticism, the Symbolist aesthetic reflected on "the inner life" and thus found much in Cassatt's later work to approve.

This view of Cassatt, taking its cue from Segard's in 1913, is, however, only one of many that her work provokes. By the tougher 1920s, Symbolism was seriously out of date, especially in the American press, and the obituaries of the artist (who died on 14 June 1926), reveal the beginnings of a less subtle reading of her late subject matter. The *Art News* (19 June,

5, 6

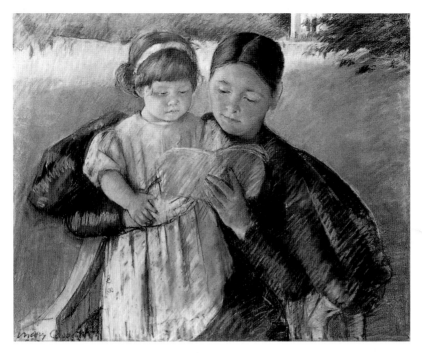

4 CASSATT *Nurse Reading to a Little Girl* 1895

1926) identified Cassatt with another artist who focused relentlessly on a limited range of subjects, Degas. Both worked consistently on the pictorial problems contained within their selected topic, and Chapter 6 will look at an exhibition in New York in 1915 in which the two artists' work confronted one another. In 1926, however, the stress was placed on "*mothers* and children" in Cassatt's work, suggesting a link between her gender and her treatment of her subject matter, although without any loss of respect for her artistic achievement. A critic commented:

> Like Degas, she sought truth, and like him was a master draughtsman, although, perhaps because she was a woman, she treated her subjects with a kinder hand. This tenderness, which might have been her strength, was her weakness. When, leaving sentiment aside, she painted the thing she saw, she took rank beside her great contemporaries.

In the *Herald Tribune,* Cassatt was hailed as "a remarkable woman, the comrade of those painters who under the banner of Impressionism achieved something like a revolution in modern art." The writer, probably the critic Royal Cortissoz, found it "an amusing paradox" that "her force, her penetrat-

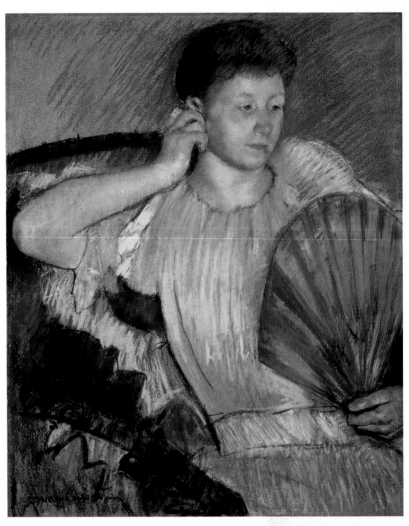

5 CASSATT *Clarissa Turned to the Right with her Hand to her Ear* 1893

ing vision, her technical clarity, were wreaked largely upon the most fragile of themes." Keeping to Segard's "children and mothers" formulation, however, Cortissoz admits that her work acknowledged sentiment, but it avoided sentimentality, he suggested, through her fine mind and exquisite taste. This made her "the most judicious connoisseur" and he acknowledges the enormous influence that Cassatt exerted on the acquisition of modern French paintings by American collections and museums.

6 CASSATT *The Cup of Chocolate* 1897

7 CASSATT *Summertime* 1893–94

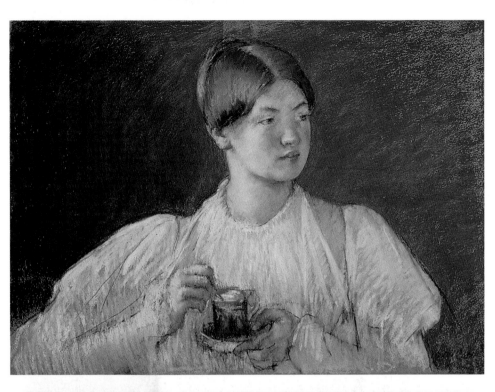

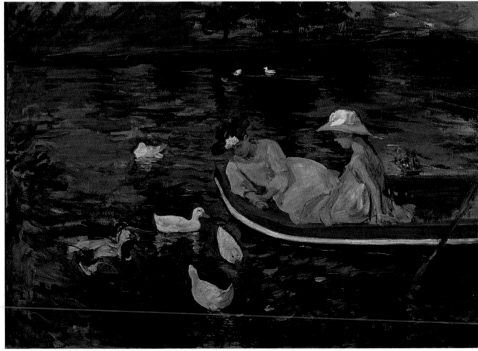

In the Philadelphia *Public Ledger* (1926) a reviewer wrote:

> She painted with tender feeling and impressionistic breadth of technique the domestic intimacies, and instead of the formal imitation of classic tradition took motherhood and infancy for her favorite themes. Thus her work had a cogent human appeal that will cause it to be remembered when many an epic and heroic canvas is forgotten.

A modern note is being struck. An art that deals with the intimacies of maternal relations with a child has a cogency and immediacy that appeals more strongly than the recycling of tired classical heroism.

There is a danger, however, in sliding too swiftly from that which we see on the canvas, a pictorial analysis of human relations, to a sensibility ascribed to the artist, because she is a woman. Other critics insist less upon her tact and tenderness, revealing a more stringent view of her artistic personality. George Biddle, a young American artist influenced by Cassatt, recorded her comments (*The Arts,* August 1926) when he visited her as a frail and blind elderly woman. Garrulously expressing her often prejudiced opinions of other nations and their taste, views typical of a patrician Philadelphian despite her years as a widely travelled expatriate, Mary Cassatt dismissed the Russians and their art. Biddle dared to raise the names of several distinguished Russian composers of the time. She replied derisively: "Music is a purely emotional art. The finest art is intellectual in its appeal." Compare this with Segard's insight into the rigorous intellectuality that produced the pictorial effects of a Cassatt work:

> [Miss Cassatt] is constantly seeking to simplify, desiring to transfigure, pursuing the effect to be produced, with purely pictorial means (and in this sense one might say with scrupulous integrity); she reaches a certain depth of sentiment and through that sentiment to a certain grandeur, she achieves a style.

In the great traditions of art based on drawing (*disegno),* style is the complete achievement of an integrated understanding of art making, combining conceptual and technical realization. Style was, in art theory, coded as masculine and virile. Segard affirmed Cassatt's style in the painting, once owned by Degas, and even attributed to him by his executors, *Girl Arranging her Hair,* 1886. It was painted specifically to disprove a provocative and hurtful remark by Degas that women do not even know what style is. Segard writes:

> It has style. Firstly, because all useless details have been eliminated, and all essential details graduated with discernment, these last contributing to an impression of the whole that is clean and vigorous; secondly,

8

because of the tone of deep sincerity and life that animates the entire work, then because of the felicitous combination of lines that converge precisely and harmoniously, demonstrating the truth the painter wishes to demonstrate, and finally because of the happy balancing of masses and areas of color, which, in perfect proportion, are also subordinated to the impression of the whole, so that one could change nothing in it, nor add, nor subtract, without diminishing its order, stability, tranquillity, and so to speak the mathematics of the work. These are the qualities that make its style. It in no way depends upon the subject nor its so-called nobility.

Segard, the Symbolist, offers here a more obviously modernist appreciation of Cassatt's art as the work of rationally constructed composition and formally pursued pictorial order, comparable to that of the Old Masters whose work she so diligently studied throughout Europe.

Since the 1970s, social and feminist histories of art have challenged modernist art history's narrowed focus on form alone, correctively insisting on the social meanings thematized within the new protocols of modern painting. Social histories of art have, however, also taught us that the *what* of painting, drawn from modern life, was made modern only because of the *how*: modern art is modern because of a self-conscious manipulation of paint and surface in order to bring out the ambivalence and complexity of the relations between painting as a fabricated representation and its referents in the social world. Modernism in art is not merely the anecdotal recording of scenes of contemporary life. In modernism the *what* and the *how* are in tension, making viewers work with the alternation between seeing a painting as a painting and seeing a painting as a representation that makes us think about an experience in the world.

Cassatt's contemporary critics reveal another dimension of modernism: *psychological* modernism. Painting, literature and the new disciplines of psychology and psychoanalysis shared a common interest. Through process and theme, painting could give a pictorial form to a sense of subjective interiority externally visible through gesture and the formalities of social interactions in both the public and private worlds. Margaret Breuning, writing on Cassatt in 1944 states:

She sought no symbolism, but the poignant expression of the relation between Mother and Child, the affecting contrast between mature figure and the immaturity of childhood. The physical basis as well as the psychological basis of the relation is stressed with an objectivity that reflected her own nature.

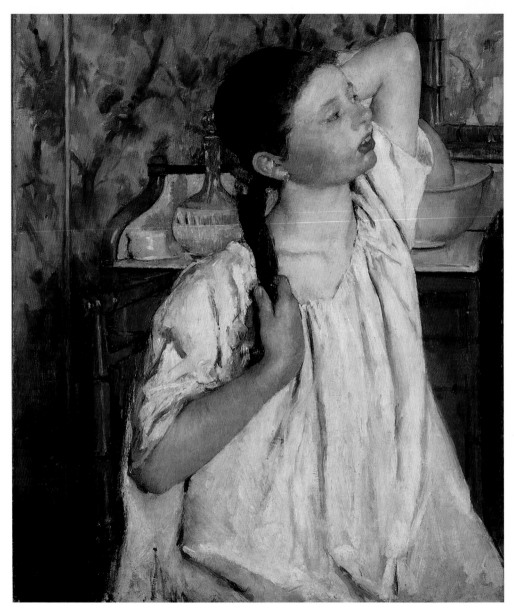

8 CASSATT *Girl Arranging her Hair* 1886

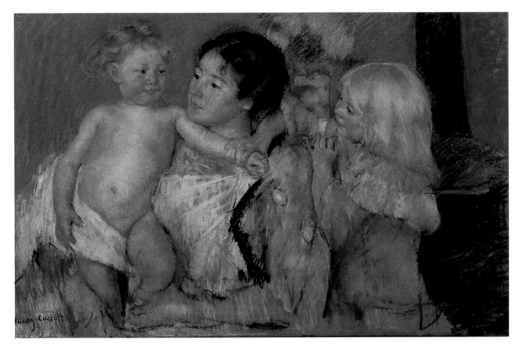

9 CASSATT *After the Bath c.* 1901

Cassatt's work allows us to see that words like feeling, emotion, tenderness, sentiment, character, which were also the stuff of the novels of the period, were coded terms belonging to a cultural milieu and aesthetic, not to the gender of the artist. It would, and did, require a formal revolution to find the compositional and spatial devices, as well as the elaboration of new technical resources and painting methods adequate to render visible the non-heroic, familiar, transient situations which could encode "domestic intimacies" or a sense of childhood's uncertain steps toward emergent self-consciousness, or the perpetual strangeness of the relation between adult and child enacted through a thousand tiny rituals of daily life. If this nuanced awareness of interiority was coupled with what Edmond Duranty, writing of the 1876 Impressionist Exhibition, called "the new painting," it was of necessity the product of particular social and historical situations. Class and nationality, culture and ideology, gender and sexuality played critical roles and were played out in the varied oeuvres that created "the new painting."

To re-read this cultural moment through the prism of Cassatt's work by drawing attention to "psychological modernism" is, therefore, not to remove her cultural practice from its social history. It is rather to read it in

23

its socio-historical complexity. This alone will ensure that we grasp what it meant to be an American woman—upper-class, white, an artist—choosing to paint with the Parisian vanguard between the 1870s and the First World War.

Segard's monograph had situated Mary Cassatt as a *painter*. In a letter written to the New York *Herald Tribune*, Cassatt's younger contemporary, the painter Childe Hassam (1859–1935) called her: "One of the most distinguished living artists in the world, one of the two or three most eminent painter-etchers, and the most able and eminent woman ever etched on copper or used the drypoint; in fact, hers is the most notable name in the history of the graphic arts." After the 1860s, the graphic arts underwent a major revival by modernist artists like Manet, Degas, Pissarro and Whistler. The Black and White Movement—a creative experimentation with all forms of etching and printing—was an integral element of the new art with its radical experimentation with composition and economy of drawing, as was the influence on the use of color in printing from recently imported Japanese graphic arts. Adelyn Breeskin's first catalogue raisonné, published in 1948, was devoted to the graphic work of Cassatt, who was always renowned in print circles for the major series of color prints produced in 1891—the topic of Chapter 5. Cassatt, like Degas, Manet, Morisot, and many of her contemporaries on both sides of the Atlantic, also revived the eighteenth-century medium of pastel, using it to produce works that rivaled her paintings and color prints in their brilliance and boldness.

As a painter, like her contemporaries Cézanne and Renoir, Cassatt demands to be considered as an exceptional colorist. In her obituary in the French *Journal des Debats* (9 July 1926), the critic writes that the American painter Mary Cassatt "chose French art" and after a confusing start, acknowledges her as a colorist:

7

> No colorist translated the emotions of young mothers or the mischievousness of cherished children more variously than Mary Cassatt. The painter of the nursery, she captured with a free, bold and always caressing hand the attitudes of the little ones, and the apprehensive, enveloping gestures of those who look as if they could be elder sisters.

Her colorism was most evident and most acknowledged when she tackled a most difficult area of painting, and one which the naked infant allowed her—a woman neither desiring to work with the female nude nor trained to do so—to examine repeatedly. The reviewer of her first major retrospective exhibition at Durand-Ruel's gallery in New York in 1895 introduced a lengthy aside on the history of flesh painting because:

169

24

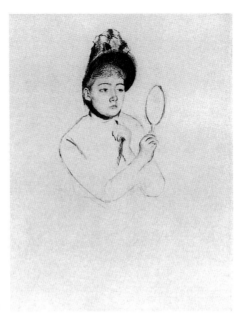

10 CASSATT
The Mirror 1889–90

"In the technical rendering, the painter has apparently addressed herself, as the important thing, to the solution of the unsolvable problem of painting flesh." With a survey that runs from Titian through Rembrandt to Rubens and Fuseli, the writer concludes:

> Miss Cassatt's selections and compromises, among the various methods of flesh-painting known, constitute one of the most interesting features of her work. She cannot reconcile herself to the painting of a beautiful, smooth, hard substance like tinted ivory, and she is not satisfied with the coarsely hatched structure of many of her contemporaries, which at least suggests the depth of the fleshly integument, if not the finish. By wise and vigorous painting, with the full strength of her palette and a careful observance of local variations, she secures the intrinsic qualities of her fleshly tones—so that you can well imagine that her rendering would feel under your fingers much as the naked body does in life—and she is much aided in securing this desirable effect by a free use of that hard outline which the impressionists so generally disregarded.

It is perhaps through this prism of her singular combination of artistic resources that we can detect how educated an artist Cassatt was. She had, none the less, a keen understanding of just what her contemporaries in Paris—Degas, Manet, and Morisot—were doing with, and to, that heritage of Western art. Cassatt was able to illuminate ancient and modern

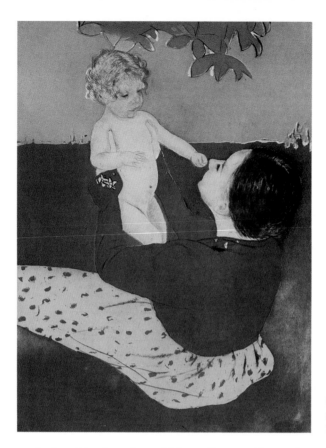

11 CASSATT *Under
the Chestnut Tree*
1896–97

art for her friends and would-be collectors. She explained it in a way that
thoroughly reflected the reassessment of the art of the past that character-
ized, and made possible the innovations that we now call modernism.
Thus Louisine Havemeyer, who was to become a major American collec-
tor of modern and old master paintings recalled:

> As usual, I owe it to Miss Cassatt that I was able to see the Courbets. She
> took me there [an exhibition in Paris in 1881], explained Courbet to
> me, spoke of the painter in her flowing, generous way, called my atten-
> tion to his marvellous execution, to his color, above all to his realism, to
> that poignant, palpitating medium of truth through which he sought
> expression. . . . She led me to a lovely nude, the woman drawing the
> cherry branch down before her face, and I recall her saying to me: "Did
> you ever see such flesh painting? Look at that bosom, it lives, it is almost
> too real. . . . You must have one of his nude half-lengths some day."

26

The city of Philadelphia awarded Mary Cassatt, its one-time citizen, a Memorial Exhibition in 1927. Louisine Havemeyer was invited to write an introduction to the catalogue. This also included extracts from a lecture that she had given in 1915 at an exhibition at Knoedler's New York galleries of the works of Mary Cassatt, Edgar Degas and selected Old Masters from the Havemeyer's exceptional collection, which Cassatt had helped to create. The 1915 exhibition was a benefit show for the American women's campaign for the suffrage, which Mary Cassatt, like Louisine Havemeyer, named *the* cause. Contemplating the horrors unleashed by European militaristic culture in 1914, Cassatt wrote to Louisine Havemeyer: "The great drama is opening around us! How will it all end? Possibly in a United States of Europe? Work for suffrage, for it is the women who will decide the question of life or death for a nation."

There is, therefore, also a feminist "Cassatt." Her ambition and eloquence, education and intelligence were stressed by Louisine Havemeyer, who wanted to avoid the sentimentalization of her friend's art by placing her firmly as a working professional in the history of art. As her artistic adviser, Cassatt was the woman who educated Louisine in seeing paintings, understanding them from a painter's point of view. Thus could Louisine Havemeyer make Cassatt and Degas face each other at Knoedler's, next to 180 Bronzino, Van Dyck, Rubens, Rembrandt, and Vermeer, and conceive the

12 Mary Cassatt Memorial Exhibition at the Pennsylvania Museum of Art in Philadelphia 30 April–30 May 1927

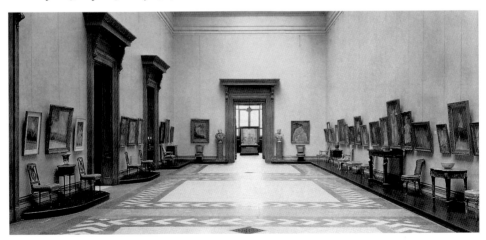

whole as a statement of "political modernism": an assertion of women's distinctive and necessary place in the public world of culture and history which through Degas and Cassatt would jointly sound the "modern note." In her lecture, Louisine Havemeyer insisted that Mary Cassatt was not a pupil of Degas, but his colleague; nor an Impressionist, but as dedicated as Degas or Manet to bringing the radical force of art learned in the museums—design, line, composition and color—out of its dismal academicism and into alignment with the defining novelties of modern urban experience.

Individuality was to be coupled with contemporaneity, psychological subtlety with the nuances of social difference, and all delivered in a self-conscious form of painting, pastel or etching that would banish sentimentality, convention, cliché and anecdote. From our vantage point, far from simply delivering what these painters called "truth," the art of the late nineteenth century now appears much more opaque and difficult to interpret. As students of art and its histories, we have to work, with diligent pictorial and historical analysis, to create the conditions of its legibility in our own different historical moment.

Between the first great wave of women's activism in the nineteenth century and the feminism that reclaimed Mary Cassatt after 1970—a recovery made possible by the dedicated work of many women scholars, notably Adelyn Breeskin—lies a gulf in which a wide range of women's history in the nineteenth century was forgotten, leaving but a few isolated names to distort our view of women's activities in that period. With the complacent victory of a narrowed story of modernism, we stopped being able to hear what Cassatt's contemporary commentators were saying about her work across a range of Symbolist, Realist, Impressionist and Post-Impressionist aesthetics. Nancy Mowll Mathews has pointed out that by the 1970s feminists worked in an art historically created vacuum, obliged to reclaim a lost heroine, seeing Cassatt as an isolated fighter against a sea of Victorian prejudice and gender stereotyping. So much research has been done to repopulate the nineteenth-century cultural landscape with the many women working in diverse styles and art worlds, that it will be necessary, therefore, to reposition Cassatt in the context of her numerous women contemporaries, from the American art students who joined her in her European studies, Eliza Haldeman (1843–1910) and Emily Sartain (1841–1927), to the many American women working in Paris, like Elizabeth Gardner (1837–1922) and Mary Fairchild MacMonnies (1858–1946), to the younger generation moving between the two continents like Cecilia Beaux (1855-1942) or Lilla Cabot Perry (1848–1933), as well as those women active in the tiny but ultimately

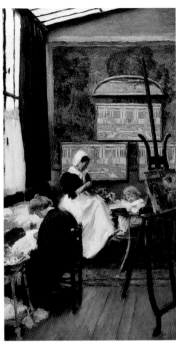

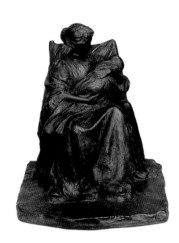

13 MARY FAIRCHILD MACMONNIES
In the Nursery: Atelier at Giverny 1897–98

14 BESSIE POTTER VONNOH
The Young Mother 1896

influential Parisian art circle around the Independent exhibiting society, Berthe Morisot (1841–95), Eva Gonzalès (1849–83), Marie Bracquemond (1841–1916), and finally, a sculptor who shared Mary Cassatt's modern fascination with mother-child relations, Bessie Potter Vonnoh (1872–1955). Equally, Cassatt, whom one critic called a painter of Jamesian women, might be considered in relation to novelist Edith Wharton, who like Mary Cassatt eventually settled in France, happy to escape some of the more dulling aspects of "old society" in the United States and its limiting attitudes to women.

The skewed viewpoint in which artists who were women had become invisible was not surprising, however, given the way in which Cassatt's representations of a world of women, gardens, drawing rooms and nurseries came under a withering dismissal during the regressive return to fixed gender ideologies during the Cold War years. In 1954 the Chicago curator Frederick Sweet organized an exhibition of the expatriate triumvirate—James McNeill Whistler (1834–1903), John Singer Sargent (1856–1925), and Mary Cassatt. While admitting that Cassatt's *intimist* views of her social contemporaries and close family, painted with "luminosity and elegance," held something in common with the dashing and innovative art of these other Americans, the American art historian Edgar

Richardson expressed in his review in the *Art News* (April 1954) what would become a standard response: boredom.

> She offers us a circumscribed Jamesian world of well-bred ladies living lives of leisure, delighting in their dresses, their company and their well behaved children. There is an odd contrast between the boldness of her style and the world of perpetual afternoon tea it serves to record. Did she exhaust her sense of discovery in becoming an artist at all?... For all its distinction, her art is that of a very conventional person living in the very conventional world of the nineties. As a recorder of the female side of that little circle of wealth and privilege, she will always have a place. But, tea, clothes, and nursery; nursery, clothes and tea.

Nursery we know and can define more analytically: Cassatt was the painter of children's and of maternal subjectivities. Tea and clothes introduces a new note: class, fashion, and social life. Elizabeth Bilyeu has pointed out in an important study (1995) of gender and the critical reception of Mary Cassatt in the United States in the 1920s that when the Boston Museum of Fine Arts in 1932 acquired Cassatt's pastel study (1894) for what is now known as *The Banjo Lesson* (then titled *Mother and Daughter*), the purchase was announced as: "Boston Buys a Typical Work by Mary Cassatt." Conversely, when *La Loge* (The Loge, 1882) entered the Chester Dale Collection in 1930, showing two fashionable but tense young women at the theatre, the *Art Digest* reported: "An Unusual Cassatt for the Dale Collection."

This suggests at least two "Cassatts," one of the period up to the mid 1890s, and the later artist on whom Segard focused attention through his title. I have titled this book *Mary Cassatt: Painter of Modern Women*, as a corrective gesture to allow both Cassatts into equal view. Initially, I want to lay equal stress on the early Parisian years in which Mary Cassatt made her significant choices as an artist and first joined with a grouping of independent French painters concerned with modernity. I shall argue that 1893 was a turning point at which both theme and method shifted significantly, as one would expect with an artist working across so dramatic a period in the history of art. The Impressionist project was, as a whole, short-lived, and by 1886 had virtually collapsed, to be succeeded by a kaleidoscope of competing initiatives and practices that, none the less, considered themselves to be its inheritors. The Cassatt of the 1870s and 1880s was, as a reviewer of her 1895 New York retrospective noted in *Scribner's Magazine*, a painter of urban themes: theatres, driving out, socializing, involved in that most urban and modern question—fashion—which meant, for women of the bourgeoisie both the pleasures of

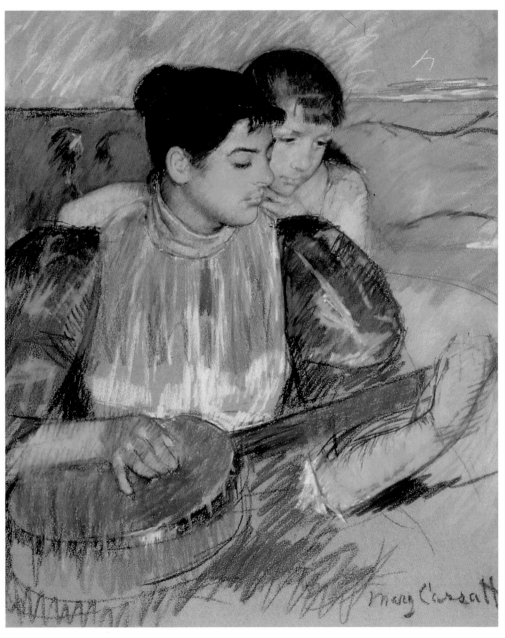

15 CASSATT *The Banjo Lesson* 1894

femininity and the consumption of luxury goods, and the coding of precise status and etiquette—tea and clothes. This Cassatt was recognized in ways that could (and did in a more hostile climate later in the twentieth century) become a liability. Téodor de Wyzewa, Wagnerian and advocate of Monet, commented in 1903: "Women painters do not lack in the history of art. What is missing is the true painting of women—a painting that expresses the particular aspects which offer objects to the perception and imagination we call 'feminine.' " And writing in 1907 of Berthe Morisot, Cassatt's colleague in the Independent movement, Claude Roger-Marx could say that Impressionism was "in essence, a method that was totally appropriate for the realization of a feminine painting....Only a woman had the right to practice, in all its rigor, the Impressionist system." We lose our bearings here for we do not understand what either critic means by "feminine." Since the term is part of the moment in which Cassatt worked, we shall have to define it in all its historical instability.

"Feminine" is a term which marks a difference, based on gender. Yet, for some later nineteenth-century critics, it signified something special about that difference, even to the point of acknowledging a privileged intimacy between a modern way of painting and the world perceived by intelligent and creative bourgeois women. By the 1970s, however, "feminine" had negative connotations. It meant the ideal of the little woman at home that re-emerging feminism aimed to challenge. A hundred years ago, there was evidently another cultural space—what historian Carroll Smith-Rosenberg has called "the female world of love and ritual" in which the difference ascribed to the world and sensibilities of women might be valued for producing both a "truth"—something spoken authentically in the first person rather than copied from tired classical formulae—and a view into the particularities of the modern world that a strict ideological division of the sexes had created.

If we acknowledge the difference of history, that even ways of thinking and using common words may vary from our present usage, we need to read the past, to examine its inscriptions as if we were deciphering the monuments from a lost civilization whose alphabet we can hardly yet decode. The work of Mary Cassatt is a monument created in its historical moment, which we cannot spontaneously understand. Yet it stands at the beginning of a process of cultural modernization that included a sustained exploration of women's cultural and political consciousness. This book will offer a reading of Cassatt's work, taking its note from the insightful, if often unexpected interpretations offered by her contemporaries between 1895 and 1930, framing them through the interrupted histories of feminist thought.

Mary Cassatt was not a "woman painter," American or French, modernist or ultimately conservative, so much as a "painter of modern women." This title invokes the most famous text associated with the generation of Parisian painters with whom Mary Cassatt allied herself in 1877. Charles Baudelaire's *The Painter of Modern Life* (1863) set an agenda for his artistic peers, creating a conceptual identity between modernity and the city. Urban spaces were the playground of *the* modern figure, the *flâneur*, decidedly masculine, reflecting deeper socio-economic and ideological structures that were, as part of modernity, creating a gendered topography: public/private: city/home: masculinity/femininity. Cassatt, the attentive reader of the most Baudelairian of Parisian modernists, Manet and Degas, along with her many women contemporaries, explored a particular, and different terrain: modernity and the spaces of femininity. Of course, as a woman, she had privileged access to these spaces. That mattered because the culture was coming to value "the authentic" or self-referential in art, calling this individuality the signature of its modernism. We can track how Cassatt came to find her compelling subject matter in the mid 1870s through studying the art worlds she explored, the artistic and institutional choices she ultimately made, the media she tried, and most importantly, the subjects she created in her work—dimensions of social and psychological modernity to which she, as a modernist painter-etcher and a "new" woman, gave pictorial form.

Like all artists, Mary Cassatt was a strategic player in the art she made. We consider her decisions, actions and tactics. Yet as work that circulated in public, to exhibitions and collectors, entering art worlds in Europe and America, her paintings, pastels and etchings are "texts." Each work is not just an expression of Cassatt's thought or personality or a reflection "of its times." It is the product of a cultural situation, whose legibility and significance lies in its relations with other "texts" that form the overall context of artistic practice and reception. The possibility that any art work achieves meaning depends upon this "intertextuality," this web of references to past and present. Her work had to participate in the avant-garde game of reference, deference, and difference, recognizing its debts to past and contemporary artists, while marking out its own intervention in this new culture of modernism. Yet her work was also being shaped within the lived worlds of situated social actors who played out their lives on this novel terrain of the modern city.

I have chosen to start the book in 1893, in the middle of Cassatt's long career. The major events of 1893 serve as a vantage point from which to explore the varied projects, themes, and media that made Mary Cassatt, the "aristocrat" from Pennsylvania, the painter of modern women in Paris.

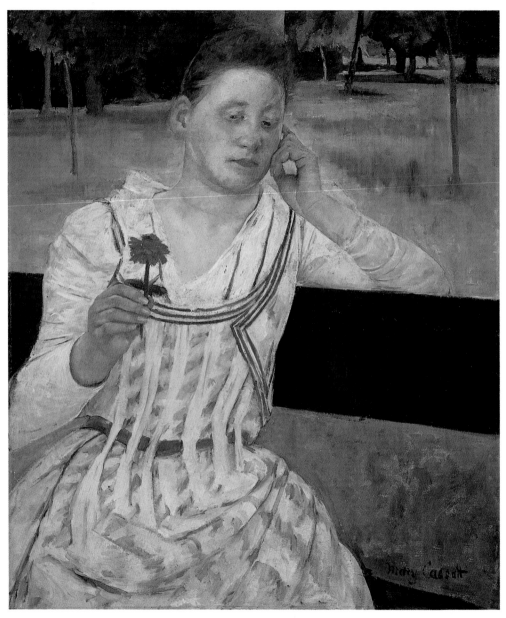

16 CASSATT *Woman with a Red Zinnia* 1892

Mary Cassatt, Painter of "Modern Woman," 1893

I consider your panel to be the most beautiful thing that has been done for the Exposition, and predict for it the most delightful success. It is simple, strong, sincere, so modern and yet so primitive, so purely decorative in quality, and with still the possibility of having an allegory extracted if one wants to look for that sort of thing.

Bertha Palmer to Mary Cassatt, 15 December 1892,
on the arrival of Mary Cassatt's mural in Chicago

The year 1893 was a turning point for Mary Cassatt. It was the year her art both came home to the United States and "arrived" in Paris. In that year, Cassatt appeared before the American public with a massive mural exhibited in Chicago titled *Modern Woman*. Cassatt also had her first retrospective of over a hundred works in the galleries of Paul Durand-Ruel in Paris from November to December, 1893. In the exhibition's catalogue André Mellerio concluded: "In all sincerity, it must be said that, at the present time, Miss Cassatt may be, with Whistler, America's only artist of lofty, personal and distinguished talent." Starting this book at this critical mid-point of her career allows us to discern the dominant themes as well as the key moments of change that define the body of work united under the name "Mary Cassatt."

THE COMMISSION

In the spring of 1892, when Cassatt was forty-eight, she was visited in her apartment at 10 Rue de Marignan, Paris, by two distinguished Americans: Bertha Honoré Palmer, the President of the Board of Lady Managers of the Woman's Building for the World's Columbian Exposition in Chicago, and Sara Tyson Hallowell, curator of international art exhibitions. Their purpose was to commission one of the two major murals for the Hall of Honor at the Woman's Building, then being erected for the World's Columbian Exposition of 1893.

The exposition was yet another of the world fairs and exhibitions. The series, initiated in London by the Great Exhibition at the Crystal Palace of

19

18

17

35

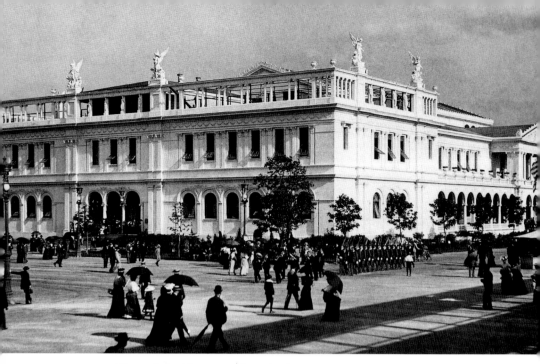

17 Woman's Building, World's Columbian Exposition, Chicago, 1893, architect Sophia Hayden

1851, and followed by exhibitions in Paris 1855, London 1862, Paris 1867, Vienna 1873, Paris 1878 and 1889, allowed the competing nations of the industrializing world to display their achievements in science, technology, and manufacture in a collective eulogy to unfettered industrial and colo-nial "progress." After 1851, the arts were included in this international festival of nationalistic competition.

The exposition in Chicago, marking the five-hundredth anniversary of Columbus's journeys, was the first to inscribe the Woman Question into the international script. The Woman's Building was designed by Sophia Hayden, the first woman architect to graduate from Massachusetts Institute of Technology, with a sculptured pediment by San Francisco sculptor Alice Rideout. Its interior displays of art and decorative crafts from all around the world were dedicated to "the advancement of women," and there were displays of statistics enumerating the progress of women into the worlds of work and the professions in over forty countries. Busts of leading American women's rights campaigners provided the presiding genii of the building.

18 MARY FAIRCHILD MACMONNIES *Sara Tyson Hallowell* 1886

19 Bertha Honoré Palmer, 1900

20 Mary Cassatt at Château Beaufresne, Mesnil-Théribus, with Mme. Joseph Durand-Ruel (left) and her daughter Marie-Louise, 1910

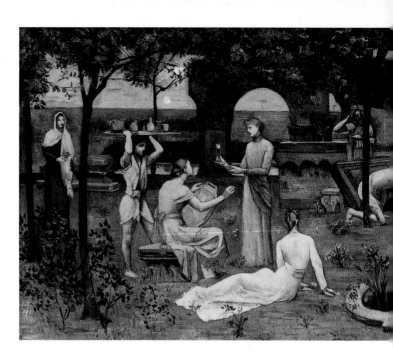

21 PIERRE PUVIS DE
CHAVANNES *Inter Artes et
Naturam* 1888–91

The initial commission for a mural had been offered to Elizabeth
Gardner, a bemedalled American Salon painter in the still highly success-
ful academic style. Then in her early sixties, she declined the arduous
work of preparing a 12-x-58-foot (4-x-19-metre) mural for which she
would have to spend many hours painting up a ladder. Mary Fairchild
13 MacMonnies was then approached. She had gone to Paris as a student in
1885, and was familiar with the work of the leading French muralist
Pierre Puvis de Chavannes, whose vast work *Inter Artes et Naturam* for
the Rouen Museum had been exhibited in replica at the Salon of 1890.
23 MacMonnies' theme was to be *Primitive Woman*. The delayed, and
unexpected, choice for the second mural, Mary Cassatt, was asked to take
22 on the subject of *Modern Woman*. Cassatt wrote to Louisine Havemeyer
in the summer of 1892:

> I am going to do a decoration for the Chicago Exhibition. When the
> Committee offered it to me to do, at first I was horrified, but gradually
> I began to think it would be great fun to do something I have never
> done before and as the bare idea of such a thing put Degas in a rage and
> he did not spare every criticism he could think of, I got my spirit up
> and I said I would not give up the idea for anything. Now one only has
> to mention Chicago to set him off.

38

THE THEME

In a letter of 24 February 1892 to Sara Hallowell, Bertha Palmer explained her thinking behind the two themes proposed for the murals: "My idea was that perhaps we might show woman in her primitive condition as a bearer of burdens and doing drudgery, either in an Indian scene or a classic one in the manner of Puvis, and as a contrast, woman in the position she occupies today." The pitting of modern versus primitive to gauge the nature of the new era was a recurrent theme in the modern muralist movement led by Puvis de Chavannes. An easy opposition to create, it revealed almost nothing about modernity except its false sense of history and implicit racism. Mary Fairchild MacMonnies opted for historicism, using Puvis de Chavannes's classically white figures and draperies in a vague lakeside setting. The color scheme was subtle, with harmonies of blue and green and gray. The figures were partially draped, though studied from the nude. For Cassatt, however, the theme of *Modern Woman* offered a chance not only to show what made women "new" but also what made art "modern."

Women occupied a paradoxical position in the age of massive social and economic change we call modernity. As ideal and icon, Woman was symbolically made to represent the antithesis of modernity. Synonymous

22 CASSATT *Modern Woman* mural for the south tympanum of the Hall of Honor, Woman's Building, World's Columbian Exposition, Chicago 1893

23 MARY FAIRCHILD MACMONNIES *Primitive Woman* mural for the north tympanum of the Hall of Honor, Woman's Building, World's Columbian Exposition, Chicago, 1893

with timeless Tradition and Nature, Woman was paradoxically both an elevated ideal and a social non-person. The continuing exclusion from political life of the daughters and sisters of the economically and politically dominant bourgeoisie led to the feminist challenge to this double-edged Victorian ideal of Woman. Since the first congress for American Women's Rights held in 1848 at Seneca Falls, New York, white American women had made some impressive inroads in a number of professions, such as law, education, literature, social work, as well as the visual arts. Some were able to go to the newly founded women's colleges and even train as doctors. They could travel and study, and lead a life of some degree of independence and limited self-determination. In 1893, on the other hand, no Western women had the vote. Furthermore, the vast majority of working-class women were still sunk in poverty and drudgery, and recently emancipated African-American women were not represented on the Board of Lady Managers. They were refused a special section within the Woman's Building to document their struggles against the added burden of racism.

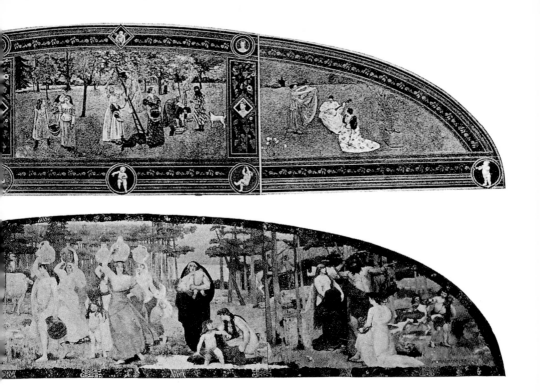

One of the smaller decorative panels painted for the Woman's Building by Lydia Emmett, titled *Art, Science, and Literature*, reflects the consciousness of white American feminism. In a garlanded, classically porticoed space, middle-class white women sit in elegant poses as they play the violin, paint at an easel, sculpt, and in academic gown and mortar board relax from reading a heavy book. Each is a contemporary example of women acting as creative and intellectual professionals.

In a letter to Bertha Palmer of 11 October 1892, Cassatt gives us some insight into how she had planned her "decoration":

> I took for the subject of the central and largest composition *Young woman plucking the fruits of knowledge and science* &—that enabled me to place my figures out of doors & allowed of brilliancy of color. I have tried to make the general effect as bright, as gay, as amusing as possible. The occasion is one of rejoicing, a great national fête. I reserved all the seriousness for the execution, for the drawing and the painting. My ideal would have been one of those old tapestries brilliant yet soft.

This is a complex statement, revealing many conflicting purposes as well as the condensation of diverse resources. The idea of medieval tapestries evokes two alternating images of the garden in Christian culture: a primal garden scene, the Garden of Eden, in which woman is associated with disobedience and sin; and the *hortus closus*, the enclosed garden in medieval art, which is often associated with the unworldly purity of the new, redemptive Eve, the sinless Virgin, whose body, like the walled garden, is a pure, unpenetrated space. By the nineteenth century, the dichotomy was expressed as the pure woman at home opposed to the fallen woman on the streets and by the segregation of men and women in their separate spheres.

Nineteenth-century feminism challenged traditional ways of understanding the world and questioned myths about Woman, symbolized by figures such as Eve or the Virgin. In a text almost contemporary with Mary Cassatt's mural, *The Woman's Bible*, compiled over several years and published in 1895 by leading feminist Elizabeth Cady Stanton, we find a radical revision of the scene of Eve tempted by the Serpent that might provide the theological complement to Mary Cassatt's utopian reworking of women in the garden in her mural:

> In this prolonged interview, the unprejudiced reader must be impressed with the courage, the dignity, and the lofty ambition of the woman. The tempter evidently had a profound knowledge of human nature, and saw at a glance the high character of the person he met by chance in his walks in the garden. He did not try to tempt her from the path of duty with jewels, rich dresses, worldly pleasures, but with the promise of knowledge, with the wisdom of the Gods. Like Socrates and Plato, his powers of conversation and asking puzzling questions, were no doubt marvellous, and he roused in the woman that intense thirst for knowledge, that the simple pleasures of picking flowers and talking to Adam did not satisfy. Compared with Adam she appears to great advantage through the entire drama.

In her preface to the official handbook of *Art and Handicraft in the Woman's Building*, 1893, Maud Howe Elliott inverted the image of Eve in the Garden of Eden as a manifesto for the modern woman. Picturing a great tower, from which seers viewed the coming of prosperity, electricity, and a great city—modernity—she writes:

> A clearer, sweeter prophecy went forth from the tower, where the wise women watched the signs of the time: "Woman, the acknowledged equal of man; his true helpmate, honored and beloved, honoring and

loving as never before since Adam cried: "The Woman tempted me and I did eat."

We have eaten the fruit of the tree of knowledge and the Garden of Idleness is hateful to us. We claim our inheritance and are become workers not cumberers of the earth.

Cassatt's project thus took its place in the contemporary feminist contest for women's right to determine their own meanings, collectively questioning the history, theology, and culture of patriarchy.

Her mural creates a modern, feminist allegory by seeming to abjure all obvious allegorical modes in favor of a contemporary, everyday setting. The setting she describes as a fête, familiar to the artist from her summers spent in the French countryside, although this has an art historical association with the *fête galante* in French eighteenth-century painting of courting couples in contemporary dress enjoying love and leisure in a somewhat Arcadian landscape.

The garden setting also had modern associations. Cassatt's Impressionist colleagues Claude Monet (1840–1926) and Gustave Caillebotte (1848–94) were dedicated gardeners in their suburban villas as well as painters of their own horticultural creations. In Impressionist art, the garden was a popular setting for domestic leisure, populated with fashionably dressed wives, sisters, or children, as in Monet's famous manifesto of outdoor painting, *Women in the Garden*, 1866–67. To superimpose, therefore, a joyful and celebratory plucking of the Fruits of Knowledge and Science on the modernist landscape of suburban pleasure, country holidays, and recreation associated with Impressionist new painting is at once to find a way to signify the "new" women's guilt-free claims to education and intellectuality as well as to propose modernity's supersession of the age-old definitions of Woman created in the Biblical condemnation of Eve.

The absence of Adam suggests a reference to Alfred Lord Tennyson's long poem of 1847, *The Princess,* about aristocratic intellectual women who withdrew from the world of men to create a university for women, a comment itself on the early British feminists' campaigns for women's education that led to the foundation of Queen's College, Harley Street in 1848 as well as women's colleges at Oxford and Cambridge in the 1870s. Cassatt was a passionate reader of Tennyson's work, inspiration from which appears at least twice in her early years. British painting, exhibited to great acclaim at the Paris Salons and at the Universal Exhibitions in Paris (1855, 1867, 1878), was well known in France and America. Cassatt's mural also echoes Pre-Raphaelite images of young womanhood such as *Spring (Apple Blossoms)* 1856–59 by John Everett Millais (1829–96), showing

28

24

26

43

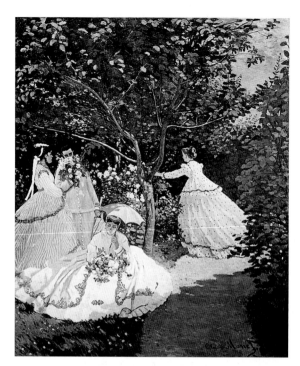

24 CLAUDE MONET *Women in the Garden* 1866–67

25 LILLY MARTIN SPENCER *We Both Must Fade* 1869

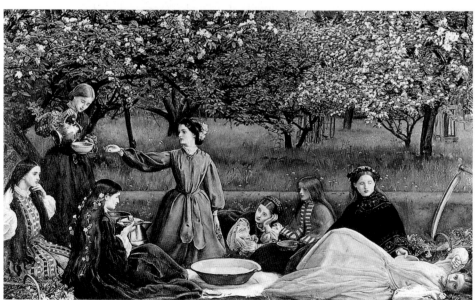

26 JOHN EVERETT MILLAIS *Spring (Apple Blossoms)* 1856–59

27 CASSATT *In the Garden* 1893

fashionable young women on a picnic in an orchard, but heavy with hints of mortality and the fragility of feminine beauty and innocence with the coming of sexual maturity—a theme that occurs in *We Both Must Fade* (1869) by the American artist Lilly Martin Spencer (1822–1902). Cassatt's work belongs with the cultural imagery that associated femininity and the garden or orchard, but her progressive utopianism is the opposite of these subliminal allegories of woman, sex, and death.

Cassatt's letter to Bertha Palmer of 1892 continues:

> An American friend asked me in rather a huffy tone the other day "Then this is woman apart from her relations to man?" I told him it was. Men I have no doubt, are painted in all their vigor on the walls of the other buildings; to us the sweetness of childhood, the charm of womanhood, if I have not conveyed some sense of that charm, in one word, if I have not been absolutely feminine, then I have failed.

If the mural reads as a feminist statement, how can the artist uncritically declare her allegiance to the "charm of femininity?" This was the century during which Woman's Nature, Duty and Destiny were proclaimed to lie absolutely in the private sphere of home and hearth. Woman was consecrated to the obligations of Motherhood and Self-Sacrifice. Barbara Welter (1966) summarizes what she defines as the "Cult of True Womanhood":

> The attributes of True Womanhood, by which a woman judged herself and was judged by her husband, neighbours and society could be divided into four cardinal virtues—piety, purity, submissiveness and domesticity. Put them together and they spelled mother, daughter, sister, wife—woman. Without them, no matter whether there was fame, achievement, wealth or power, all was ashes. With them she was promised happiness and power.

Fulfillment of this ideal could only take place in the private sphere of home and family. In Caillebotte's *Portraits in the Country* (1877), the artist's mother and sisters appear in the peaceful seclusion of their country summer house at Yerres, each woman patiently engaged in some time-passing exercise of sewing or reading, appropriate to her delicacy and class. Nothing stirs before the invisible painter's active and productive gaze in this idealized garden.

But in place of "True Woman" advanced writers of the period sketched as their leading characters what Henry James dubbed the "New Woman." As the historian Carroll Smith-Rosenberg writes:

> James used [the term] to refer to women of affluence and sensitivity. Young and unmarried, they rejected social conventions, especially those imposed on women. These women fought stagnation. They acted on their own.... Within James's novels, they suffered the consequence of their autonomy.... In short, the New Women, rejecting conventional

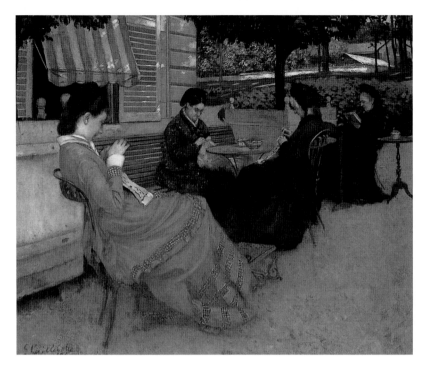

28 GUSTAVE CAILLEBOTTE *Portraits in the Country* 1877

female roles and asserting their right to a career, to a public voice, to visible power, laid claim to the rights and privileges usually accorded to bourgeois men.

Cassatt's *Modern Woman* was a New Woman. Yet Cassatt aims, and claims, to be truly feminine in her mural. Was she undoing the myth even as she declared her allegiance to "True Womanhood"? Or could the feminine have a feminist value? New Women wanted more chances to be recognized for what they could bring to the world as *women*—as *women* doctors and lawyers, writers and artists, thinkers and social workers. The middle-class feminist desired an enlarged sphere of self-realization for a feminine nature which she accepted, even if she contested the more limited ideologies that denied intellectual capacities and non-maternal desires.

Cassatt's declaration of pleasure in "the sweetness of childhood and the charm of womanhood," however, could also reveal a conventional double-think on the part of the artist—herself a New Woman, happily painting and observing True Women inhabiting a world that offered the

29

pleasures of women's sustained friendships and the long-lived bonds of mothers and their adult daughters.

The mural shows women comfortably together: as adolescents with expansive and unformed dreams of great achievements; as educated mothers, aunts, sisters, sharing the fruits of intellectual labor with the next generation; as creative artists and appreciative audiences for culture. The three-part mural has been seen as a statement on the Ages of Woman— Childhood, Youth, and Maturity—as well as a representation of Work and Play. *Modern Woman* brought into this highly significant forum the potential of modernity for middle-class femininity, which we will see had been the theme of so much of Cassatt's work since the artist had found herself part of the Parisian avant-garde in 1877.

PLUCKING THE FRUITS OF KNOWLEDGE

33 In the centre of the main panel, we see three women and a young girl. On the left a young woman reaches up to pull down the fruit-bearing branches. On the right, a slightly more mature woman holds a basket of picked fruit before her and gazes off to her left in a reflective pose. Having acquired the fruits of Knowledge and Science, she can use them to aspire to a space beyond this garden and to a fruitfulness other than maternity.

The compositional movement of the main grouping crosses from lower left against the central diagonal of the ladder on which a young woman stands. She leans down to pass a fruit to the young girl. Their mutual handclasp is the nodal point of the whole panel, visible even in the poor reproductions we have to work from because the mural itself has disappeared. One generation of women, who have struggled to pluck this fruit from unstable ladders, pass it freely on to the next. This

31 theme would be taken up in Cassatt's color print of *c.* 1893 that shares the color scheme and theme of the mural, but shows a woman on a ladder picking pears and grapes and handing the fruit to a naked baby, read by Achille Segard allegorically as the future, and eugenically as the bearer of a healthy purity.

The generational theme continues in the side panels, which also reveals Cassatt's identification with the daughter's revolt, with the New Woman.

> I will still have place on the side panels for two compositions, one which I shall begin immediately is, young girls pursuing fame. This seems to me very modern & besides will give me an opportunity for some figures in clinging drapery.

48

29 CASSATT *The Family* 1892

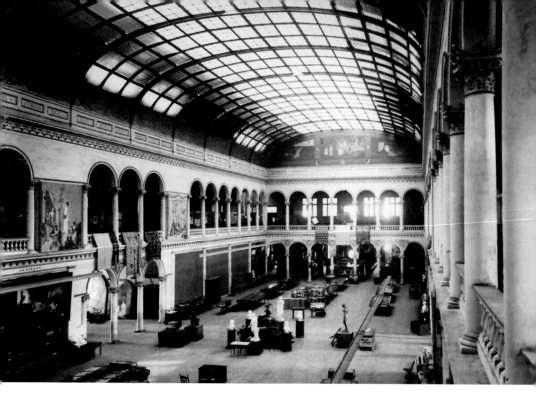

The other panel will represent the Arts, Music (nothing of St. Cecilia) [a reference to Baudry's decorations at the Ecole des Beaux Arts of 1874, *The Dream of St. Cecilia*], Dancing & all treated in a most modern way.

The girls move with physical ease through the landscape, with light, muslin dresses that allow both movement and a modern version of decorative classical drapery. They run after fame. Cassatt's fellow art student Eliza Haldeman wrote to her mother in 1867: "The difference between American and French painters is that the former work for money and the latter for fame." In a letter to her son of 23 July 1891, Cassatt's mother commented: "Mary is at work again, intent on fame and money, she says.... After all a woman who is not married is lucky if she has a decided love for work of any kind and the more absorbing the better." The Russian artist Marie Bashkirtseff (1858–84), whose shockingly frank revelations of ambition were so widely read after their publication in 1889, wrote in her diary in 1873: "It moves one so much to be admired for something more than one's dress!...I was made for emotions, for success....I dream of nothing but fame, of being known the world over."

30 The Hall of Honor, Woman's Building, World's Columbian Exposition, Chicago, showing Cassatt's mural *Modern Woman* 1893

31 CASSATT *Gathering Fruit*, 11th state, *c.* 1893

In 1860 the French critic Léon Legrange had written a lengthy article on women's status in the arts. Part of it was translated and published in 1861 as "Woman's Position in Art" in the American art magazine *The Crayon* in which Mary Cassatt might have read it in Philadelphia. Legrange notes that women are already successful in Drama, Dance and Music, but of course he means as *chanteuses*, actresses, and ballet dancers— the subjects so favored by Cassatt's future colleague, Degas—and not as directors, composers or choreographers. The animated middle-class athletes exercising in a healthy meadow on the left of Cassatt's mural imply a pointed contrast to the exhausted and overworked working-class dancers in their revealing tutus typical of Degas's work. In a subsequent passage, Legrange declares:

> Male genius has nothing to fear from female taste. Let men of genius conceive of great architectural projects, monumental sculpture, and elevated forms of painting. In a word, let men busy themselves with all that has to do with great art.
>
> Let women occupy themselves with those types of art they have always preferred, such as pastels, portraits and miniatures. Or the

32 CASSATT *Young Woman Picking Fruit* 1892, sketch for *Modern Woman*

painting of flowers, those prodigies of grace and freshness that alone can compete with the grace and freshness of women themselves.

Cassatt's painted proposition about modern woman was a riposte to such condescension. She aims for charm and femininity in her work. She intends freshness and, if not flowers, she includes fruit. Yet she has turned Legrange's views inside out by painting a great architectural piece of decoration, an elevated form of painting.

The right panel represented "Arts, Music (nothing of St. Cecilia), Dancing & all treated in the most modern way," and included a young woman playing a banjo. Although the mural has disappeared, we can imagine the intensity of color through a related pastel. A young woman strums an instrument while a younger girl leans against her, watching her fingering. The formal simplicity of the composition gives it a solidity and calm that allows nothing to distract the viewer from the concentrated attentiveness that is being represented as two people watch the creation of music through skilled fingers, the outward sign of both the thought and the technical skills that the performance of any art requires. The intimacy

15

33 CASSATT Central panel of *Modern Woman* 1893 (detail)

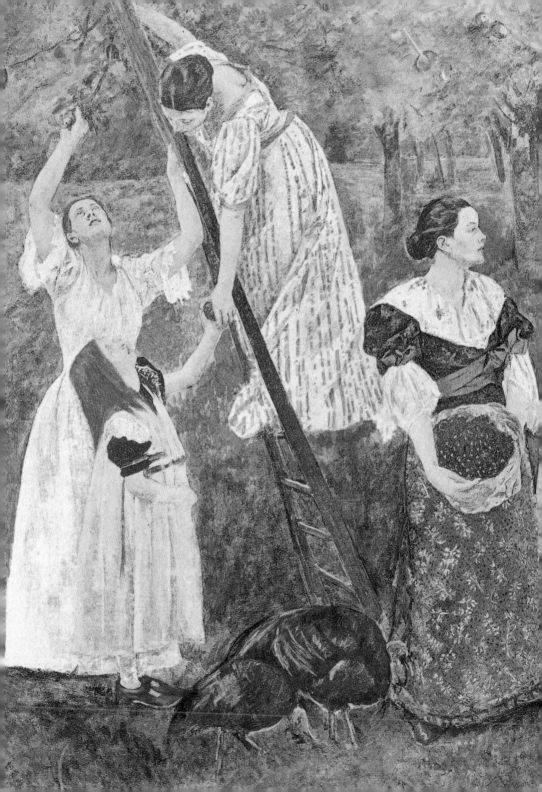

and the psychological acuity of this representation of a woman making music, and a younger woman learning from her, can be appreciated in the pastel. It might have been hard for such intimate qualities to survive their projection on to a monumental mural.

There was a border around the mural, a band three foot (one meter) wide of deep, rich blue with a great deal of gold. Into the running garlands of flowers were set roundels and lunettes showing the heads of young women and babies tossing fruit. Cassatt explained that she had gone to the East for her inspiration, meaning Persian miniatures. Like Puvis de Chavannes, she was influenced by the decorative borders of colored flowers in Italian Renaissance frescoes while painting the mural. She wrote that she was shocked that Durand-Ruel, her dealer, was unfamiliar with fifteenth-century Italian fresco cycles. In 1872, studying in Parma, she had copied frescoes by Antonio Correggio (1494/9–1534) that included elaborate decorative borders of brilliant color with putti in lunettes.

Cassatt's powerful color schemes within each panel and around its borders stood out with shocking force. Writing in *The Art Amateur* in June 1893, a critic found the color "unduly conspicuous, which is the more to be regretted as it is more pictorial than decorative in feeling." At the height of the tympana, the less than life-sized figures, their intricate relations and subtle expressions were lost to an audience mostly unprepared for such an enthusiastic revival of Italian Renaissance decorative schemes matched with arch Parisian modernism.

FASHION, FEMININITY AND MODERNITY

Mary Cassatt's subject had to be "modern." She insisted it would be truly "feminine." How did she articulate the two at the level of pictorial realization?

> Mr. Avery sent me an article from one of the New York papers this summer, in which the writer, referring to the order given to me, said my subject was to be "The Modern Woman as glorified by Worth." That would hardly express my idea, of course I have tried to express the modern woman in the fashions of our day and have tried to represent those fashions as accurately as possible & in as much detail as possible....
>
> My figures are rather under life size although they seem as large as life. I could not imagine women in modern dress eight or nine feet high.

Clothes again.

The Englishman Charles Frederick Worth (1825–95), who had settled in Paris and become designer to the Empress Eugénie, was the most renowned couturier of his era. Maison Worth on the Rue de Paix was known as the "Temple of Fashion." Worth dresses can be found in Renoir's *Madame Charpentier and her Children* (1878), and Sargent's *Madame Paul Poirson* (1885), as well as in paintings by Manet, who wrote of a fur-lined cape worn by his model Méry Laurent in his portrait *Autumn* (1881):

> She has had a pelisse made for her by Worth. Ah, what a pelisse, my friend, fawn with an old-gold lining. I was stupefied. . . . When I left Méry Laurent I told her: "When that fur is worn out, you'll leave it to me won't you?" She promised. It will make a splendid background to some things I am dreaming of.

So powerful a force was Worth in defining the appearance and silhouette of women—it was he who brought back the bustle in 1881—that a major campaigner for dress reform, Margaret Oliphant complained in 1878 of ". . . one special man-milliner, in particular, who invents and modifies at his pleasure, and whose laws the whole portion of the feminine public is supposed to obey servilely. We were not born under M. Worth's sway. He is not our natural monarch, yet we obey him like slaves."

Fashion was closely associated with both modernity and with its new modernist painting and literature. In the opening chapter of his *Painter of Modern Life*: "Beauty, Fashion and Happiness," Baudelaire argued that while there is a trans-historical element to beauty, each age has its own particular beauty which reflects the morals and aesthetics of that culture. This special beauty is found in its social manners and its fashions. Modern art was intimately connected with fashion as the locus of desire, commodities, and eroticism. Fashion, changing constantly in the competition for novelty and style, was for Cassatt's modernist contemporaries the means of representing the transience, the spectacle, the flow of commodities, and the creation of style that epitomized metropolitan modernity. This can be illustrated again and again in the relations between fashion plates and painting in the work of Manet, Monet, and Cézanne. Even the conservative Charles Blanc, founding editor of the *Gazette des Beaux Arts,* the scholarly journal of art history, published a history of clothes, writing poetically in 1875 on the bustle: ". . . the profile is the silhouette of a person who ignores us, who passes, who is in flight from us. Dress has become an image of the rapid movement which is taking hold the world and is carrying off even the guardian of the domestic hearth."

How do we reconcile intellectuality, a repudiation of the curse of Eve, with fashion as the outward sign of modernity's transience and

commodified femininity? Cassatt's letter suggests that the artist was trying to create a space, made possible by her long engagement with the independent painters, and her study of Manet and Degas, between Woman as mannequin and object of luxury whose fashionable clothes display her husband's or lover's wealth, and the lady exhibiting her "distinction," as Baudelaire would name the sometimes too subtle difference between the clothes of the lady and those of the wealthy courtesan. In Edith Wharton's *The House of Mirth* (1905) Lily Bart exemplifies the paradox of women in this society. Women of fashion and marriageability were the desiring consumers of luxury goods, bought to turn themselves into the most luxurious and desirable object on the marriage market. They strove to become the objects through whose display men competed with each other in the stakes of class and wealth. Considering a possible candidate for marriage, a wealthy but dull and egotistical collector of Americana, Lily Bart muses:

> She knew that Percy Gryce was of the small chary type most inaccessible to impulses and emotion. But Lily has known the species before; she was aware that such a guarded nature must find one huge outlet of egoism, and she determined to be to him what his Americana had hitherto been: the one possession in which he took sufficient pride to spend money on it.... She resolved so to identify herself with her husband's vanity that to gratify her wishes would be to him the most exquisite form of self-indulgence.

In 1893 Cassatt wrote to Sara Tyson Hallowell, about her preference for France over America in terms that echo Edith Wharton's indictment of elite American society's expectations of its marriageable daughters. "After all give me France. Women do not have to fight for recognition here if they do serious work. Perhaps it is Mrs. Potter Palmer's French blood which gives her organizing powers and the determination that women should be *someone* and *not something.*"

The determinedly unmarried Cassatt sisters were not aspiring to be the jewel in a rich man's collection. For them fashion offered the pleasures of feminine style and elegance. After Cassatt and Degas had fallen out over the Dreyfus affair, she was invited by a friend to have lunch with Degas. She was reluctant, fearing his acid tongue and abhorrent anti-Semitic opinions. Louisine Havemeyer encouraged her to go: "Wear that new gown, and enjoy the repose and assurance conscious elegance gives you."

In a painting related to the mural project, *Young Women Picking Fruit* (1891), the pictorial order functions around the contrast between the two styles of exquisitely designed dresses, each presenting a challenge to the

56

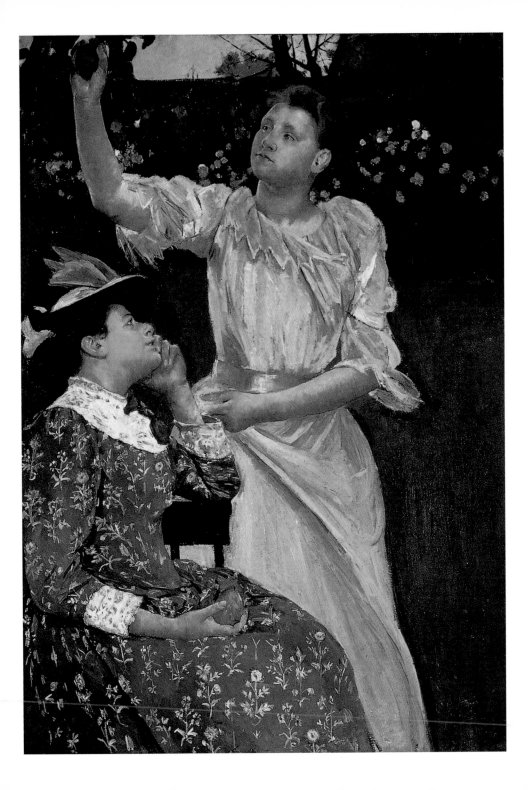

painter in rendering their design and texture, and worn by two figures of contemplation rather than display. In an elegant movement that draws the eye into and through the figurative centre of the painting, a seated woman in a floral-patterned dress looks up toward her companion clothed in muslin and silk streaked the colors of sunset, who in turn focuses on the fruit she is picking. Neither model is the typical willowy beauty of the time, and their substantial bodies and strong features allow the evocation of psychological interiority that bespeaks the kind of New Woman to which Cassatt's work gave a monumental form.

Yet, there was yet another twist to this complex issue. "Clothing in modern time," was, as Théophile Gautier called it, "a kind of second skin." With the horror of nudity, the gendered body was signified by its fashionable carapace. Feminism was bound to challenge the garments that were almost synonymous with existing gender identities if it was going to change the definitions of Woman. It was precisely the elaborate and expensive fashions visible in Cassatt's mural and on display in an exhibition of costumes by Worth's rival Jacques Doucet that came under attack at the Chicago Exposition from a group of feminists, who advocated Rational Dress, to correspond with women's new aspirations for social mobility and acknowledged rationality.

It was, however, one thing to develop scintillating techniques in oil or pastel for painting modern fashion, and quite another to use modern dress on a monumental scale in a public decoration. Classical dress or ideal nudity were the convention for heroic statements of timeless morality. Modern dress was thought too ugly and time-bound. Charles Baudelaire, however, had called on painters to discern the moral quality of the new age in its frock coats and top hats. In 1890 Puvis de Chavannes had shocked the public by painting the figures in his mural *Inter Artes et Naturam* in modern dress. Not much appreciated by the critics, the painting impressed Van Gogh, who wrote of it as "a strange but happy encounter between long distant antiquities and crude modernity." Cassatt took this "crude modernity" one stage further, banishing any visible sign of the relations between past and present. She used what would, at that great height, be seen as merely the fashionable silhouettes and the graceful forms of contemporary women to propose a radical break with tradition, showing the possibilities that modernity offered to women, if only they would reach out and take them. Haunting her work and that of Puvis de Chavannes was the most shocking breach of the proprieties of modern dress and the allegorical tradition: Manet's *The Luncheon on the Grass* of 1862, *cause célèbre* at the 1863 Salon de Refusés. In the 1860s Manet's painting took the battle for modernity into the territory of tradition,

invoking Giorgione and Raphael on the one hand, and erotic prints on the other. Puvis de Chavannes's attempt to bridge tradition and modernity was a curiosity; Cassatt's adamant embrace of modernity through fashion was elevated beyond mere genre, not by classical allusion, but by the force of her color and the boldness of its execution: the affirmation of her aesthetic alignments with the new painting that had begun with Manet.

THE STRATEGIES OF MODERNISM

At the centre of Puvis de Chavannes's panel, stands a woman reaching 21
up to the tree to pull down a branch so that the naked child propped on
her hip can pluck its fruits. The motif stems from Botticelli's *Primavera*,
and we find the same work prompting Cassatt's Impressionist colleague
Berthe Morisot (1841–95), whose painting *The Cherry Tree* (1891–92) 35
shows two young girls, one standing on a ladder to pick cherries. Puvis de
Chavannes's motif of the mother and baby plucking fruit is closer to
Cassatt's painting *Baby Reaching for an Apple*, an offshoot of her *Modern* 36
Woman mural shown at the 1893 Durand-Ruel retrospective in Paris.
These echoes advertise only that Cassatt wanted her project to take its
place in the mainstream of contemporary mural decoration with its deeply
planted art historical roots. Strategically displacing a mother and baby
from the central motif by an image of the generations of women, itself
different from Morisot's vision of feminine adolescence, Cassatt allows
another glimpse of the method by which modernists allusively point up
possible meaning by the play of "reference, deference, and difference."

At the other aesthetic and political pole, stands Camille Pissarro
(1831–1903). At the last Impressionist exhibition in 1886, Pissarro showed
a large square painting titled *Apple-Picking*, a labor performed by rural
working-class women for whom an orchard is the site of real economic
activity not mythical claims for abstract gains such as knowledge,
science or art. Cassatt's mural may invoke Puvis de Chavannes as one kind
of reference, but it adamantly declares its allegiance to the art world of
Pissarro through its prismatic colors, defiant contrasts and the attempt to
visualize women's subjectivity in the imaginary space of intellectual and
creative labor that is her painting.

The mural was the largest work undertaken by Cassatt. It gave her a
chance to display some of her enormous artistic erudition. There were
also precedents closer to home, which indicate the ambition of her
project as a synthesis of her relation not only to modernity and feminism,
but also to the history of modern art. As a "modern allegory" Cassatt's
work is preceded by Gustave Courbet (1819–77), whom Mary Cassatt

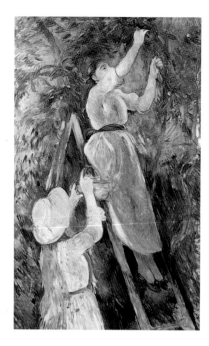

35 BERTHE MORISOT
The Cherry Tree 1891–92

much admired, notably his *The Painter's Studio: A Real Allegory Summing up Seven Years of my Artistic Life* (1855). Courbet had forged a link between Realism with its focus on time and place—my studio, my history, my art practice, my friends, my contemporaries—and Allegory, traditionally represented through abstract usually ill-clad or tinhatted female figures. The central section of Courbet's painting represents the space of Realist art making. The artist is at work on a landscape painting, watched by his nude model standing near her abandoned clothes and holding against her a sheet that will never be wound as classical drapery. He is also observed by a grubby, ragged little boy. In the Renaissance, the female nude signified Truth, and the model is used by Courbet as a Realist's foil for the opposition of the inspiration of Nature versus the tired formulae of studio Art, a point underlined by the masculine artist's self-portrayal making a landscape. In her allegory of her artistic and social world, Cassatt replaced Courbet's female nude model with a woman looking the other way, dreaming of something more than contentment with her place in nature or art. The young girl reaching up to receive the fruit in Cassatt's mural has something of the awkward stance and direct upward gaze of the romanticized raggamuffin in Courbet's canvas. The genealogy on Courbet's canvas is man to boy; Cassatt replaces that with a chain of connection from woman to girl. The action celebrated at the centre of her

36 CASSATT *Baby Reaching for an Apple* 1893

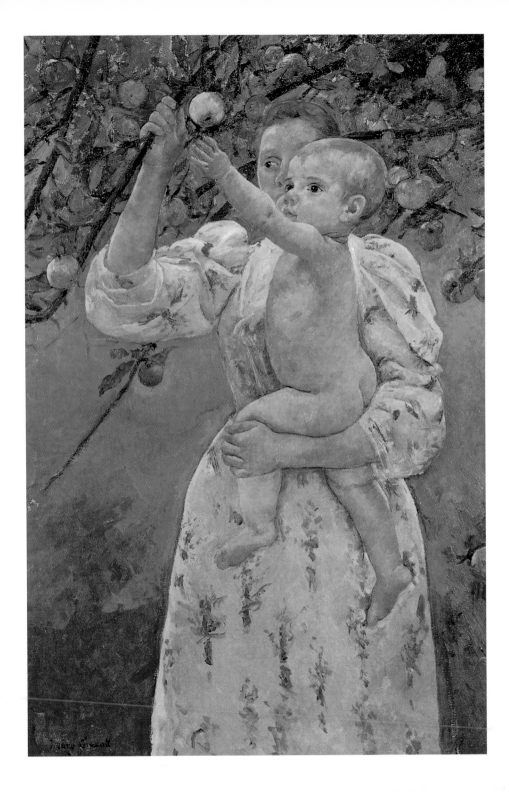

37 GUSTAVE COURBET *The Painter's Studio: A Real Allegory Summing up Seven Years of my Artistic Life* 1855

mural is not work, but what is needed for women to become great creators: knowledge and science, while active young women rush headlong through a landscape after fame, and use its resources to make and enjoy art, music, and literature. The theme of women's intellectual and creative desire is written over the spaces of these festive gardens in a canvas that notionally the masculine artist in Courbet's works was in process of preparing as a landscape in which to lay his dream of Woman. In Cassatt's mural, some see the seated figure in the right-hand panel, listening to music and watching the elegant dance, as a self-portrait of Cassatt herself.

The continuing conversation between artists in the Parisian avant-garde links Cassatt's mural to the central figure of Gauguin's *Where Do We Come From? What Are We? Where Are We Going?* (1897), a half-clad figure reaching up to pick fruit in a hybrid, recreation of the Garden of Eden somewhere on Tahiti. Paul Gauguin (1848–1903) had exhibited his Tahitian paintings in the months before Cassatt's retrospective at Durand-Ruel's in 1893. He admired Cassatt's work of which he said that, while Morisot's had charm, Cassatt's had force. Gauguin's complex and symbolic mural rephrases Christian themes of temptation and death through his new interests in non-European art to create a different combination of modernist aesthetic preoccupations with color, called *décoration*, and colonialism. Gauguin appears to betray the feminist modernism so

scrupulously located by Mary Cassatt in the present, in Paris, in her own world of class and gender, by a colonial gesture that takes us closer to Bertha Potter's conventional ideas about "the primitive."

Since this vast and potentially most significant work of a modern American artist has been lost without trace, we rely on contemporary reviews to imagine the impact of Cassatt's mural. Most reviewers were stunned by the colors: the border of blue, green and orange, the intense green of the garden setting, the gold, lilac, pink and muted red of the dresses. For some, the colors worked to create a decorative harmony even at its heightened intensity, while for others that intensity overwhelmed the subject and was in conflict with the architectural setting with which the mural failed to harmonize. Writing in *The Critic* (15 April 1893), Lucy Monroe exemplifies the responses of an educated woman reader of the work who appreciates the new art: "[Cassatt's] entire work is conceived decoratively and painted flatly without shadows. The space is admirably filled, simply and naturally; but it is in the coloring that the Impressionist has shown herself to be a true decorator." For the vast majority of its mid-Western public, however, the mural was not a success.

Writing in 1948, on the centenary of the first Women's Rights convention at Seneca Falls, Albert Ten Eyck Gardner of the Metropolitan Museum of Art compared Cassatt's mural with Mary MacMonnies's, whose much more conventional women were shown doing the ancient tasks that women "should."

> Miss Mary Cassatt's Modern Woman, on the other hand, seemed to be doing things she shouldn't.... For her there was no room for allegorical commonplaces acted out by sweet-faced prairie belles in classic robes. In fact as one studies the pictures of this mural today, the feeling grows increasingly strong, that this decoration was perhaps a most pointed and telling comment on the modern woman of 1893.

Then he imagines the perplexity of the Board of Lady Managers of the Woman's Building, less sophisticated in art matters than their President, Bertha Palmer, and her art adviser Sara Hallowell.

> "Apples?" the Board of Lady Managers asked themselves; were these merely country girls frolicking among winesaps or were they modern Eves pilfering the bitter fruit of the tree of knowledge? Bad as this central panel seemed there was worse on each side. In the panel on the left was a nude girl soaring into space and three women running

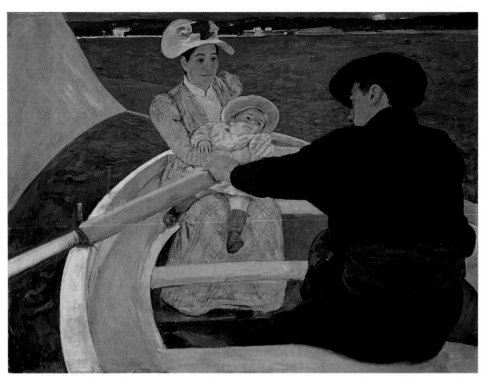

38 CASSATT *The Boating Party* 1893–94

after her in joyous abandon pursued by hissing geese. "Geese?" How very perverse and impertinent of Miss Cassatt. In the panel on the right were shown two women seated on the grass...and behind them danced a girl whirling her skirts in the most shockingly carefree manner, quite like those shameless lost creatures who pranced in the tawdry sideshows [at the exposition]. The Ladies of the Board were not only embarrassed, they did not know whether they were being outrageously teased or flatly insulted. Modern Woman was far too sacred a subject to be flippantly treated with geese and skirt dancers, and surely this was no place to bring up an uncomfortable Bible story even though it most certainly did revolve around a woman. Miss Cassatt had evidently been exposed altogether too long to the debilitating shams of foreign society and had forgotten how seriously organized American women could take themselves. She was, unfortunately, so prominent an artist, and so well connected socially, that the mural could not be withdrawn; besides they had been forced to pay

for it. It could, however, be ignored, and in the official history of the Fair no picture of it appears.

This fantasy allows us to surmise how the major work of a major artist on the central theme of the building could have disappeared without trace: destroyed? lost in a museum basement? hidden in a provincial college library?

On the other side of the Atlantic, however, the critic André Mellerio provided a positive assessment of the central panel when he reviewed Cassatt's first major retrospective exhibition at her dealer's gallery on the Rue Lafitte, November–December 1893: "There is serenity in Miss Cassatt's choice of broad color, without impasto, while her characters move freely in a limpid atmosphere. Here in France, one would have to go back to Puvis de Chavannes to find so masterful an understanding of large decorative schemes." Mellerio's review gives us a French reading of the intimate relations between Cassatt's vision of femininity and avant-garde culture. He finds in her painted "ladies" "intimate and affecting charm, with nothing artificial about it," and, revealing the eugenic sub-text that often surfaced in reviews of Cassatt's paintings at the time, Mellerio notes the way both young and old shine with fresh health and vigor. "She has been able to turn the colors and lines of modern dress to advantage. This is her secret and her talent—as it was of the masters—to have preserved the solid foundation of humanity, the eternal warp and weft of all works of art, while weaving into it the myriad nuances of an age, a race and a milieu."

Here Mellerio paraphrases the philosopher Hippolyte Taine's famous thesis that art, as part of culture, is the product of its nation, its historical moment, and its intellectual and geographical milieu. Cassatt was an American in Paris, and her work acquired its distinctiveness for both her American and her French contemporaries because of the artistic and intellectual choices she made. Thus the critic Alfred de Lostalot traced her affinity with Degas's incisive drawing and "plastic thought" on the one hand, and on the other, with Renoir's brilliant color and vibrant facture. Within its specific artistic context, Cassatt's mural and its related paintings were appreciated in Paris for qualities that were as yet unfamiliar to the American public in Chicago, so few of whom had been exposed to the "new painting." Cassatt's role as one of the leading advocates of modern French art, encouraging American collectors to acquire examples, would eventually create an American context for her own, Parisian-based art.

A classic instance of this exchange concerns one of the paintings produced in a manner related to the mural project that had, however, no thematic association, *The Boating Party* (1893–94) painted on holiday in

Antibes on the coast of the South of France. It was clearly a belated *hommage* to Manet, whose *Boating* had been exhibited at the Salon of 1879 amid general critical hostility. Cassatt eventually persuaded the Havemeyers to purchase Manet's painting, to exhibit it in America, where it came to form one of the centrepieces of the Metropolitan Museum of Art's exhibit of modern French painting that would prove so influential on subsequent generations of American artists.

Cassatt appreciated in Manet the dramatic simplification of a casual event, here a "family" enjoying a summer outing on the water, but she gave the scene an unexpected intensity through the complex exchange of looks whose full significance is not revealed: is this a family group, or a woman, child, and hired boatman? How do we interpret the powerful masculinity of the muscular oarsman in relation of the self-composure of the woman and the quizzical curiosity of the lolling toddler? Directness and formal clarity produced a painting of unexpected ambiguity lodged in a formally ambitious composition. Achille Segard commented: "It is to Miss Mary Cassatt's credit that...she was one of the first to appreciate Manet's very important qualities, and it is to her honor that she has so preserved her personality that this comparison points up only affinities of mind...."

Both Mellerio and De Lostalot commented on the range of Cassatt's achievement, not only in oil painting, but in pastel and etching, especially mentioning her drypoints as "poems" of "grace and feeling." Both critics define Cassatt by what one of them called her "eternal theme: motherhood" and the other "the source of her inspiration.... Woman and Child." Thus it appears that her reception in France in 1893 confirmed, if not publicly initiated, the association of Cassatt with the cult of True Womanhood and Motherhood which, I have argued, was interrupted by the mural she had just transported across the Atlantic for exhibition in Chicago. Yet we must listen carefully to the terms of this reaction to Cassatt's work, to catch the complex ideological weight carried by the critical approval of the finely balanced relation between her means of representation and what she painted. The promoter of Monet and Rodin, Gustave Geffroy wrote of the 1893 exhibition:

> It is impossible not to surrender to the charm of many of these light-filled paintings, velvety pastels, and firm and supple engraved drawings. From the works of her earliest years of her time in Paris, to yesterday's works, the progression of talent is apparent: the sureness of the drawing and the accuracy of the coloration are more in evidence, a particular expression is confirmed: a refined way of seeing women and children in the light of gardens, in light-filled rooms veiled by blinds.

The "essential character of Cassatt's art" appears in her appreciation of what Geffroy called "the emanation of life, made up of summer's temperature and the scent of flesh." Summertime, outdoor settings, healthy and active women, and fine-limbed and pink-cheeked babies add up to more than a trite repetition of "mother and child." Geffroy discerns an almost political meaning in Cassatt's summery formalism which runs counter to the decadent undertones of Degas's protégés, such as Henri de Toulouse-Lautrec (1864–1901), Emile Bernard (1868–1941), Louis Anquetin (1861–1932), as well as to the emergent Symbolist painters, such as Gustave Moreau (1826–98). "She rightfully loves the balance of bodies, the graceful movements of arms, the complexions of faces. She seeks out these external aspects, this fine health, this physiological tranquility of human beings." Geffroy also found "expression" in this careful observation of healthy externals. He commended particularly the *absence* of "quiverings and agonies of the maternal spirit, the embraces that love the moment and fear the future," a reference perhaps to drama-laden images of *maternité* by artists like Virginie Demont-Breton (1859–1935) whose paintings of impoverished and widowed motherhood in tragic or troubled situations were contemporary with Cassatt's studies of well-fed, well-kept, and untroubled bourgeois mothers or their rural counterparts. Geffroy pits Cassatt's thoughtfulness and social observation against generalized, pathos-laden universalism. Cassatt sees "exactly" and she sees "pink children, playing or frowning or trying out gestures," and women "with freckled faces, hard rural countenances, and clearcut, impassive faces, the nursery maids from the villages, the correct governesses, and the peaceful mothers." Geffroy acknowledged Cassatt's social perception, finding in this work a subtle anatomy of class, observed with the formalist's attentiveness. Mastery of form and color transforms the theme of mother and child, used ideologically at that time to signify something non-social, eternal and ideal, into the concrete field of social interaction and difference between women in an equally "political" gesture.

By 1893, therefore, Cassatt was being hailed as a leading modernist painter of both the New Woman and her socially varied, motherly sisters. She was becoming more visible as a major force in the American avant-garde in America where she would have her first retrospective at Durand-Ruel's Gallery in 1895, and she was acknowledged in France for an "oeuvre that is complete and distinctive, worthy of commanding the public's attention." (Mellerio).

How did a young woman from Pittsburgh arrive there?

39 Mary Cassatt in Paris *c.* 1867

Americans At Home and Abroad

In my earliest memories I see myself, a little girl of five or six, learning to read in
Paris, where my parents had come to consult a physician about one of their children.
They remained in Paris for five years. We then returned to Philadelphia, where
I received my education. Toward 1868 my mother and I returned to Paris for a little
over a year. Shortly before the war [Franco-Prussian], that is around 1868,
I decided to become a painter.

<div align="right">

Achille Segard, Mary Cassatt:
Un Peintre des enfants and des mères, 1913

</div>

Mary Cassatt was born 22 May 1844 in Allegheny City, the twin city of
Pittsburgh, Pennsylvania, into which it has now been absorbed as a smart
suburb. Wealthier and more cultured than its twin, Allegheny City was
also the terminus of the Pennsylvania Railroad/Canal system, which was
important for the family's business interests. The Cassatt family lived on
Rebecca Street from 1840 to 1847, the year in which the artist's father, the
investment broker and merchant Robert Simpson Cassatt became the
city's mayor.

1844, the year of her birth, puts Mary Cassatt in a significant relation
to the history of both American and French art. Edmonia Lewis (1844–
?1911), an African-American and Ojibewa sculptor who made her spec-
tacular career in Boston and Rome, and Thomas Eakins (1844–1916) were
her closest contemporaries. Eakins also studied in Paris in the 1860s, but
made his career in Philadelphia after 1870. Winslow Homer (1836–1910),
James McNeill Whistler (1834–1903), and Elizabeth Gardner (1837–1922)
were almost a decade older than Mary Cassatt, while John Singer Sargent
(1856–1925) was twelve years younger, closer in age to Cecilia Beaux
(1855–1942) and J. Alden Weir (1852–1919); the Munich-trained New
York painter William Merritt Chase (1849–1916) was five years younger
than Cassatt. In the French school, with whom Mary Cassatt would
align herself in the 1870s, Edouard Manet (1832–83), Edgar Degas
(1834–1917), and Camille Pissarro (1831–1903) were a decade older;
Claude Monet (1840–1926), Pierre-Auguste Renoir (1841–1919), and
Berthe Morisot (1841–95) were closer in age to Cassatt.

For five years, Cassatt was the youngest child of a large family that tragically contracted through childhood mortality. Her mother, Katherine Kelso Johnstone (1816–95) had married Robert Simpson Cassatt (1801–91) in 1835 when she was nineteen. In thirteen years, she bore six children of whom the surviving were: Lydia Simpson (1837), Alexander Johnston (1839), Robert Kelso (1842), Mary Stevenson (1844), and Joseph Gardner (1849). George Johnston, born in 1846, had died in infancy. The children's names reflect the family pride both parents took in their long-established American heritage, stemming on the paternal side from French Huguenot immigrants, originally named Cossart, who had arrived in New York in 1662, and down the maternal line from Scottish-Irish ancestry.

The Cassatts straddled "old society," the aristocracy created in the colonial period who socially dominated East Coast America, and the new, dynamic, entrepreneurial capitalist society that would actively move the centres of gravity westward towards Chicago and allow New York to become the leading city of the Union. Robert Cassatt's enterprise as financier and mercantile broker was viewed with some suspicion in elite circles, but his financial success ensured that he and his family were financially independent by the time he was in his early forties. The combination of social privilege and entrepreneurial energy that would characterize Cassatt's artistic career, also shaped that of her brother Aleck, who very early

40 PIETER BAUMGAERTNER
Robert Cassatt and His Children
1854, Mary Cassatt standing
centre

41 CASSATT *Robert Cassatt on
Horseback* 1884–86

wanted to be an engineer and rose, after a technical education in Europe
and America, to become one of the top managers in the American railway
business and one of the wealthiest in the country. When the family moved
in 1849 to Philadelphia, the second city of the United States (and the fifth
largest in the world at the time), the Cassatts would have moved in upper-
class circles, bringing with them habits and customs from the intervening
two years spent living the life of country gentry at Hardwicke, a mansion
in Lancaster, Pennsylvania, which Robert had extravagantly enjoyed after
his retirement from active business life. There the children were educated
at home by governesses, all learning to ride and enjoy a sporting and
outdoor life. In a letter of 27 November 1867 to his fiancée Lois Buchanan,
Cassatt's brother Aleck wrote:

> Mary was always a great favorite of mine. I suppose because our taste
> was a good deal alike—Whenever it was a question of a walk or a ride
> or a gallop on horseback, it didn't matter when or in what weather, Mary
> was always ready, so when I was at home we were together a great deal.

In 1851 the family left for Europe for the sake of the younger Robert's
health. They spent two years in Paris, one in Heidelberg and one in
Darmstadt, where Aleck attended a technical school of high repute. It was
there that Robert died, aged thirteen. The loss was a massive blow to the

eleven-year-old Mary. The two had been closest in age and temperament and now she was stranded between older, teenage siblings (Lydia was eighteen and the absent Aleck sixteen—he was to remain in Europe to complete his education) and a brother five years younger than herself. This sense of separateness, that later enabled her to leave her family and spend the years 1865–77 abroad mostly alone while she studied, may have been fostered in this radical and tragic change to the family structure that occurred in 1855.

The European years meant that as a child Cassatt was educated in French and German schools, becoming fluent in their languages and familiar with both cultures. On the Cassatts' arrival in Europe, they spent a month in London and probably visited the Great Exhibition at the Crystal Palace. Before they left for the States in 1855, the family would have been able to see the Exposition Universelle in Paris that opened in May that year, featuring exhibitions of the reigning monarchs of French history painting, Delacroix (1798–1863) and Ingres (1780–1867). They could also see the dissenting pretender in the Pavillon du Réalisme, opened the following month by Gustave Courbet to exhibit forty of his paintings, the chief of which, refused for the Beaux Arts Section of the International Exposition, was *The Artist's Studio: A Real Allegory Defining Seven Years of My Artistic Life.* The Exposition Universelle would also have exposed the Cassatts to the newest directions in British painting by the Pre-Raphaelites.

After three years in somewhat subdued and more middle-class circumstances in West Chester, the Cassatts moved again to Philadelphia in 1858. Here Cassatt lived and studied for four years, almost her longest single residence in an extremely unsettled but stimulating childhood. In 1860 she was enrolled in her first formal art class. She was sixteen, tall, athletic, and intense.

These critical years established a life-long connection with Philadelphia's art world. The city boasted the Pennsylvania Academy of Fine Arts, founded in 1805 as a museum, a permanent art collection, a space for temporary exhibitions and an art school. Until the 1860s, its annual exhibition was the American equivalent of the Paris Salon. It also provided its students with the standard art education offered in Europe, drawing from casts and engravings from the antique, and learning to paint by copying from a growing collection of Old Master and more recent paintings. When Cassatt enrolled as a student in the Antique Class in 1860, she and her fellow women students (21 out of 100 in the classes for 1859–61 were women) could have seen works by the Swiss British Academician Angelica Kauffman (1741–1807), the American genre painter Lilly Martin Spencer,

42, 43 The modeling class at the Pennsylvania Academy of Fine Arts, 1862, Eliza Haldeman and Mary Cassatt on the right; (inset) Mary Cassatt in 1863

and the famous French animal painter Rosa Bonheur (1822–99). She may also have read Elizabeth Ellet's enlarged, Americanized translation of Ernst Gühl's *Women Artists in All Ages and Countries* (1859) which documented the many women artists in the history of European art. Philadelphia also had significant private collections in which art students could see works by Jean-Léon Gérôme (1824–1904), later to be the Paris teacher of Cassatt 46 and Eakins, William Bouguereau (1825–1905), Spanish painters such as Fortuny (1838–74), as well as modern Dutch and Belgian painters. 62

Promising as this art world was when Cassatt entered it as a student, we should not overstate the possibilities. While it was open to women, it was without a sufficient infrastructure of dealers, exhibition galleries, collectors and intellectuals to create the environment necessary to sustain the young American artist for anything more than becoming a society portraitist. Portraiture had played a major role in the development of a buying public for the visual arts in the fledgling United States, and there had been distinguished practitioners since the eighteenth century, such as John Singleton Copley (1738–1815), Gilbert Stuart (1755–1828), and Thomas 44 Sully (1783–1872), and many of the Peale artistic dynasty. Sully earned

73

44 GILBERT STUART
Mrs. Richard Yates 1793–94

over a quarter of a million dollars from his 2500 portraits, yielding an annual income of $3500 at a time when it would cost a student about $600 a year to live and study in Paris. Cassatt may have read in the new *Cosmopolitan Art Journal* of 1860 an article on "The Dollars and Cents of Art" and calculated the possibilities of earning her living from art. Her family later decreed that her artistic practice had to be self-financing and so the question of exhibitions, sales, dealers and collectors would, as always, be a major factor in her later decision-making about where and what to paint.

The artistic and cultural centre of the United States was soon to move to New York, a shift which reflects on the reasons why Cassatt and so many of her ambitious contemporaries felt the need to work in Europe. Philadelphia, dominated socially and culturally by the old elite, was wedded to the idea that a solidly traditional and valuable art could be fostered around academies and Old Master collections. New York, like Paris, was to show that it would be an alliance of an intellectually and culturally diversified community with an emergent industrial and commercial bourgeoisie, that would desire and engender a distinctive new art. The conditions for modern art were rooted in the structures of such urban-industrial, commercial and consumerist metropolitan economies, first developed in Paris. Should Mary Cassatt have gone north where an independent exhibiting society, the Society of American Artists, akin to the Independent initiatives in Paris, would be formed on 29 October 1877 in the home of the artist Helena de Kay Gilder (1848–1916), and which Cassatt was invited to join in 1878?

74

During the Civil War, which hardly touched her loyally Democratic family directly, Cassatt lived at home in the country. Then in December 1865 she left for Europe with her mother, despite her father's apparently profound anger either at her desertion or her ambition to be an artist. After three years of drift within her family and its social world, Cassatt was beginning to form a plan of escape which would express her own desire to pluck the fruits of knowledge and (artistic) science from the cultural garden of Europe. In her social milieu, the get-up-and-go acceptable for Aleck was probably not at all suitable for his sister Mary. Cultivated art practice, even a few sales, pursued in a dignified and respectable way from within the family circle was one thing, but independent professionalism, pioneered by a generation of women sculptors in Rome like Harriet Hosmer (1830–1908) and Edmonia Lewis, was much more challenging to even the most enlightened and cosmopolitan parents. It was not until 1877 that the family finally conceded that Mary was not coming back to them, and went to join her, to surround her with the envelope of respectability, and indeed companionship, congruent with both family and class values.

The trip to Europe had always been on the agenda of any aspiring American artist since the eighteenth century. At first it was a necessity since there was no training and too few Old Masters to study in the colonies. Travel offered access to the Great Tradition through Grand Tours, and to the necessary skills and practical knowledge available only in Europe's main cultural centres. London had drawn Benjamin West (1738–1820) and Copley in the late eighteenth century as, by the middle of the nineteenth century, Rome and Florence were to draw sculptors like Hiram Powers (1805–1873), William Wetmore Story (1819–95) and a whole generation of women sculptors. Between 1830 and 1875 over 200 American artists studied or worked in Rome, although before 1860 less than a dozen recognized American artists stayed permanently in Europe.

So the decision to study abroad was part of the expected exposure to the great treasures of Western art still held in Europe. The Metropolitan Museum of Art, New York, would not be founded before 1870; the Philadelphia Museum of Art was not established until 1876; while Chicago only got its Art Institute in 1879. By the 1850s and '60s London and Rome were now rivaled by Munich or Düsseldorf in Germany, and increasingly by Paris. Museums such as the Louvre offered opportunities for learning the craft of painting and the secrets of composition and color through copying Old Masters. Winslow Homer's illustration for *Harper's Weekly* 45 1868 shows the Grande Galerie of the Louvre cluttered with art students

45 WINSLOW HOMER
*Art Students and Copyists in
the Louvre Gallery* from
Harper's Weekly January 1868

and copyists, many of whom were women. It was here that during the
1860s that Cassatt's future friends and colleagues, Manet, Degas and Morisot,
copied as did Cassatt herself along with Elizabeth Gardner, Eakins, and
Eliza Haldeman who had arrived in Paris a few months after Cassatt.

The early 1860s was a turning point for American artists in Europe.
Artists of an older generation went to Rome, a city described by Lois Fink
in her 1990 study of American art at the Paris Salons as holding "nostalgic
remembrance of lost roots for New World migrants, a spiritual home rich
in traditions of art history so lacking in their own country." Paris,
however, was the centre for the art of the moment. Benjamin Champney,
a painter from Boston, visited Paris in the mid sixties after travelling in
Italy, and wrote:

> Now it seemed pleasant to come back to Paris, to be surrounded by the
> interests of today, to see what the greatest artists of the greatest modern
> school were doing...it was with delight that I turned from the musty
> old galleries to find so much freshness and nature here.

Over 1800 American artists studied in Paris in the later nineteenth century,
and in the 1880s Henry James was to declare of his country's art: "When
we look for 'American art' we find it mainly in Paris. When we find it out
of Paris, we at least find a great deal of Paris in it."

The city's singular advantage as an art centre lay in its annual state-
supported Salons showing contemporary art, which increasingly formed
a focus for an international community not only of artists, but of dealers
and collectors. In the Salons the aspiring art student could see over 3000
art works, track the current critical debates that raged in the volumes of art
criticism generated by this vast and often chaotic display, while discerning,

notably throughout the 1860s, aesthetic realignments and the creation of new artistic languages. In 1855 at the Exposition Universelle the giants of French art were the representatives of the competing schools of Romantic colorism (Delacroix) and Neoclassical linearity (Ingres) treating the lofty themes of history, religion and mythology. The Salon of 1863 showed that the pressure of diverging tendencies and political interests had rendered this binary division obsolete. Intense competition and diversity forced the Emperor to announce both an official Salon and a Salon des Refusés for the thousands of artists refused entry and thus access to potential sales and reputation. In the Salon des Refusés hung not only Manet's notorious talking point, the extraordinary *Luncheon on the Grass*, but also Whistler's perplexing mixture of Courbet and Rossetti, *The White Girl* (1862).

Twentieth-century art historians have underestimated the Ecole des Beaux Arts and its education, radically reformed in the 1860s, undervaluing its continuing hegemony, relevance and success in the training of painters, many of whom departed from the traditional forms of expression associated with the Academic tradition without abjuring the discipline and the historical perspective it provided. For many women artists the battle for access to this most prestigious and disciplined form of art education was waged until the end of the century.

One of the newly appointed professors in whose atelier those privileged men who passed the entrance examinations could study was Gérôme, who had made his Salon debut with a *néo-Grec* painting *The Cock Fight* (1846). By the 1860s he was producing a range of erotic Orientalist works. Eakins was accepted into his studio and became one of Gérôme's most dedicated students from October 1866 to November

46 JEAN-LEON GEROME
The Cock Fight 1846

1869. Prevented by her sex from formal admission to the Ecole, Cassatt, none the less, pulled off the coup of persuading Gérôme—who, it was reputed, did not regard women as artists—to take her on as a private pupil. Stunned, American friends wrote to Eakins to find out how "Miss Cassatt was honored by Gérôme's private lessons."

Women could become pupils of those painters who would provide them with instruction, and Cassatt and Haldeman tried out a number of ateliers where, for a fee, they would have access to models to paint from and regular appraisals of their efforts. In 1866, they worked with Charles Chaplin (1825–91), a painter of "pink-fingered chiffonné young women... painted with distilled rose leaves and dewdrops" (Henry James, 1876). Cassatt and her American colleagues needed access to the insider's secrets about the complicated and fascinating process called painting. During long apprenticeship years, the question of subject matter might be separated from the job of just learning how to handle paint. Manet studied from 1850 to 1856 in the studio of Thomas Couture (1815–79), and did not exhibit at the Salon until 1859. While working on technicalities with accomplished artists able to pass on necessary tips and experience, Cassatt used the vibrant cultural life of Paris to discern what would be ultimately a more intellectually formative message.

Cassatt was in, or near, Paris for the 1867 Exposition Universelle. Outside its huge boundaries, another dissident declared his independence. Manet, following Courbet's example in 1855, built himself his own pavilion which opened on 22 or 24 May 1867. In January, Emile Zola published the first major defence of Manet in *La Revue du XIXe siècle*, and this article appeared as a pamphlet with the one-man show of over fifty paintings which enabled visitors to get a sense of the artist's whole project over the last eight years. Zola's advocacy of Manet drew together some disparate tendencies that could get lost in the sea of paintings at the Salon and local exhibitions at dealers' shops, and gave them shape, in the minds of the cultural gatekeepers at least, as a new school.

While ever-growing numbers of young artists tried to work out what they could or should be doing, commentators of all persuasions offered to discern trends that in turn confirmed or redefined the tentative annual experiments of the artists contesting the official art world. For some critics Manet's work seemed dangerously close to the poet Charles Baudelaire, author of the censored poems *Les Fleurs du Mal* (*The Flowers of Evil,* 1857), who called for "a painter of modern life" to discern the melancholy of modernity. In opposition to this view, Manet was mobilized in 1867 by the journalist and novelist, Emile Zola, to represent his conception of art as "a corner of nature seen through a temperament."

47 Painting class of Charles Chaplin (detail), with Mary Cassatt top left, 1866

Zola provided a detailed technical reading of Manet's painting strategies to convince the public that they were knowingly constructed rather than indifferent to or ignorant of normally required and valued procedures. Zola named this work "the language of simplicity and exactitude"; Manet was called "a child of our times," and his work was appraised for simplicity, boldness, unity, and the elegance of the artist's observation of the law of tone which produced an unfamiliar brightness of atmosphere and luminosity. In a pamphlet for the exhibition another critic wrote that "the artist [Manet] does not say, 'Come and look at works without faults.' He says, 'Come and look at sincere works.'"

Zola's writings signaled a challenge of great significance not to academic theory per se, but what to what many people felt its current practice had descended to: debased, unimaginative academicism in which all sparks of originality and spontaneity were progressively schooled out of an art student, crushed beneath the dead hand of a tradition that was now reduced to over-taught formulae. The need to reconnect the skills and intellectual ambitions of art with an energy that could renew inspiration and find ways to capture the heroic and the tragic as well as ordinary and singular elements of modern life led many critics to call upon artists to soak themselves in a more direct encounter with what they called Nature. This meant several things. Literally, it encouraged landscape painting and especially sketching "impressions" and "effects," both technical terms well established in academic vocabulary for painting *en plein air*, out of doors. Practically, it meant producing less finished pictures in which the freer facture of the paint signaled a more direct relation with the original inspiration from the world than the artist's representation produced in the city

studio. Allegorically, it heralded the liberal ideology of individualism expressed as artistic individuality.

The left-wing democrat Théophile Thoré was another influential critic calling for a modern art in the 1860s. He wanted a new art for a democratic society, and his ideal was modeled on the realism of the seventeenth-century Protestant Dutch schools. When Thoré reviewed the Salon des Refusés of 1863, it was, he explained, as if the French school was reinventing itself:

> French art, as one sees in those proscribed works, seems to be starting out or starting afresh. It is baroque and savage, sometimes exactly appropriate and even profound. The subjects are no longer those in the official galleries: little mythology or history; present-day life, above all in its popular types; little effort and no taste at all: everything revealed just as it is, beautiful or ugly, distinguished or vulgar.... And the method of working [is] altogether different from the working methods consecrated by the long domination of Italian art. Instead of searching for contours, what the Academy calls drawing, instead of insisting on detail, what lovers of classical art call finish, they aspire to render the effect in its striking unity, without worrying about the correctness of the lines or the minutiae of the accessories.

For a young painter in Paris in the 1860s, trying to master painting's traditions in order to become a professional, these debates must have been both provocative and exciting. They led in opposite directions; but the key to grasp was that serious artistic realignments could only take place on the basis of total mastery of tradition, not as a substitute for it. Manet and Degas were deeply schooled in the history of art, available through their own student travels, the expanding museums and the concurrent foundation of the study of the history of art, and through learned publications like Charles Blanc's *Histoire des peintres de toutes les écoles* (1859–76) and journals like the *Gazette des Beaux Arts* (founded 1858). It would take Mary Cassatt at least a decade to reconnect with the arguments and debates she first encountered at this time and build a distinctive artistic project on these ideas about what painting could do and why it should rework the past rather than merely emulate it. At the same time, many critics were hailing, with mixed responses, a massive and noisy challenge by landscape painters like Théodore Rousseau (1812–67) and Charles-François Daubigny (1817–78), and their younger followers such as Pissarro and Monet. In 1863 Jules Castagnary proclaimed: "Let us get down to earth, where the truth is. The object of painting is to express, according to the nature of the means at its disposal, the society which produced it."

48 CHARLES CHAPLIN *The Pearl Necklace* n.d. 49 PAUL SOYER *The Dead Bird* 1866

If seeping oneself in nature as opposed to schooling oneself in art was thought to be the route to the production of singular, sincere, and original art, then decamping to the countryside was a necessity. In February 1867, Cassatt and Haldeman took up lodgings in the village of Courances, near the most famous artist colony at Barbizon, in the Forest of Fontainebleau, forty miles south west of Paris. At Barbizon the best known representatives of peasant and landscape painting Jean-François Millet (1814–75) and Rousseau were working. It is significant that at first Mary Cassatt moved to the vicinity of Barbizon, possibly contemplating the need to study landscape painting.

51

By April, however, Cassatt and Haldeman decided to move northward to another artists' colony at Ecouen, where several Americans were living. Here, as Haldeman wrote in a letter to her mother, they could get instruction from one of the two leading genre painters in France at the time, Edouard Frère (1819–86) and Paul Soyer (1823–1903). Soyer did not charge for the benefit of his friendly advice and Cassatt remained loyal enough to this teacher to list herself as his student in her many entries to the Paris Salon for the ten years she submitted.

In the mid nineteenth century, genre painting—representations of daily life, local customs and seasonal labors of country regions and peasant workers—offered to the newly urbanized bourgeois consumer a sanitized

and comforting sense of a world of simple labors and regular habits. The dirt and disease that attended underdeveloped regions only twenty miles from Paris, on which the outspoken Haldeman commented in shock in her letters home, was turned by a warm, brown palette into reassuring visions of timeless rural homeliness. It was such scenes of youth, old age, and domestic work, featuring women, children, and the elderly, that Frère and Soyer showed at the annual Salons. In April 1868, during her stay in Ecouen, Cassatt and Haldeman went back to Courances and visited Barbizon where it would appear that Mary Cassatt contemplated studying with Jean-François Millet. On 24 April, 1868, Haldeman wrote:

> We were at Barbizon last week but she was not pleased with the Master she intended taking. You can imagine the horror we were seized with in hearing he painted without models.... Of course he dont draw well and though a very celebrated painter would not be as good a master on that account. He is one of the Best of the school of Barbizon and was engaged in painting a fat pig being led to slaughter. The school there is composed entirely of landscape painters contrary to that of Ecouen who are all figure and interior painters. Though at the former they also paint figures and animals out of doors. Mary is very anxious to learn the style and it is very fine. [Constant] Troyon [1810–65] was the head of it when he was living and it is the most original manner of painting in regard to subject now in existence, for none of the old masters did anything like it.

Cassatt took the trouble to investigate the potential of landscape and peasant painting at its most innovative and shocking in the practice of Millet. While rejecting it, she did take something from Millet's work, observed on these visits to Barbizon as well as at the Salon. She made her Salon debut through a work that owed a great deal to Millet, who in the 1860s was exhibiting substantial paintings of single figures of rural workers in oil as well as in a medium Cassatt would later use herself, pastel.

51

CASSATT'S FIRST SALON PAINTING

Back at Ecouen Cassatt planned a Salon subject which did not make it into the 1867 Salon, but she soon produced what we now know is her first exhibited picture, *The Mandolin Player,* which was exhibited at the Salon of 1868 under the name Mary Stevenson.

The Mandolin Player is a large painting on a standard-size canvas which shows a half-length female figure holding her instrument against a simple brown background. The figure is seen with light falling from one side

50 CASSATT *The Mandolin Player* 1868

casting most of the face into shadow. It is not a straightforward piece of genre painting for it is not a scene of peasant music-making, and the viewer is required to engage with two demands whose tension produces the painting's allure. The uncluttered directness of the figure's presentation draws the eye towards the paint itself, the broadly blocked paint of the white chemise as the light falls upon it, the carefully modulated muted reds of the sash that provides the only local colour, and the finely brushed,

shaded face from which expressive eyes emerge to arrest the viewer's appraisal of painterly finesse. This feature suggests that on her visit to Millet's studio she may have seen his *Goatgirl of Auvergne* (1868–69), an example of "naturalist portraiture," in which the girl's face is partially obscured by the shadow of her flowerpot hat. As we discern the features of the young woman in Cassatt's painting, through an almost Rembrandtesque chiaroscuro (Rembrandt's late *Self Portrait* in the Louvre of 1660 has a similar cast shadow) we confront an expressive face, evoking already a sense of psychological interiority associated with portraiture rather than genre painting.

A rustic musician who barely seems to belong to the locality in her picturesque simplicity (some later critics called her an Italian woman) would be easily admitted into the Salon, especially when painted with this degree of finesse. Closer attention, however, would reveal that the painter had synthesized a solidity of drawing and realization of the figure with some of the new tendencies so decried by the reactionary Salon juries of the later 1860s. Manet had appeared at his Salon debut in 1859 with a simple single-figure painting *The Absinthe Drinker,* indebted, he claimed, to Velázquez, and in 1861 with a more clearly flagged piece of *espagnolisme, The Spanish Singer* which was in his 1867 mini-retrospective. The motif of a woman playing the mandolin occurs in seventeenth-century Dutch as well as eighteenth-century French art, examples of which were in the Louvre in the 1860s. The elegant lady's accomplishment has been relocated in the rural working class not by generic anecdotal details, but through a declared formal relation to Dutch and Spanish painting mediated by the work of the two most important surrogate "teachers" whom Cassatt was evidently absorbing in these years, Manet and Courbet.

After a short trip to Paris for the Salon of 1868, Mary Cassatt went to another rural artists' colony, taking rooms in the village of Villiers-le-Bel, and sought out instruction from Manet's teacher, Thomas Couture. Couture offered the example of a dramatic and rugged painting style achieved through a bolder and freer application of paint and less moderated tonal oppositions that were coupled with a reflective, if not a Romantic, sensibility already anticipated in Cassatt's Salon painting. Cassatt then began to work on an unexpected subject drawn from Tennyson's poem, "Mariana in the Moated Grange," a choice suggesting her interest in the Pre-Raphaelite painter Millais who had painted *Mariana* (1850–51) and exhibited a scene from Keats's poem "The Eve of St. Agnes" in Paris in 1867. In a letter to his fiancée Lois Buchanan in August 1868, Cassatt's brother reported the project, commenting, "Mary is an enthusiastic admirer of Tennyson, and she always said she would paint a picture of Mariana."

51 JEAN-FRANÇOIS MILLET
The Spinner: Goat Girl of Auvergne 1868–69

52 EDOUARD MANET
The Spanish Singer 1860

Cassatt remained in Ecouen and Villiers-le-Bel throughout the winter of 1868–69 and prepared a Salon painting which, to her immense chagrin was rejected. Attempts to get her former teacher Gérôme to pull strings were one day too late. Her response was to stay in Paris, apply for a copyist's permit for the Louvre where she worked before joining a Miss Gordon for a sketching tour of a very picturesque and popular region in the Savoy Alps. On her return to Paris, uncertainty reigned, although there was much to see and absorb, for the Salons of 1868 and 1869 contained significant works by De Gas (as he was then known), Morisot, Renoir, Pissarro, Monet, as well as Millet, Couture, Gérôme and Manet. At the Salon of 1869 Manet showed *The Balcony*, for which Morisot had 59 posed, and *Luncheon in the Studio*. Works of this scale and ambition were inevitably a talking point of the Salon, declaring the possibility of a grand but alternative "tradition" whose subjects referred unapologetically to the present, while ironically quoting, and reworking, established artistic prototypes from Rembrandt through to Goya.

So little work by Mary Cassatt remains from these early years, that it is hard to track the steps taken after so decisive an entry in the Parisian art world as *The Mandolin Player*. Redated to this period, *The Young Bride* shows 53 a young woman knitting. She is dressed in a heavy, ribbed silk dress with a square lace collar and wing sleeves that open to reveal well-rounded arms.

Apparently the sitter was Cassatt's maid, Martha Ganloser, who received the painting as a wedding gift. Yet the dress is red and has the look of evening fashion that neither suggests the garb of a maid nor the robe of a bride. The signature "Mary Stevenson" dates the work to the period between 1867 and 1873. The subject is not rural but urban, bearing more than a passing resemblance to Courbet's *Woman with Jewels* (1867), exhibited in his pavilion in 1867. While the effect of melancholy in *The Mandolin Player* engages the spectator, the woman in *The Young Bride* seems detached and preoccupied by her sewing. The large area of the painted satin dress forms a contrast with the deep shadowed background, and the tonalities are carefully modulated in the shadowed face and highlights on forehead and chest to give the person and her activity a singular dignity and precision. Perhaps Mariana sat in her moated grange awaiting the return of her faithless lover with such muted, or dutiful, pensiveness.

Cassatt's next move was partly conditioned by family intervention. In December 1869, Katherine Cassatt arrived to join the daughter she had not seen for four years, and together they traveled to Rome. Here Mary Cassatt established a studio and took another master, Charles Bellay, about whom very little is now known. She was, however, to list herself also as his pupil when she again gained access to the Salon in 1870 with a painting, *A Peasant Woman of Fobello,* now lost.

The move to Rome might be read as retrogressive—joining the more established American artists' colony in that classical and Renaissance city after disappointments and confusion in the centre of modern art, Paris. Perhaps it was necessary to complete her artistic education with a sight of the Sistine Ceiling and Raphael's great cartoons in the Vatican as well as many other major works of fifteenth to sixteenth-century Italian art. Rome was special. It housed a colony of distinguished American *women* artists, particularly sculptors, who had entered into American annals of art through the novel by Nathaniel Hawthorne, *The Marble Faun* (1860).

The Marble Faun was one of the earliest of American novels to make the artist a theme, and to present, in the persons of its two female heroines, the modern, independent woman artist. One is Miriam, an exotic figure shrouded in mystery and tragedy, who paints dramatic pictures of biblical murderesses—Jael, Judith and Salomé—as well as pictures of an infant's shoe. The other is the sylph-like, virginal Hilda, who so deeply grasps and feels the power of great art that she foregoes her own creativity in order to become its copyist. In fact she achieves the remarkable feat of reproducing a painting that no one is allowed to copy: Guido Reni's *Beatrice Cenci.* No longer attributed to Reni, this painting of the allegedly patricidal daughter was one of the master's most famous works in the nineteenth

54

53 CASSATT *The Young Bride c.* 1869

century. The subject was also made famous by Shelley's 1820 poem *The Cenci*. Hawthorne provides an insight into both American literary Romanticism, in which Cassatt would have been educated, and into contemporary ways of reading paintings—and this may well have shaped her sense of what effect a figure painting should aim to achieve.

> The whole face was quiet; there was no distortion or disturbance of any single feature; nor was it easy to see why the expression was not cheerful, or why a single touch of the artist's pencil should not brighten it into joyousness. But in fact, it was the saddest picture ever conceived; it involved an unfathomable depth of sorrow.... It was a sorrow that moved this beautiful girl out of the sphere of humanity, and set her in a far-off region, the remoteness of which—while yet her face is so close before us—makes us shiver as at a spectre....
>
> "And now that you have done it, Hilda, can you interpret what the feeling is, that gives this picture such a mysterious force? For my part, though deeply sensible of its influence, I cannot seize it."
>
> "Nor can I, in words," replied her friend. "But, while I was painting her, I felt all the time as if she were trying to escape from my gaze.... It is infinitely heartbreaking to meet her glance, and to feel that nothing can be done to help or comfort her; neither does she ask help or comfort knowing the hopelessness of her case better than we do."

We do not know what Cassatt did and learned in Rome in these important six months. There is some trace in the Salon paintings of the early 1870s, which presented half-length figure studies of single women that bear some affinity with this painting, though freed from the heavy burden of guilt and sorrow Hawthorne perceived in Reni's *Beatrice Cenci*.

In July 1870 Cassatt and her mother left Rome for Paris and then sailed for the United States. The four years had been productive, though not without their setbacks and confusions. Uncertainty may also be read as a willingness to experiment, a desire to do more that be slotted into the existing and comfortable patterns of young Americans abroad. By carefully reading back from the convictions already held in the early 1870s about which artists to appreciate and buy, we know that Cassatt garnered a great deal from her exposure to the radical shifts taking place in Parisian art world during the 1860s. At Salons and special exhibitions she saw major figure paintings by Courbet, Manet, Degas, and Renoir. In the cacophony of polemical criticism and the measured tones of the new art history journals she studied the competing aesthetic theories that were being articulated. The loudest call was for art to reattach itself to its own moment; yet that realignment seemed also to require a reconsideration

54 Anonymous, formerly attributed to Guido Reni, *Beatrice Cenci,* early 17th century

of selected moments of the art of the past. Spanish art—particularly Velázquez—and Dutch art—notably Hals and Vermeer—remained for Cassatt to study for herself.

When she went home in 1870, she joined many of the artists she had known in Paris: Eakins, Earl Shinn (1838–86), Haldeman, and Howard Roberts (1843–1900). Did she mean to stay, set up her studio and make it in Philadelphia? Did her family hope that the years abroad would have satisfied her *wanderlust*? Mary Cassatt did not rest long. In search of sales and the money to support her work, she went to Pittsburgh, and then to Chicago to try and sell some paintings. The works were destroyed in the Great Fire on 8 October 1871. Her ambitions to return to Europe were fulfilled when the Catholic archbishop of Pittsburgh commissioned her to make copies of frescoes in Parma by the Old Master most admired in the nineteenth century, Correggio. In addition, the archbishop, himself a Spaniard, gave her letters of introduction to the bishops of Spain, a pass-port to entry into respectable society in any of the cities of a country that had obsessed her since her return to Pennsylvania.

In December 1871, passing through Liverpool, London and civil-war-torn Paris, Cassatt and her new traveling companion, the artist Emily Sartain, arrived in Parma, where she stayed until October 1872. She then traveled to Spain, stopping briefly in Madrid before settling for six months in the city of Seville. Visits to Holland and Belgium, Paris, and Rome (spring 1874), Villiers-le-Bel (summer 1874) brought her back finally to Paris, where in 1875 she rented a studio and apartment at 19 Rue de Laval. After a summer visit to Philadelphia in 1875, Mary Cassatt chose to settle in Paris. Why?

89

55 CASSATT *Portrait of a Woman* 1872

Cassatt's Choices 1870–77

Emerging from the museums where she had studied the old masters, Miss Mary Cassatt unhesitatingly recognized—from the first works of Degas she had the good fortune to see—the continuator of the classical greats. No one helped her make this selection, and she abided by this personal manner appreciating the works through the efforts she pursued in her solitary studio in order to perfect her art.

Achille Segard, *Mary Cassatt:*
Un Peintre des enfants and des mères, 1913

It was at the Salon of 1874 that Cassatt appeared for the first time under the name "Mary Cassatt." It was at this Salon that Degas apparently saw Cassatt's painting *Ida,* and declared: "Voilà quelqu'un qui sent comme moi." ("Here is someone who feels as I do.") Despite this possibly apocryphal event, the two artists did not actually meet until the spring of 1877. In that year Degas invited Cassatt to join the Independent group of artists which had been formed in 1874. 72

For the crucial period between 1874 and 1877, however, we have almost no documentation to help us understand what led Cassatt to this most dramatic decision to join the Impressionists and turn her back on a career in the Salon. We can, none the less, retrace her steps through the choices she had been making in the years leading up to this momentous appearance at the Salon of 1874.

The first half of the 1870s had been both productive and significant in Cassatt's professional career. Substantial paintings from Cassatt's residences in Parma, Seville, Antwerp, and Rome survive. So many sketches, drawings, studies, as well as Salon paintings of the mid 1870s are missing—Cassatt appears to have destroyed much of the evidence, and other works are untraced in private collections—that any picture of her development remains a little provisional. What we have enables us to analyze the choices she was making during the period of her second trip to Europe which culminated firstly in her return to Paris in 1874 and secondly in the dramatic decision three years later to join the Independent exhibiting group.

Cassatt went to Parma with the commission from the Archbishop of Pittsburgh for two copies of works by Correggio. In addition to the famous fresco cycles in the city's churches, the Galleria in Parma also had a number of his oil paintings including *Madonna and Child with Saints Jerome and Mary Magdalene and Angels,* known as *Il Giorno (The Day),* 1527. Cassatt planned a copy of *Il Giorno* as well as working from Carracci's copy of Correggio's *Virgin Crowned.*

Correggio's paintings were a mine of compositional possibilities. In *Il Giorno,* Correggio placed the heads of the Madonna, Child and Mary Magdalene in close proximity. The ensemble was made both elegant and affecting by staggering the heights of each head, producing the sense of recession and depth of field, while different emotional states were evoked through the gestures that linked the three figures: the Madonna's hand holds the baby gently under his arm; his hand rests in benediction on the blonde saint's head, inclined in mystical adoration towards his infant body; while her finely drawn and foreshortened hand cups the baby's outstretched heel. Focusing on these internal and structuring relations of gesture and space, as was the custom of copyists, two key features of Cassatt's own subsequent fascination with compositions of child and adult

56 ANTONIO CORREGGIO
Il Giorno 1527–28 (detail)

57 Mary Cassatt in Parma, Italy, *c.* 1872

can be identified: the expressive or contemplative head and the signifying potential of the linking gesture.

Deep compositional structure creates the possibility of affect through the positioning of each element in a sequence of formal relations whose metaphoric meaning is keyed in by the finely observed facial types that index a psychological disposition. Correggio created an image of a serene mother, a spiritually affected worshiper and an infant face and body seated with an almost regal composure while its infant gestures are both the credibly observed movements of a baby and the formal iconography of royal benediction.

By 18 February, 1872, Cassatt had begun a painting destined for the Paris Salon, *Two Women Throwing Flowers During the Carnival*. In the Salon 58
carnet of 1872, it was catalogued as *During the Carnival* under the name

Mary Stevenson. The painter has selected an unusual angle. The viewer is placed inside the space of the balcony, exceptionally close to the figures. This arrangement allows Cassatt the opportunity to display her skill in orchestrating figures in a confined space where all the impact of the painting and its meaning must be carried by expressive faces and gestures. The two heads inclining in different directions within a confined space echoes a compositional device used by Gustave Courbet in an early, romanticized scene, *Lovers in the Countryside*, 1844, exhibited in Paris both in 1855 and 1867.

Several scholars have suggested a parallel between this little scene of women throwing flowers from their balcony during carnival and Hawthorne's *Marble Faun* in which this Roman carnival custom was incorporated into the plot:

> Every window was alive with the faces of women, rosy girls and children, all kindled into brisk and mirthful expression by the incidents in the street below. In the balconies that projected along the palace-fronts, stood groups of ladies, some beautiful, all richly dressed, scattering forth their laughter.... Often the lover in the Corso may thus have received from his bright mistress, in her father's princely balcony, the first sweet intimation that his passionate glances had not struck against a heart of marble. What more appropriate model of suggesting her tender secret could a maiden find, than by the soft hit of a rosebud against a young man's cheek.

The description of Roman carnival, much commented upon by visiting Americans such as Henry James, appears towards the very end of the novel when dark deeds have clouded the lives of the four main characters and the corruption perceived by the sculptor Kenyon is contrasted to the happy scenes a year before when "Miriam had been, alternately, a lady of the antique regime, in powder and brocade, and the prettiest peasant-girl of the Campagna, in the gayest costumes; while Hilda sitting demurely in a balcony, had hit the sculptor with a single rosebud—so sweet and fresh a bud that he knew at once whose hand had flung it."

Perhaps the scene before us in Cassatt's painting shows the fair and virginal American Hilda, tossing her single pure rosebud from a balcony, beside the more exotic dark-haired and dark-featured European Miriam, dressed as an Italian country girl. Literary inspiration was not alien to the artist who had a few years before attempted a "Mariana in the Moated Grange" from Tennyson. There is a significant relation between this painting from Cassatt's "Italian Journey" and *the* novel of American artistic experience in Italy. Cassatt has, however, reworked the underlying drama

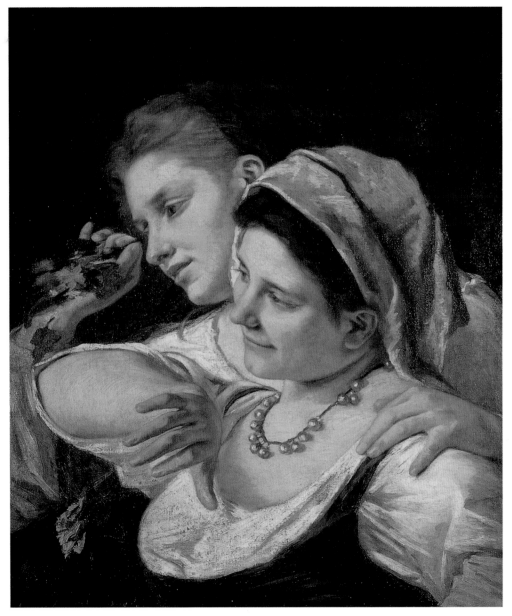

58 CASSATT *Two Women Throwing Flowers During the Carnival* 1872

of romantically contrasted women in a painterly reformulation that brings the viewer close to two female figures, without direct explanation of the mood or meaning of the scene. The painting's brilliant execution, notably in the difficult gestures of the hands and the precise characterization of the facial expressions, draws us back to the "contemplative" mode of viewing that is associated with the Correggio painting discussed above.

The painting also has echoes of Manet's *The Balcony*, exhibited at the Salon of 1869, a work that was to haunt Cassatt in the early 1870s. Cassatt had garnered a mass of conflicting information and debate about the possible directions of contemporary art in France between 1866 and 1870. This carnival painting of 1872 was her artistic "working through" of the most perplexing of all problems of modernism, first encountered in Paris in the 1860s. The road to the "new" lay through a reworking of the Old Masters, not in order to emulate them as a fixed standard as within the academic model, but because paradoxically they offered means to change art and represent modernity.

If Cassatt's painting of 1872 still appeared as a skilled contribution to an accepted Salon genre—a picturesque scene of Italian life, quaint, romantic, "other"—it was, none the less, a strategic combination of three elements that signal her struggle to understand emergent modernism in Paris. The painting refers to Hawthorne's novel about the American experience of Europe's difference and corrupted traditions, and about women artists. It shows Cassatt learning from Correggio, "master" of composition, gesture and religiously profound affect. It explores the challenging and perplexing lessons of the most daring contemporary artist, Manet, whose work knowingly used the past and referred to popular cultural icons and favored genres while emptying them of all that made them trite, banal, and over-romanticized. As an aesthetics of creative negation, Manet's work was a necessity for any ambitious young artist, and while Cassatt clearly was thinking it over, she was equivocating, still powerfully drawn to the work of Manet's own predecessor in this complex game of modern art, Courbet, whose powerful painting, especially of female figures, always impressed her, pulling her back in the direction of Realism tinged with latent Romanticism. Cassatt was clearly intellectually and artistically hungry, but for a long time, she was frightened of Paris and its problematic art world. Her work in Parma shows how she contemplated and manipulated its lessons from a safe, uncommitted distance.

Other paintings survive from Parma. There is a very academic figure study, inscribed to the Academy's Professor, Carlo Raimondi (1809–83). It is the first work signed Mary Stevenson *Cassatt*. In style it appears formulaic in the classical, academic mode. *The Bacchante* is signed and dated

55

60

96

59 EDOUARD
MANET
The Balcony
1868–69

Mary S. Cassatt/Parma/1872. (Cassatt referred to it as "my cymbals.") Despite
the ivy headdress, the costume suggests a Romany figure, even the charac-
ter of the dancer Esmeralda from Victor Hugo's *Hunchback of Notre Dame.*
Between these two paintings— both on the same size canvas—the impact
of Parma is evident in the move from the static, almost sculptural quality
of the classically draped woman and the energy and dynamism of the
woman with her clashing cymbals. The theme of music, running through
from *The Mandolin Player* (1868) to the banjo player in the mural *Modern* 50
Woman (1893), also provided a subject for a painting done in Rome, *The* 22
Musical Party, signed and dated "M.S.Cassatt/1874," which was exhibited 61
at the Pennsylvania Academy of Fine Arts in 1876. The contrasting figures
of a fair-skinned, red-haired mandolin player and her dark-haired,
olive-skinned companion are watched by an almost spectral figure out
of a Courbet self-portrait in a composition that is another adaptation of
Correggio's *Il Giorno.*

97

60 CASSATT *The Bacchante* 1872

61 CASSATT *The Musical Party* c.1874

In May 1872 Emily Sartain left Parma while Cassatt stayed on to finish her copies. On 1 October 1872, however, she travelled to Madrid, spending days in the Prado studying Velázquez and Murillo, even copying Velázquez's portrait of *Prince Balthasar Carlos* before she moved on to settle for the winter in Seville, the birthplace of both Velázquez and Murillo. Cassatt wrote to Sartain about her unbounded enthusiasm for the paintings of Velázquez: "Velasquez oh! my but you knew how to paint!…Oh dear to think that there is no one I can shriek to, beautiful! lovely! painting what arn't you?"

After three months in Seville, Cassatt, wrote to Sartain:"I confess that if I did not live to paint life would be dull here, dreadfully dull, nothing absolutely going on…." The city did have a splendid collection of Spanish painting past and present, and two of the most famous modern Spanish artists, Mariano Fortuny (1838–74), and his brother-in-law, Raimondo di Madrazo (1841–1920). Both had painted in Seville in 1872. Their work, widely valued in the United States, exercised a clear and decisive influence on Cassatt at this stage.

Six large canvases survive from Cassatt's Seville period. They represent Spain in two different ways. Cassatt provided a touristic view of Spain reduced to souvenirs and stock characters in paintings of toreadors in the famous "coat of lights," of women on balconies, and dancers in lacy mantillas. Cassatt's choice of subjects align with an established taste for *espagnolisme* represented by artistic tourists like the Scottish painter, known as "Spanish"John Phillip (1817–67), and recorded in distinguished literary travelogues like Théophile Gautier's *Un Voyage en Espagne*, 1843 (referred to by Cassatt in a letter of 13 October 1873), and, with characteristic difference, by Edouard Manet whose numerous paintings on Spanish themes predated his own journey to the country in 1865. Cassatt would have known Manet's Spanish paintings from his special exhibition in 1867 where they were shown as a group.

If Cassatt's paintings reflect the Spain of the travel guide and foreign visitor, they also responded to the museums of Spain where she studied the great seventeenth-century artists—the realists Velázquez and Zurbarán, the devotional Murillo—and Goya's (1746–1828) paintings and etchings of the horrors of war and pastoral scenes. Spanish art was a major factor in cultural modernization in mid-nineteenth-century French culture. Like Manet who visited in 1865, Cassatt's American contemporary Thomas Eakins had worked in Seville in 1870 to complete his European apprenticeship. Cassatt's decision to visit Madrid, copy a

63 RAIMONDO DE MADRAZO
Gypsy Girl c. 1870s

62 MARIANO FORTUNY *A Spaniard Lighting a Cigarette c.* 1860s

Velázquez, and settle in Seville to paint Spanish subjects and experiment with a Spanish manner was thus an intelligent move in her search for the means to become a notable painter.

On 31 December 1872, she wrote to Emily :

My present effort is on a canvass of thirty and is three figures life size half way to the knee. All the three heads are foreshortened and difficult to pose, so much so that my model asked me if the people who pose for me live long. I have one man's figure the first time I have introduced a man's head into any of my pictures.

In contrast to the compositional daring of *During the Carnival* (1872), this painting, *On the Balcony* (1873) is more conventional in positioning two women and a man on a balcony as if seen from the street, in a manner reminiscent of Manet's own source, Goya's *Majas on a Balcony* (1824–35), and there is possible source in Murillo's *Two Women at A Window: A Young Girl and her Duenna* (c. 1670). When *On the Balcony* was shown at the National Academy of Design in New York in 1874, a critic wrote: "In one of the Balcony groups there is a leaning girl's head, full of somber power and painted with the best traditions of Murillo."

58
65

The balcony theme encapsulates a number of critical issues around gender, sexuality and the social division of space which were to be further explored in Cassatt's work in the 1880s. In Muslim Spanish architecture, the segregated quarters of women were enclosed but had balconies (*miradores*, watching places) projecting beyond the walls with carved wooden grilles that protected the women from being seen while they watched the world outside. The open balcony from which to see while also being seen, forms a more dangerous, liminal space, a borderline between respectably hidden interiors and the unregulated space of the public street. In the nineteenth century, femininity was calibrated across this spatial division. The idealized, respectable "lady" was located inside, and her sexualized and laboring opposite was outside. Social order itself was identified with the secure equation of Woman/Family/Home. The balcony, in this context, was a visual sign of ambivalence and provocative exchange. The "women on the balcony" theme often was prostitutional, with women leaning on balconies in fluid and thus sexually propositional poses that were interpreted as sexual invitation, indicative of demeaned social class. A class reading need not, however, necessarily imply overt sexualization. A supporter of Eakins wrote of Cassatt's painting when it

64 JOHN PHILLIP
The Balcony 1857

65 CASSATT *On the Balcony* 1873

was shown in Philadelphia in the windows of Bailey's jewelry store in 1873—her first recorded exhibition in that city—that the work seemed to be studied closely from life, showing "intense vitality," "an ease, an unconstraint, in the attitudes of the figures, a careless grace." When exhibited at the Cinncinnati Industrial Exhibition in 1873, the work was explicitly titled: *The Flirtation: A Balcony in Seville*. The sexual theme is openly acknowledged in the exchange between the luminous "Olympia" figure in the foreground —she has the flower in her hair and is dressed in the shawl that Manet's naked prostitute had discarded in his famous painting of that title (1863–65)—and the heavily shadowed but perfectly characterized male figure inclining towards his flirtatious partner. Cassatt removes much of the ambience of sexual ambivalence by positioning the viewer close to her figures. The division between inside and outside, that could become the metaphor for sexual impropriety, is offset by the flirting couple's movement inward and backward, contrasting with the forward lean of the Murillo-esque woman in the red shawl who looks affectionately, or longingly, rather than archly, out of the picture. The lack of reticence in the figures' demeanor is hard for contemporary viewers to recognize since our codes governing comportment and gesture are so radically relaxed. But smiling and revealing her teeth would be an instant give-away of the lack of social status. The art historian Nanette Salomon has examined this iconography in seventeenth-century Flemish and Dutch paintings where a woman showing her teeth had direct class associations with sexuality. In a much later review of this painting, when it became the first work by Cassatt to enter an American public collection in 1908, the *New York Times* critic, Elizabeth Luther Cary, wrote: "The attitude and gestures are free and animated and give the impression of the class to which the people belong, a class unrestrained by conventions of self-repression and conformity to rigid standards of personal reticence."

By treating flirtation without coyness, the artist focuses our attention on her skills in compositional tension, and on the liveliness of effect in the representation of human character, expression, and a contemporary situation. Contrasting this with comparable paintings by Fortuny, Madrazo, or John Phillip's *La Bomba* (1863), whose subject relates also to Cassatt's painting accepted by the 1873 Paris Salon, *Young Woman Offering the Panal to the Toreador*, we can see how Cassatt's bold technique and simplified setting eliminated the raunchy innuendo of the genre painters who specialized in projecting sexual fantasies on to people in exotic costumes from other lands.

The *Young Woman Offering the Panal to the Toreador* was also shown at the National Academy of Design in New York in 1874 and a third painting in

69

66 JOHN PHILLIP *La Bomba* 1863

this trio, *Toreador Smoking*, was exhibited at the Pennsylvania Academy of Fine Arts in 1878. These represent the most sustained use of a male figure in her work, a rarity (see also *The Boating Party*) that has often been explained by class etiquette and gender reticence. Could she sit alone with a male model in a studio without compromise? In producing compositions with several figures, male and female, Cassatt enjoyed a rare opportunity not only to paint male figures, but men dressed in bejewelled costumes that were a challenge to a painter exploring new kinds of painterliness associated with Velázquez and his French successor, Manet. *Offering the Panal* is a great leap forward in Cassatt's boldness in creating the effect of deep space through the confrontation of figures and the play of light produced by stark tonal contrasts. The bent elbow, with its highlight, pointing directly out towards the viewer, creates a demanding area of foreshortening and a shocking rupture of the smooth surface of the imaginary spatial container in which, classically, pictorial representation is confined. The solidity of form and demanding pose of the woman seen in backview call to mind another of Cassatt's "surrogate" teachers, Courbet in his *Grainsifters* (1855), then in a public collection at Nantes.

Cassatt's ambition was to be a figure painter and thus her paintings have "subjects." Her family had hoped she would become a portrait painter.

68

38

67 CASSATT *Spanish Dancer
in a Lace Mantilla* 1873

68 CASSATT
Toreador Smoking 1873

69 CASSATT *Young Lady Offering the Panal to the Toreador* 1873

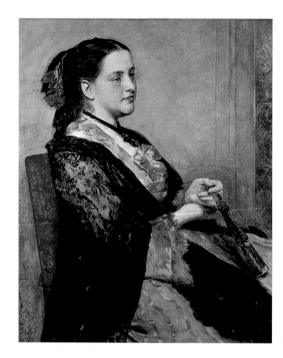

70 CASSATT *Portrait of a Lady of Seville* 1873

She had painted portraits in 1870–71—or tried to do so—of her father. From a recently discovered work, it appears she was painting portraits in Seville. *Portrait of a Lady of Seville,* however, seems very advanced in comparison with a study in homage to both Manet and Courbet: *Spanish Dancer in a Lace Mantilla.*

67

ANTWERP 1873

Emily Sartain wrote to her father on 8 May 1873 after Cassatt's return to Paris from Seville:

> Oh how good it is to be with someone who talks understandingly and enthusiastically about Art....I by no means agree with all of Miss C's judgements,—she is entirely too slashing,—snubs all modern Art [that is, current Salon fashion],—disdains the Salon pictures of Cabanel Bonnat and all the names we are used to revere,—but the intolerance comes from earnestness with which she loves nature and her profession....Her own style of painting and the Spanish school she has been studying all winter is so realistic, so solid,—that the French school in comparison seems washy, unfleshlike, gray. Coming from Italy last winter, the salon made the same effect upon me.

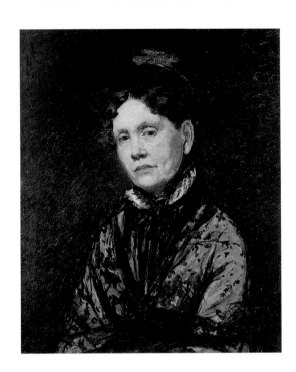

71 CASSATT *Katherine Kelso Cassatt* 1873

The intense six months in Spain had had an immense impact. But still Cassatt felt she needed to supplement her studies with the other seventeenth-century school critically presented as a model for modern art. With her mother, who arrived in Paris a week after she did, Cassatt set off for Holland and Belgium. She would have stayed in the Hague had a studio been found, but she settled for the summer in Antwerp. Here exposure to Rubens and Hals gave new insights into direct painting with a loaded brush that would move her on from the somber palettes of Manet and Courbet in ways that subsequently facilitated her alliance with the even more radical generation of Renoir, Monet, Pissarro, and Degas.

Models, however, proved hard to find in Holland and Belgium, and the only surviving work from this summer is a portrait of the artist's mother, *Katherine Kelso Cassatt*, pressed into service as a sitter so that Cassatt could try out some new techniques for getting vivid color and—what the critics admired in Rubens and Hals—"life" into the face through the use of carmine reds and a kind of painterly drawing. Whatever the practical reasons for using her mother as model, it must have been significant as a time of exchange and closeness between the intelligent, literate and multilingual mother and her driven and ambitious daughter so fascinated by painting. It had been Katherine Cassatt, herself educated by a

Frenchwoman, who ensured that her children learned several languages, and appreciated the world through the literatures of many nations, while also encouraging them to be engaged with politics and contemporary culture in all forms. Cassatt shows the viewer a woman of character and intelligence.

The impact of Rubens was technical—especially in terms of color and a loosened facture—but his work also introduced a new conception of femininity whose traces appear in a portrait done the next year in Rome, another striking image of an older woman, *Madame Cortier*, and in the softened silhouettes and forms of *The Musical Party* as well as in the Salon painting for 1874, *Ida*.

61

ROME 1873–74

From Rome Cassatt sent to the 1874 Salon a painting titled *Ida*. Until recently it was known only through a caricature in which the woman's head appears to be draped in a mantilla, suggesting one of the Seville subjects, with which *Ida* was at some time identified. The rediscovered painting of a woman with intense dark eyes set in strong features in a pale face produces a sense of character that transcends the portrait. It is a subject picture. Ida was the name of the central character of Tennyson's poem *The Princess* (1847). Cassatt had read and enjoyed Tennyson's poetry since childhood and planned a painting of a subject from his work in 1868. The poem, set in feudal times, tells of a Princess who, refusing to marry, sets up an university for women whose portals are guarded by caryatids named Art and Science. Into the mouths of Ida and her co-tutors are put impassioned speeches denouncing the universal degradation of women, claiming women's equal intellectual rights which echo some of the terms used in 1893 to justify the Woman's Building and resonate with the themes Cassatt later used in her mural. Instead of halls filled with odalisques and "stunted squaws of East and West," their university inspires its inmates with statues of great heroines.

> Embrace our aims: work out your freedom. Girls,
> Knowledge is now no more a fountain seal'd:
> Drink deep until the habits of the slave,
> The sins of emptiness, gossip and spite
> And Slander die. Better not be at all
> Than not be noble.

Disguised as women, Ida's betrothed and his companions enter the Academy and encounter Ida:

110

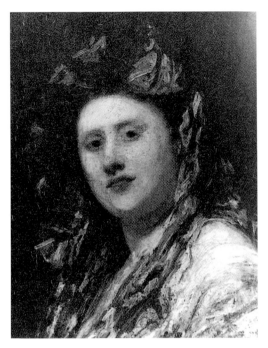

72 CASSATT *Ida* 1874

There at a board by tome and paper sat,
With two tame leopards couch'd beside her throne,
All beauty compass'd in a female form,
The Princess; liker to the inhabitant
Of some clear planet close upon the Sun,
Than our man's earth; such eyes were in her head,
And so much grace and power, breathing down
From over her arch'd brows, with every turn
Lived thro' her to the tips of her long hands....

Cassatt's decision to return to Rome in 1873–74 may reveal her affinity
with the most famous generation of internationally reputed American
women sculptors in Rome, who themselves were inspired by Elizabeth
Barrett Browning, author of the feminist epic *Aurora Leigh* (1857) with its
artist heroine. They sculpted monumental images of the heroic women
celebrated by Ida and her students: Zenobia and Cleopatra. Ida is their
modern descendant, through whose inspiring ambitions for women to be
"someone and not something" the young Cassatt may have been encour-
aged in her own pursuit of art rather than marriage.

Miss Mary Cassatt, though, has not gone the way of fashion, of the popular styles, of success, for she has gone to the disparaged Impressionists. A similarity of vision determined this choice, and this vision has expanded, has become increasingly searching; this strong-willed woman has truly learned to paint.

(Gustave Geffroy, *La Vie Artistique*, 1893)

Rome was not the centre of modern art and the cradle of modern womanhood, however much its ruins and treasures might forge links with a heroic feminine past. Cassatt returned to Paris in the spring of 1874, spending her summer at Villiers-le-Bel with Couture before taking a studio at 19 Rue Laval in the new artists' quarter near the Boulevard Clichy, just walking distance from the Café de la Nouvelle Athènes, the haunt of the artistic radicals. Emily Sartain was amazed at this decision, and wrote to her father of how much Cassatt had always "detested" Paris and despised the official art world. Cassatt was, however, now fully equipped by an astutely chosen art education to appreciate the most interesting developments then taking place only in that city.

A last gasp of the grand style appears in three full-length portraits of family and friends in 1875–76. The largest easel painting she ever did was of her nephew Eddy Cassatt, undertaken on a short summer trip to Philadelphia in 1875—the last one for two decades. A now lost portrait of her sister Lydia was refused at the Salon of 1875, although with a darkened background it was accepted in 1876 much to Cassatt's cynical disgust. The third, known only through a caricature, was titled in the 1875 Salon catalogue *Mlle. E.C.* The child portraits suggest the legacy of Velázquez's paintings of royal children, such as *Prince Balthasar Carlos*, while Eddy's knickerbockers and long curling hair are also reminiscent of the eighteenth-century English tradition.

In 1896, Cassatt wrote of the period 1875–77 as one of uncertainty and indecision: "I thought I must be wrong and the painters the public admired right." Yet there is really little sign of backsliding in the work surviving from this period. Instead, some radical breakthroughs occur precisely because Cassatt abandoned subject-oriented painting—the romantic, costume or literary genre of her first decade—and began to understand a new stage of the modernization led by Manet. It had been necessary to commune with the Old Masters and learn anew old secrets that made academic recipes seem insipid and too narrow for the rich possibilities of paint itself. But now an unembarrassed engagement with the actual and the contemporary was required through a fastidious

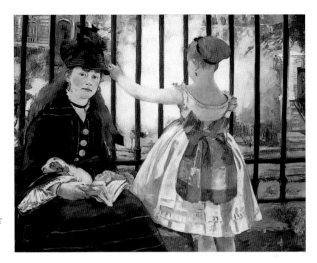

73 EDOUARD MANET
Gare St Lazare
1872–73

observation of exactly what Baudelaire had advocated: contemporary fashions, gestures, faces, and actions, that form the signifying details of the new urban classes in the spaces of leisure and entertainment.

It would, moreover, have been strikingly evident to Cassatt on her return to Paris that Manet's work itself had radically shifted under the influence of a generation she did not yet know. At the 1874 Salon, Manet exhibited the brilliantly luminous *Gare St. Lazare,* a contemporary study of a Parisian woman seated, book and dog on her lap, with a smartly dressed little bourgeoise watching the steamy railway beyond the garden railings. Manet exhibited *Argenteuil* at the 1875 Salon and *Boating* in his studio in 1876, both paintings showing a man and a woman of no social pretensions in holiday gear messing about in boats. The heightened color range and compositional simplicity indicated a focus on urban life and suburban recreation. Cassatt would only have become aware of this shift on her return to Paris when she began haunting the color merchants' shops and smaller dealers where the inspiration for Manet's grand embrace of the complexities of modern social life could be studied in even more daring oils by Monet and radical pastels by Degas.

Cassatt's artistic journey to the "Impressionists," reveals the paradox of Modernism in the early 1870s. Inspired by the development of art history which revived and reassessed seventeenth-century Dutch and Spanish art as well the French school of the eighteenth century, artists felt equipped to set aside the conventions and formulae that had seemed synonymous with art itself. Courbet and, to a greater extent, Manet and his followers, shattered the hierarchy that had governed art by proposing to paint only what they "knew." This odd and impossible ideology served to liberate

painting from its service to a pretext—a subject—for which artistic skills were mobilized to produce an aesthetic realization. In what seemed almost an anti-art gesture, "observe and report," the possibilities and pleasures of manipulating art's resources acquired a degree of autonomy through which novel artistic languages could be forged. These new ways of painting sought to create a form for the perplexing peculiarities of modern, urban experience. By painting what appeared to some as anonymous "portraits" and others as "figures in an interior," Cassatt tried out for herself what she now saw Manet himself doing: grappling with the immediate, inconsequential yet revealing situations of contemporary Parisian life in ways that made visible the process of painting itself as an ambiguous register of social perception.

Once back in Paris in 1874, Cassatt had visited Emily Sartain at Mme. del Sarte's *pension* where she was introduced to a young American, Louisine Elder (1855–1929)—later Havemeyer—on whom she had an enormous impact. In her memoirs, Louisine Havemeyer wrote:

> When we first met in Paris, she was very kind to me, showing me the splendid things in the great city, making them still more splendid by opening my eyes to see their beauty through her own knowledge and appreciation. I felt that Miss Cassatt was the most intelligent woman I had ever met and I cherished every word she uttered, and remembered almost every remark she made. It seemed to me, no one could see art more understandingly, feel it more deeply, or express themselves more clearly than she did.

In 1875, on a second visit to Paris, Louisine went with Cassatt to Durand-Ruel's galleries on the Boulevard Haussman and to Père Julien Tanguy's color shop on the Rue Clauzel. Cassatt persuaded her young friend to use all her own and her sisters' allowance to buy a small pastel by Edgar Degas, *The Ballet Rehearsal* (c. 1875), the first Degas bought by an American, for 500 francs ($100). Havemeyer wrote in words which may indirectly record Cassatt's appreciation of Degas: "The drawing in the picture was as firm as a primitive, the difficulties of planes and perspective handled like a master, while the effect of light and shade and the beauty of color were simply entrancing." She then added revealingly:

> It was so new and strange to me! I scarce knew how to appreciate it, or whether I liked it or not, for I believe it takes special brain cells to understand Degas. There was nothing the matter with Miss Cassatt's brain cells, and she left me in no doubt as to the desirability of the purchase and I bought it on her advice.

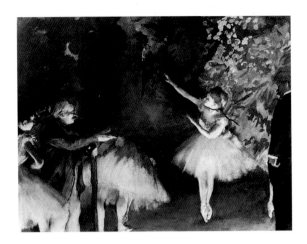

74 EDGAR DEGAS
The Ballet Rehearsal
c.1875

Louisine and her husband Henry Havemeyer later purchased a number of works by Degas and by Manet including the key works of Manet's "Impressionist period" in the 1870s, *Gare St. Lazare, Boating, In the Garden* as well as *Luncheon in the Studio* from the 1869 Salon, and at least three of the major "Spanish" paintings of the early 1860s. The Havemeyer collection directly reflects Cassatt's advice, and provides the best evidence we now have for Cassatt's responsive understanding of the making of modernism in the mid 1870s. For the recommendation to Louisine Havemeyer to purchase a pastel by Degas in 1875, Cassatt's previous history does not, however, prepare us. It was the first sign of an artistic exchange that would provide the sustaining intellectual and aesthetic partnership for the new era upon which she embarked in agreeing to Degas's invitation in 1877 when they were introduced by Léon Tourny, an artist Cassatt had met in Antwerp.

THE DECISION TO JOIN THE INDEPENDENTS

In 1877, I submitted again [to the Salon]. They rejected it. That was when Degas made me promise never to submit anything to the Salon again, and to exhibit with his friends in the group of the Impressionists. I agreed gladly. At last I could work absolutely independently, without worrying about the possible opinion of a jury! I had already acknowledged who my true masters were. I admired Manet, Courbet, and Degas. I hated conventional art. I was beginning to live....

(Cassatt to Achille Segard, 1913)

Cassatt had not been in Paris, when the first exhibition of the Société Anonyme des Artistes Peintres, Sculpteurs, Graveurs, etc., opened on 15

75 DRANER (JULES RENARD)
*Chez MM. les peintres
indépendants* from *Le
Charivari* 23 April 1879

April 1874 in the studio of the photographer Nadar at 35 Boulevard des
Capucines showing about two hundred works, all for sale. As a response to
the stranglehold of the Salon juries on competing tendencies in French
painting during the later 1860s, from which Cassatt had also personally
suffered, there had been some discussion of a break-away exhibition as
early as 1867. The idea surfaced again in 1869, after a large number of
rejections at the Salon that year. The Franco-Prussian War of 1870 and the
Commune with its bloody aftermath in 1871 had dispersed the group:
Monet and Pissarro fled to England while Frédéric Bazille (1841–70),
the prime mover, was killed in action. It was not until 1873 that a group,
led by Monet, Pissarro, Renoir, and Degas formed a joint stock company
to put their works directly before the public without the official sanction
of the art establishment. This eclectic and confusing group came to
be dubbed "Impressionist" through a hostile critic's play on the title of

116

Claude Monet's *Impression, Soleil Levant* (*Impression: Sunrise*). Degas had wanted just a "Salon of Realists," focusing on modern themes in figure painting, and he and his followers called themselves "Independents."

A slightly reformulated group organized a second exhibition in 1876, opening on 30 March at 11 Rue le Pelletier, the showrooms of the dealer Durand-Ruel. The exhibition received a great deal of attention: dramatist August Strindberg, poet Stéphane Mallarmé and novelist Henry James reviewed the work, as did Emile Zola and the writer Edmond Duranty (1833–80), who published a key essay: "La Nouvelle Peinture" ("The New Painting"), in which the term Impressionist never appeared. Cassatt, an avid observer of the Parisian art world, no doubt visited the exhibition and gleaned its significance from the intellectually astute readings of such startlingly different works. Duranty's text helped to redirect her artistic career at a critical moment of indecision.

Duranty, a champion of Courbet and the Realist project of the 1850s–60s, saw the artists in the 1876 show as Courbet's successors. To defend them against accusations of incompetence, he proposed a critical idea: that novelty in art develops out of a soundly based struggle with tradition, admired but resisted. The key elements of art—drawing, color, composition, and subject matter—had been radically reworked by this group of new Realists in the manner of the novelist Balzac who used descriptive details of appearance to reveal inner character and social position. Thus Duranty argued: "A back should reveal temperament, age, and social position." He attacked the artificiality of studio conventions with soupy colors and unreal lighting, admiring the way the new artists broke down "the partition separating the artist's studio from everyday life to introduce the reality of the street...." Duranty also offered a list of possible subjects from contemporary urban experience and setting, social types and places of entertainment, travel, and consumption, but he concluded:

> ...it matters very little if the public understands. It matters more that the artists understand.... *Laissez faire, laissez passer.* Do you not see the impatience in these attempts? Do you not see the irresistible need to escape the conventional, the banal, the traditional, as well as the need to find oneself again and run far from this bureaucracy of the spirit with all its rules that weigh upon us in this country?

Cassatt later expressed opinions congruent with these French critics in her hatred of juries and awards, her commitment to "liberty in art," and even a desire for more democratic access to art through inexpensive prints. Her subsequent sense of artistic independence bears the hallmark of these important public debates around the "new painting" in 1876.

In 1912, Cassatt wrote to Paul Durand-Ruel about a Degas painting (dated to *c.* 1884, although it must be earlier) that had been hanging in the room next to her studio, but with which she intended to part. Her chief concern was that although the painting was a picture of herself it should never be known as such. While it had "artistic qualities," it was so "painful and represents me as a person so repugnant that I would not wish it to be known that I had posed for it." A watercolor by Mary Cassatt dated to *c.* 1880, shows the same woman, presumably herself, in identical dress and hat. The two images attest, therefore, to a joint painting session that may have taken place in the first few years of the two artists' acquaintance. The contrast could not be more marked. In her own watercolor we see the upright, reticent, self-controlled figure of a woman, with her face in shadow from which, however, an intense look emerges, while her painter's hands are barely indicated behind the sketching board on which she is working. Degas's painting presents a seated woman, leaning forward, elbows on her knees, with ungloved hands holding colored cards, in the

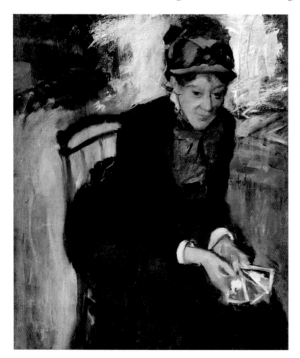

76 EDGAR DEGAS
Mary Cassatt
c. 1880–84

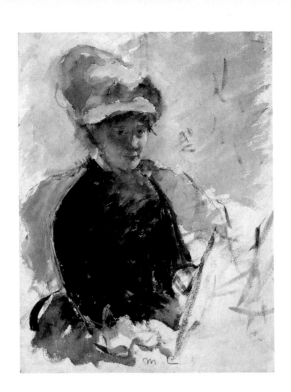

77 CASSATT
Self-Portrait c. 1880

no man's land of a studio. Around 1879–80, Degas did a series of pastels and etchings of two women in the galleries of the Louvre which have been identified as Cassatt, seen from the back leaning on her furled umbrella, and her sister Lydia, seated and peering over a guide-book. In one pastel the sisters are shown in the gallery of paintings; in an etch-ing they are in the Etruscan rooms. Without compromising Cassatt's fiercely defended sense of class and respectability, these images are consid-erably more interesting for showing Cassatt turned away from the spectator, looking elsewhere, studying art of the past. Indeed they illus-trate Duranty's call for a back view that could reveal "age, temperament, and social position." Degas places Cassatt in the museum appraising, studying, interrogating the art of the past to whose resources both she and Degas adhered in order to create a new art. His images demonstrate this modernism in the radical play with space, angles of viewing and composition of the two intelligent, culturally engaged women. Alongside the ballet dancers, prostitutes, jockeys, laundresses, and all the other working figures that populated Degas's vision of modern life in the 1870s–80s, the "new" woman artist in the person of Cassatt takes her visual place in the modern world.

78 Photograph by Theodate Pope of Mary Cassatt reading a newspaper, Château-Beaufresne, Mesnil-Théribus, *c.* 1905

Modern Women—Modern Spaces 1877–91

Women often strive to live by intellect.... Society forbids it. Those conventional frivolities, which are called her duties, forbid it. Her "domestic duties"...forbid it.... The family? It is too narrow a field for the development of the immortal spirit, be that spirit male or female.... The family uses people not for what they are, nor for what they are intended to be, but for what it wants them for—its own uses.... This system dooms some minds to incurable infancy, others to silent misery.

Florence Nightingale, *Cassandra*, 1858

After 1877 Mary Cassatt remade herself artistically as a modern painter of modern women. That did not, however, make her a "woman painter," merely reflecting her culture's ideals of womanhood as celebrated by the author of *Women Painters of the World* (1905), Walter Sparrow, who identified a specifically *feminine* genius in art.

What is genius? Is it not both masculine and feminine? Are not some of its qualities instinct with manhood, while others delight us with the most winning graces of a perfect womanhood?...No male artist, however gifted he may be, will ever be able to experience all the emotional life to which women are subject; and no woman of abilities, how muchsoever she may try, will be able to borrow from men anything so invaluable to her art as her own intuition and the prescient tenderness and grace of her nursery-nature. Thus then, the bisexuality of genius has limits in art and those limits should be determined by a worker's sex.

We would be wrong merely to dismiss Sparrow's patronizing sexism. His text provides an alternative prism through which to detect a singularly modern sense of the role of subjectivity and sexual difference in art, even if his views of it are locked into stereotypical gender categories.

To be a woman artist in the nineteenth century was to be both on the margins of culture and at its centre. This was the century during which Woman's Nature, Duty and Destiny were proclaimed to lie absolutely in the private sphere of Home and Hearth; these were the designated "spaces of femininity." Woman—a repetitiously painted fantasy appearing in

various, always extreme guises—was consecrated to the obligations of Motherhood and Self-Sacrifice. Woman was the antithesis of intellect and agency. Yet in the face of modernity, its radical changes and instabilities, Woman became what in literary theory would be called a trope, that is, a metaphorical figure, allegorizing the city and modern life itself. Through the various fantasies of La Femme and La Fille—wife and mother at home or the women of the streets—the ideals and anxieties of modern life found a rhetoric. We will miss vital aspects of nineteenth-century culture and society and Cassatt's practice if we do not recognize the paradoxical centrality of femininity to the theme of modernity which so preoccupied its intelligentsia.

After 1878 Cassatt grasped the significance of both the "spaces of modernity" and their defining figures, but her representations were produced from the socially and psychologically specific position of the New Woman. Cassatt's work was never an anecdotal picturing of upper-class social life among her family circle of Americans in Paris. Its details are studied and recorded through a penetrating pictorial analysis that reveals the deeper meaning of these apparently superficial performances of class and social interaction. She also sought to bring out the psychological interiority of her subjects' social and personal interactions, as well as moments of private reverie or intellectual preoccupation. As Achille Segard argued: "The Impressionists in general were mad for the wonderland of atmospheric conditions and the riches and brilliance of the palette. They remained strangers to the painting of individual expressions.... Within this group Cassatt is the exception." Cassatt's paintings of women, therefore, parallel emerging feminist political consciousness. Her reformulation of "the new painting" to represent the new feminine subject as a subject of reflection, culture, and intellectuality remains the hallmark of this oeuvre, placing it within the complex history of the cultural challenge of feminism in the nineteenth century. Cassatt's work from 1877 to 1891 may be read as a study of modern, feminine, bourgeois mentalities. Her oeuvre works, therefore, against the *troping* of femininity, bringing into visual representation both social and psychological dimensions of historically and culturally specific experiences not of "true" women, but of "new" women that had not before found a pictorial form.

What I am suggesting can best be explained by some juxtapositions of paintings by Cassatt and her contemporaries. The nineteenth-century American and French galleries in our major museums are filled with paintings of contemporary bourgeois life. Many aspects of the world of women, its style, fashions, social exchanges, and emotional values were the stuff of this art, whether in genre scenes, portraits, or subject pictures,

79 JOHN SINGER SARGENT
Lady Agnew 1892–93

by independents or Salon stalwarts. Woman was *the* continual subject of much of what we consider modern painting.

One of Cassatt's younger American contemporaries, Sargent was a hugely successful portrait painter serving both the American colony in Europe and the British market. His paintings offer more than mere depiction of a named sitter. *Lady Agnew*, painted 1892–93 is a fashionable society portrait that evokes the femininity idealized by that class and age. It is just one of a thousand that offers one—significant and influential—view of Woman pervasive within modernity. Seated in a pale, patterned French chair, a woman's figure curves against its shape, one arm draped over the side, another resting in her lap. A slick of gray paint outlines the edge of her slim thigh as it elegantly crosses her right leg and loses itself in a billowing nothingness of creamy satin. Her chiffony white bodice, transparent enough to reveal bare arms through delicate puffed sleeves, is belted by a lilac sash that matches floral bouquets on each sleeve. A rectangular diamond pendant hangs over the large, soft collar. So far our attention, as the painter intended, is drawn to costume. The dress is not only the sign of feminine fashionability, it is almost the very emblem of the femininity which is the real subject of the painting itself. Soft, floating, insubstantial, the dress and its complementary decorative and fake Chinoiserie setting is all pastel shades and delicacy. Within this sea of pale blue-green, white and lilac, the sitter's head is framed, dark-haired,

123

the face and neck pearly skinned. The emphatic eyes gaze directly towards the painter/viewer, in a much etiolated version of a Rossettian beauty. They are momentarily arresting but are pretty rather than fatal. They are without character enough to stay our wandering gaze across the body here displayed within an elegant and stylish setting. The contrast between dark-eyed sitter and pallid setting has been chosen to create an almost theatrical effect. Here is the mystery of modern woman in her enigmatic elegance and utterly passive beauty. Cassatt was not unusual in being a painter of women, the major topic for artists at the end of the nineteenth century. Glamour, fashionable costume, exquisitely tasteful settings served to create an idea that was understood to be intensely modern, a pale legacy of the poet Baudelaire's idea of woman as artifice and lure, deceit and betrayal, ephemeral froth and melancholy proposed in his influential essay *The Painter of Modern Life* (1863).

If the "lady" could be the jewel in the rich man's collection, at the other end of the social and ideological spectrum women of the working classes—Dutch, Italian, Egyptian or Breton, fisherwomen or peasants, in working clothes or regionally picturesque finery—were represented in most Salons, and by women as much as men. Their devoted drudgery,

80 ELIZABETH GARDNER
Two Mothers 1888

81 WILLIAM MERRITT CHASE *A Friendly Call* 1895

dedicated motherhood and stoic acceptance of bereavement were the morally uplifting face of the cult of True Woman applied to the economically exploited. Elizabeth Gardner, later Bouguereau, offered works such as *Two Mothers* to the Salon of 1888. A barefooted peasant mother with strong, bare arms, cuddles a sturdy child while watching a hen with her chicks. Virginie Demont-Breton's painting *L'Homme est en mer (He is At Sea)*, exhibited at the 1889 Salon, shows a mournful mother cradling her sleeping baby beside her simple open hearth. Such affecting nuances of maternal solicitude or personal anxiety are framed within the narratives of working-class women who form the fundamental prop of family life.

William Merritt Chase's *A Friendly Call* (1895) is a more bourgeois genre scene, touched by a French Impressionist palette. In the artist's summer house and studio two women—one modeled by the artist's wife—are engaged in conversation. Their elegant clothes with their full sleeves and floral hats form "a curious analogy to the cushions and textiles," leading one contemporary critic to complain that the figures "seem to count for almost less that the embroidered cushions and the tall mirror," while a modern commentator agrees that these women "appear to be collectible objects of beauty, graceful, refined, decorative and gracefully displayed."

Cassatt's *Five O'Clock Tea* (1880) represents a comparable scene of bourgeois sociability. Two women are seated on a floral sofa before a tea table 84, 118

displaying a fine silver tea service and a bone china cup. Instead of the distance maintained by Merritt Chase, the viewer is placed just across the table from the pair, and close enough to observe the details of the hand which holds the cup with elevated little finger. But neither woman is allowed to become a mere additional prettiness, a form displaying feminine beauty, or even illustrating female social intimacies. We, the viewers, cannot master the scene, for the women pictured are also looking, engaged by an unseen interlocutor from whose conversation we are excluded. Because we cannot spin a narrative within which to contain these figures, and because the painted space does not put them entirely within our visual grasp, we become observers of details—the wallpaper, the fireplace, the gilt mirror, the tea set, the differences between the two women in style, age, character. The last emerges slowly from the revealing nature of their gestures. Yet both are withheld from us. The face of the visitor, hatted and gloved, is ironically obscured by the tea cup—a daring move on the painter's part, and the woman closest to the viewer seems quietly restrained and pensive, with her hand resting gently before her mouth. While the cut and design of costume is clearly noted with an awareness of fashion, the dresses stretch to insist on substantial bodies straining the fine seams. The more we observe, the more we are drawn to look at the painting's facture, each fabric or space delivered to us by a different kind of brush-stroke so that we do not lose ourselves before the illusion of femininity as in the Sargent, but confront the work of the woman who so emphatically signals her artistic presence in her signature to the lower left. Indeed, as I have repeatedly argued, the very hallmark of Cassatt's painting at this time is the way in which the represented space within the painting registers the space from which the painting was made, a space that included the artist, looking, painting, thinking, organizing, interacting with her models. Cassatt radically reconceptualized three spaces: the spaces of femininity— the social locus and activity that is being painted; space in painting—the repression of deep space in favor of shallow space, producing the effect of immediate proximity to her sitters; and the space from which the painting was being made. This was her artistic and imaginative space, which, occupied by a selfconsciously *woman* artist, renders the viewing position we are offered a historically and psychologically *feminine* one, but not in Sparrow's stereotypical sense. To see these paintings historically, the viewer needs to recognize the position from which the artist produced them.

In 1883, at the end of a long European tour, the artist's sister-in-law, Lois Buchanan Cassatt wished to have her portrait painted. Cassatt recommended Renoir. Alexander and Lois Cassatt selected instead fellow American James McNeill Whistler who was settled in London, building

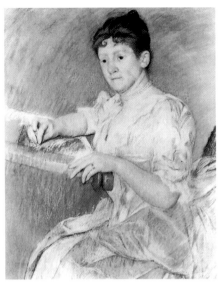

82 JAMES MCNEILL WHISTLER *Arrangement in Black No. 8: Mrs. Alexander Cassatt* 1883–85
83 CASSATT *Lois Cassatt at a Tapestry Frame* 1888

up a fine reputation. It would look good to have "a Whistler" in the collection. To neither the artist's nor the sitter's satisfaction, and after some years' delay, Whistler produced *Arrangement in Black, No. 8: Mrs. Alexander Cassatt* (1883–85). He asked Lois Cassatt to pose in her black riding habit, the better to fulfill his current artistic fascination with closely graduated studies in black, broken by minimal touches of white, the buff color in the gloves, and the flesh tones of the sitter's face. On 14 October 1883 Cassatt wrote to Aleck about the painting of his wife.

> I thought it a fine picture, the figure especially beautifully drawn. I don't think it is by any means a striking likeness, the head inferior to the rest, the face has no animation but that I believe he does on purpose. He does not talk to his sitters, but sacrifices the head to the ensemble.

In 1888 Cassatt finally did a pastel portrait of Lois Cassatt, *Lois Cassatt at a Tapestry Frame*. Cassatt allowed her to wear one of her elegant evening dresses for whose purchase the trips to Paris were made. Here is a middle-aged woman, embroidering, elegantly attired, and seated with the erect

self-composure that class and money ensure. Yet we must remember that she was seated in proximity to a member of her family, and that troubled intimacy translates into Cassatt's characteristically close viewpoint in which the figure, whatever size the paper or canvas, comes before us embodied, substantial, filling its space. In the pale but plump face, the strong dark eyes are not limpid, expressionless pools, as in the Whistler portrait. They are sharp, self-aware, and create a sense either of the sitter's character or of the painter's still equivocal view of her sister-in-law. Note the hands, the way her left hand rests on the frame, and the working configuration of the fingers that will in a moment return to the tapestry. Instead of the vacant fixity of gaze that takes the sitter out of time and place, allowing the allegorical frame to recast this woman as Woman, Cassatt's details create on the pictorial and fabricated plane of her drawing or painting, the sense of class identity and socially defined femininity. To be a fashionable woman of wealth and privilege has its codes and defines its characters, while disciplining its bodies. Dress can be a part of that self-presentation, as in the Cassatt portrait. It can also make the wearer merely the passive bearer of the ideas of Femininity coded into fashion. Cassatt's portrait of Lois Cassatt leaves us in no doubt about the age of the sitter, allowing us to see her, like the artist's own sister Lydia, whom she also portrayed dramatically at work at the tapestry frame (1882) as women in time, as well as of their own time.

At a deep, structural level, when viewed as a whole, Cassatt's oeuvre reveals a discourse on "the ages of woman": infancy, childhood, youth or coming of age, adulthood and maternity, maturity, and old age. These themes were not abstractly conceived, but unfolded before the artist as a result of the unexpected arrival of the artist's family: her father, mother, and elder sister, who settled with her in Paris in 1877. This transatlantic move drew brothers Alexander and Gardner and their young families to Europe on a regular basis after 1880, surrounding Cassatt with the unfolding evidence of the processes of aging and childbearing, infancy and growing up, intergenerational contacts as well as sibling bereavement. Cassatt outlived both parents (who died in 1891 and 1895), both her brothers, and her sister Lydia, who died aged forty-five in 1882. What happened in the paintings of the years from 1877 to 1891 are not inevitable reflections of known intimacies so much as the artistic record of their discovery, the unexpected revelations made interesting by the conjunction of an artistically long-schooled painter's eye and a modernist's desire to see the bourgeois world of immediate social interaction uncluttered by sentimentality or contrived narrative; the point at which the naturalist critics' ideas of "sincerity" met a distinct social consciousness of the modern.

This is not the stuff of bourgeois melodrama and soap opera but the anticipation of some of Freud's insights into the powerful significance of the everyday and the oft-repeated. These images can be approached with that same sense that something mundane may be the condensed locus of profound meaning, memory, desire, as well as ambivalence.

One of the two dominating factors of Cassatt's working life from 1877 to 1891 was the presence of significant members of her family living with her in Paris or other relatives and their young children who regularly visited from the States. The pressures of illness in the family and of death sometimes crowded out her painting. The other factor was the cycle of exhibitions of the Independent group with whom she showed in 1879, 1880, 1881, and 1886. In 1879 Cassatt made a radically new debut. It was, in effect, the beginning of her second career even while it has been hailed as a final homecoming. She was acknowledged immediately as one of the Independent group's most significant members. We can putatively reassemble her contributions to four exhibitions in order to understand the impact of her engagement with "modernity and the spaces of femininity." Yet we are missing one critical stage, the works that would have been shown had there been a group exhibition as planned in 1878. I want to assemble, therefore, an exhibition that never took place. The paintings of this missing 1878 show focus several themes that continued to fascinate Cassatt over many years: the young girl; women reading; women and theatre.

108–34

86, 91, 103, 105

THE GIRL

Little Girl in a Blue Armchair (1878) was modeled by the daughter of friends of Degas. In a letter to the dealer Ambroise Vollard, Cassatt recalled that she had painted the child in the armchair she had in her studio, using her preferred close-range viewpoint and compressed pictorial space. The extended background is unique in Cassatt's paintings of this period. She wrote that Degas had advised her on this setting, whose steeply rising perspective, cropped furniture and luminous windows, which are pure white in contrast to the subtle, shadowed gray-greens of the interior, bear a significant relation to Degas's paintings and pastels of the ballet rehearsal rooms that Cassatt had advised Louisine Havemeyer to purchase in 1875.

86

This painting is one of the most radical images of childhood painted at this period. It is turned from the prettiness and subliminal eroticism of Madrazo's *Young Lady in Pink* (c. 1870), for instance, or Renoir's *Mlle. Legrand* (1875), by a boldness of posture whose daring would later affect Pissarro's paintings of young peasant women. There is nothing cute, nothing of the miniature "lady" in this portrayal of the awkwardness of a childish

129

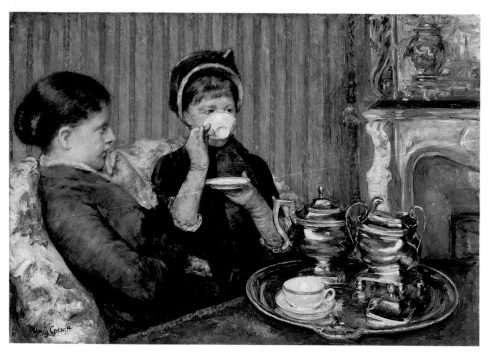

84 CASSATT *Five O'Clock Tea* 1880

85 Photograph by Theodate Pope of Mary Cassatt drinking tea, Château-Beaufresne, Mesnil-Théribus, *c.* 1905

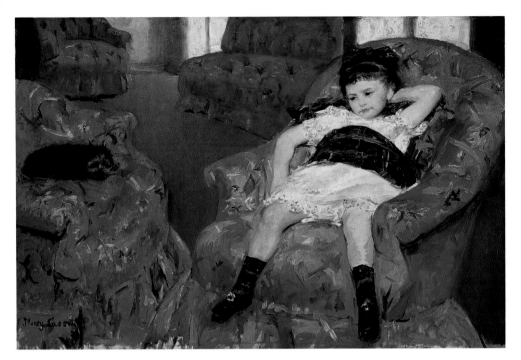

86 CASSATT *Little Girl in a Blue Armchair* 1878

body maladjusted to adult comportment as she sprawls on an outsized, upholstered armchair too large for her short limbs. The expression is not quite dreamy. It is slightly sour, a touch of discontent shapes the mouth in a face whose features are still being formed beneath a childish fleshiness. The sweeping perspective of the room, viewed from an oblique angle, low down in front of the child, reveals more about the psychological ambience of the space as it might be experienced by a young child than a mere desire to upset conventional geometries. Yet this is a contrived studio set up, repeating the two pieces of furniture in an invented space. We can discern not only the artistic conversation with Degas, but the atmosphere he also sought, whose origin lay in his major resource, the interiors painted by Jan Vermeer.

Cassatt later wrote: "I love to paint children. They are so natural and truthful. They have no *arrière pensée*." The single child image, initiated in this 1878 work, continued in a series of powerful confrontations between the artist and the young girl: *Little Girl in a Large Red Hat* (1881), and *Girl in a Straw Hat* (c. 1886). The latter shows a working-class child in simple 87 shift and pinafore under an outsized straw hat perched upon her roughly

87 CASSATT *Girl in a Straw Hat c.* 1886

88 CASSATT *Ellen Mary Cassatt in a White Coat* 1896

cut fair hair. Stripped of cleverly contrived background in favor of the gray simplicity of Velázquez, a plaintive little face regards a viewpoint off centre with a touching perplexity.

The sequence of child portraits culminated with the monumental *Ellen Mary Cassatt in a White Coat* (1896), which has been compared to Velázquez's painting of the Infanta Margarita Teresa (1653) in the Louvre. Seated off-centre in a large eighteenth-century armchair, wearing a white coat bordered with fur, the very young child peers solemnly from under her matching bonnet. The strict geometries of furniture and clothes heightens the pathos of the tiny hands clutching the armrests and the barely outlined but rigid feet, toes pointing upwards, that just overhang the edge of the chair's seat. The comparison with Velázquez serves to underline the tension between the immature or the childish—that would be explored mostly by Cassatt in the uncluttered freedom of the nude baby—and the restrictive disciplines of class and the costumes of classed gender. In these studies of the female child, Cassatt tracks a contemporary feminist question: is there a woman's nature, or is the governing idea of gender a social prescription encasing and confining both the body and the intellect?

132

The earliest painting of a woman reading, dateable by the striped sofa which appears in many works of the mid 1870s and which probably belonged to Cassatt's studio in Rue Beaujon, is a tiny panel that has a distinctly eighteenth-century feel. It is reminiscent of Jean-Honoré Fragonard's *Young Girl Reading* (*c.* 1776) whose relevance to the new painting was provoked by Edmond and Jules de Goncourt's *L'Art au dix-huitième siècle* (*Art in the Eighteenth Century*), 1856–75, which featured the painters Boucher and Fragonard, and the pastellists Chardin and Quentin de la Tour—both of whom were also a major resource for Degas. The warm reds and blues of Cassatt's panel, dated 1875, soon give way to a light background and a study in ivories, white, and pinks in *The Reader* (1877). This small step—using a light background that enraged the Salon jury in the lost 1875 portrait of the artist's sister—marks Cassatt's decisive choice to abandon academic models and let the light of contemporary actuality radically change what her paintings looked like.

The monumental statement on this theme, *Reading "Le Figaro"* (1878), was a painting of the artist's mother, Katherine Cassatt, reading a newspaper, the Baudelairian sign of modernity. She is seated in the same floral

91

89 CASSATT *Young Woman Reading* 1875

90 CASSATT *The Reader* 1877

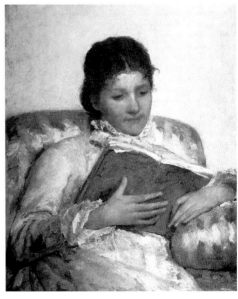

86 armchair as the girl, against a pale ivory wall. The artist has introduced a mirror in which the newspaper is partially reflected. Indicating the interest in Cassatt's work in her new circle, in 1879 Manet painted a fashionable young woman reading an illustrated newspaper in the gardens of a Paris café: herein lies the moment of difference but not where born gender produces different kinds of genius, as Sparrow would have it. The difference is created by Cassatt's maneuver of condensing contradictory images of femininity, maternity, and intellectuality: the mother is represented, but middle-aged, educated, working with her mind; fashionable but not young or available, for the wedding ring glints on her finger. The image of the intellectual mother is created by her adult, artistically creative, daughter whose gaze is implied in the space of the studio where together the daughter painted and her mother read.

For all the scintillating use of color which no reproduction can ever match in Cassatt's symphony of intensely colored "whites," none of the Impressionist techniques are used to elide the frothiness of fashion, the transience of newspapers into the levity of Woman. Instead we confront the solid form and quiet preoccupation of a middle-aged woman who is the artist's mature mother.

28 It was an apparent transgression to show a bourgeoise, or indeed any woman, engaged in intellectual activity. Caillebotte's mother appeared at the 1877 Impressionist exhibition sewing, and when Whistler painted his
93 mother in 1871 the black-clad widow is seated in monumental stillness.
94 In Lilly Martin Spencer's *War Spirit at Home* (1866) a nursing mother holds the baby and the newspaper that reports on Civil War casualties, creating a sentimental narrative to explain the unexpected juxtaposition.

Yet a woman reading was paradoxically one of the paradigmatic images of a *negative*, feminine relation to modernity. From Fragonard to Van Gogh, women appear as readers of novels in paintings of modern life. The advanced novels of the time, like Flaubert's *Madame Bovary* (1857), exposed the woman reader as silly and susceptible to sentimental fiction in an implied contrast to the disciplined rationalism of the modernist male author.

92 Cassatt's representation of her mother reading a newspaper differs radically from a painting of 1866 by Cézanne. His father, Louis-Auguste Cézanne, is represented informally, with cap, smoking jacket, and slippers, reading not his usual Republican paper but *L'Evénement* in which Cézanne's childhood friend Emile Zola was publishing bold articles in defence of Manet and the other artists of the radical new tendency in Paris that Cézanne aspired to join. While the painting is *of* his parent, the image is addressed, aggressively, *to* his father who opposed his son's vocation. Cézanne's heavily painted still-life hangs above his father's head

134

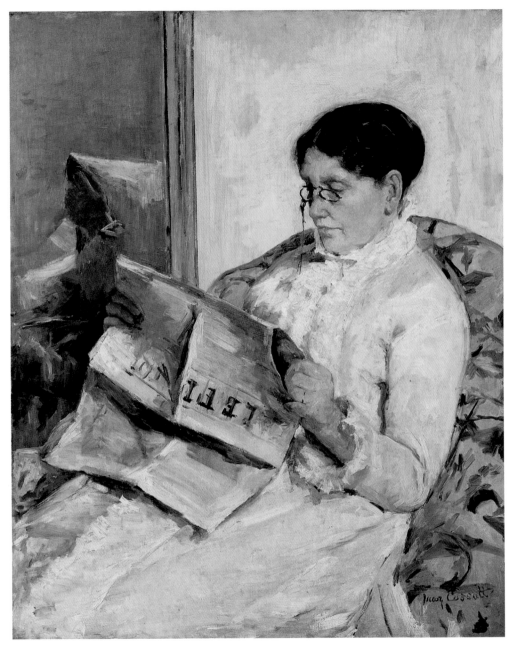

91 CASSATT *Reading "Le Figaro"* 1877–78

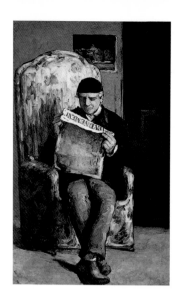
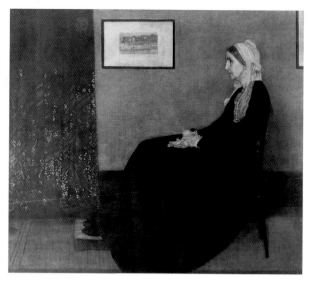

while the bold use of the palette knife seen in the still-life is used to refashion Louis-Auguste in terms of Cézanne's own fabricated persona—rough, workmanlike, dissident, self-exiling from his father's bourgeois place. In contrast, Cassatt signifies the continuity between her presence and her mother's singular, adult, and self-regarding intellectual identity by producing an image which shows one woman, yet invites us to imagine the presence of the daughter painting her. At the 1874 Impressionist debut Morisot exhibited *Reading*, a painting of her mother and her sister Edme, a fellow art student, who, having married and become pregnant, as she is shown in the painting, was obliged to give up her own artistic ambitions. Within these biographical details we can discern Morisot's ambivalent reflections on the prescribed paths for bourgeois femininity which her own act of painting disturbed. Envy of her sister's procreative body and psychological self-absorption, perplexity before her mother's complacent success as a middle-class mother with married daughter, and relief at her own absorption in the difficult problems of painting whites and blacks, these mingle and mark a painting that is as characteristically ambiguous as Cassatt's is formidably assertive. At the 1881 Independent exhibition, Cassatt showed a painting of her mother as grandmother, reading to Alexander's children, whose eager listening faces circle the solid form of the older woman like angels in a Renaissance fresco.

95, 128

As coda to this series of images of her mother as intellectual is the final portrait that Cassatt painted in 1889, showing a drained and exhausted vision of someone who had only just survived a near-fatal illness. This

96

92 PAUL CEZANNE
*Portrait of Louis-Auguste Cézanne
Reading "L'Evénement"* 1866

93 JAMES MCNEILL WHISTLER
*Arrangement in Gray and Black:
The Artist's Mother* 1871

94 LILLY MARTIN SPENCER
War Spirit at Home 1866

painting is once again monumental yet utterly tender, the stark expanse of the black dress broken by her cameo brooch, setting off one aging hand clutching her handkerchief, while the changed features of her stricken face are still patiently examined, its lineaments lovingly retraced. Although not shown reading, the artist's elderly mother sits in the posture of the thinker that is iconographically linked to melancholia and to death.

In her memoirs Louisine Havemeyer wrote:

Anyone who had the privilege of knowing Cassatt's mother would know at once it was from her and from her only that she and her brother, A. J. Cassatt, inherited their ability. Even in my day, when she was no longer young, she was still powerfully intelligent, executive and masterful and yet with that same sense of duty, that tender sympathy that she had transmitted to her daughter Mary. I think Mrs. Cassatt had the most alert mind I ever met. She was a fine linguist, an admirable housekeeper, remarkably well read, and interested in everything.... Even in her last illness, I recall sitting beside her holding her thin hand in mine, filled with pity for the poor sufferer and with regret that this world must lose such a remarkable woman.

Cassatt's mother died on 21 October 1895. "To poor Miss Cassatt the loss was irreparable. She struggled bravely," wrote Louisine Havemeyer. The artist wrote to Rose Lamb when she visited the United States in 1898 for the first time since 1875: "I lost my mother two years ago in October, and was so bereft and so tired of life that I thought I could not live...."

137

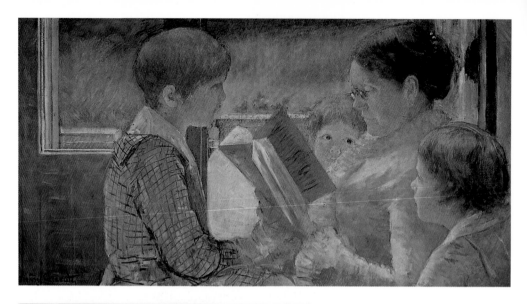

95 CASSATT *Katherine Cassatt
Reading to her Grandchildren* 1880

96 CASSATT *Portrait of
Katherine Kelso Cassatt* 1889

97 CASSATT *Lydia Crocheting at Marly* 1880

The years of Cassatt's major interventions in Parisian modernism coin-
cided with the arrival of her mother to live with her—a decision which
removed Mrs. Cassatt from the daily life of her sons and their growing
families. It was an act of both faith and dedication, creating the necessary
environment of personal and intellectual support for the daring advance
the painter daughter had made, a step which must have in some way,
registered with the mother as a fulfillment of what she, as her first teacher
had begun. In the nineteenth-century bourgeoisie, women often contin-
ued the close bonds between mothers, daughters, and sisters as the
unbroken friendships of creative life-times. In this female world we can
see the cultural values and psychological strengths that are the positive
dimension of a system of sexual segregation. That it also produced a stunt-
ing intellectual poverty was powerfully decried by Florence Nightingale
in her essay *Cassandra* (1858). It is in this context that the large pastel *Nurse* 4
Reading to a Little Girl (1895), showing an adult woman supporting the
young girl in her first steps towards education and an intellectual sense of
herself, links both back to the opening salvos of Cassatt's induction into

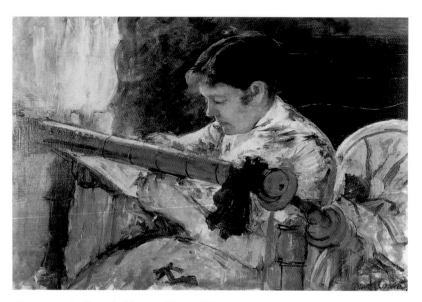

98 CASSATT *Lydia at the Tapestry Frame* 1881

91
22
the new painting with her painting of her mother *Reading "Le Figaro,"* and sideways to the monumental mural of 1893 with its central theme of intergenerational struggle for and transmission of Knowledge and Science, which is its more allegorical legacy.

In addition to her paintings of her mother, a group of paintings from 1879 to 1882 feature Lydia Cassatt, whose companionship Cassatt had gained in the mid-1870s when Lydia spent part of each year chaperoning Mary in Paris. Lydia was not shown reading but working at a tapestry 84, 97,
162 frame, elegantly taking tea, driving out with her young niece, and, in failing health, crocheting in the garden of the rented summer villa at Marly. It is a kindness to one's model to paint her doing something to pass the hours of posing. But even mundane tasks like sewing can have deeper resonances. Henri Fantin-Latour painted his double portrait *The Two Sisters* in 1859, showing one at the tapestry frame and the other reading, creating the stillness of the idealized feminine interior that was both a masculine fantasy and an oppressive social regime.

In *Lydia at the Tapestry Frame,* proximity to the frame, the close view-point that Cassatt so insistently establishes in her paintings at this date, puts the painting sister within the intimated space of the painting, sublim-inally recreating that sisterly scene of companionship and difference, both working with their hands, both creating with color. Iconographically there is a throwback to the artist's latent romantic fascination with English

140

poetry, for a woman at a tapestry frame evokes the cursed figure of the Lady of Shalott—" 'I am half sick of shadows,' said the Lady of Shalott." At the same time, the uncompromising ordinariness of this scene marks the feminist modernist's adamant negation of woman as trope of fatal sexual desire—the curse of Eve reworked by nineteenth-century medievalism. In its place is a mixture of the personal acknowledgment of familial intimacy and the artistic experimentation with radical fore-shortening and color in a luminous interior that brings into art the dignified representation of the unmarried, middle-aged woman.

AT THE THEATRE

The young Louisine Havemeyer's memories of Paris in the mid-1870s included trips to the theatre and opera with Cassatt: "She took me to the Opéra where, without depleting our pockets, she found a place where we could enjoy the fine ballets that were attracting Degas's attention at the time." Opera and theatre were the major cultural pastimes of the metropolis. In the 1880s, 500,000 Parisians went to the theatre once a week and over a million did so once a month.

Cassatt's first theatre picture shows a prospective member of the audience *Dressed for the Matinée*, in smart black suit, gloved and almost too 103
elaborately hatted—theatre owners were obliged to forbid their female patrons from wearing anything larger than bonnets, and put up shelves in the corridors for the deposit of over-exuberant hats that would impede a view of the stage. The woman in this painting holds her opera glasses in a studio set-up. Matinées—originally only on Sundays—had first been introduced in 1869. To encourage an audience to attend in the daytime, one producer, Hilarion Ballande, offered introductory lectures which succeeded in recruiting a largely middle-class and mostly female audience, with a notable absence of working-class participation. The title of this painting, therefore, indexes a relatively new phenomenon which should make us read this theatregoer as a woman of education with a serious interest in contemporary culture, here signified by her opera glasses, which were more commonly used in prints of theatre scenes as a sign of the sexually provocative woman who dared to usurp men's prerogative to 106
look at women in public.

The rare survival of compositional studies for the next painting, 104
the first real theatre subject, *At The Opera* (1878), confirms that Cassatt 105
was, like Degas, an intellectual artist, experimenting with angles of vision, scale, composition to produce a distilled, and synthesized painting rather than some swiftly brushed record of a transient impression.

141

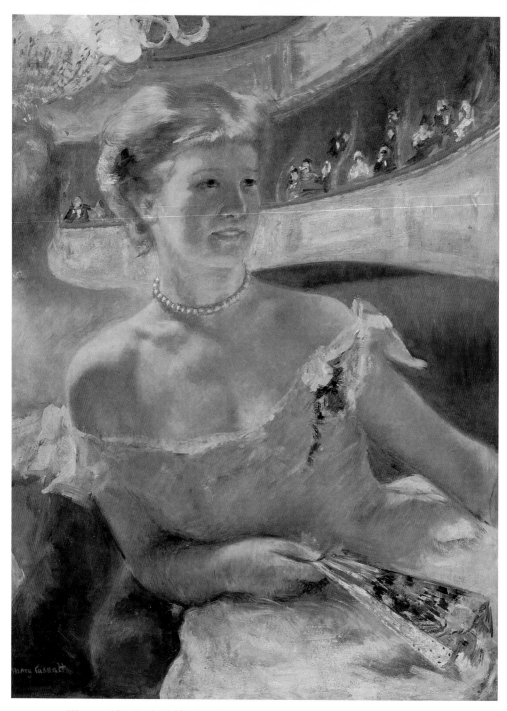

99 CASSATT *Woman with a Pearl Necklace in a Loge* 1879

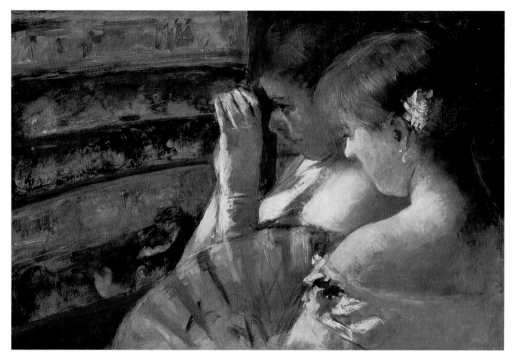

100 CASSATT *In the Box c.* 1879

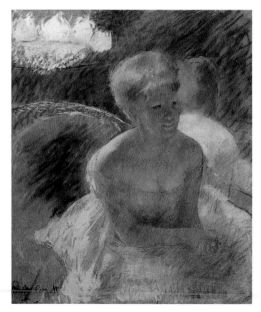

101 CASSATT *At the Theatre* 1879

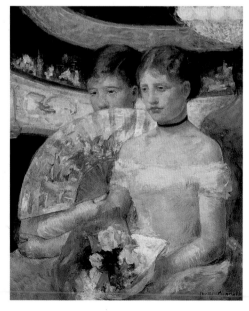

102 CASSATT *The Loge* 1882

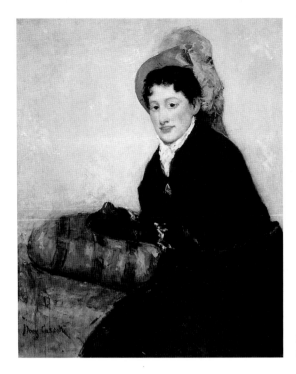

103 CASSATT *Dressed for the Matinée* 1878

In one tiny pencil study, we see the first sketch of the key feature of this painting. Dressed in black daytime clothes suitable for a Sunday matinée and lecture, a woman holds her opera glasses to her eyes. She is, however, seen in profile and looks across the viewer's line of vision in a determined action. Her looking elsewhere adamantly ignores the viewer's gaze, which finds itself confronted instead with a sketchily painted man, peering from his box deep in the picture's imaginary space, at the woman in the box in whose space the viewer is putatively placed, performing the role of chaperone. This arrangement offers a stark contrast to Renoir's paintings of a man and woman together in the box, where a sexual narrative impugns the status of the young woman so prominently on display.

The theatre was a place of fantasy and stories, of artifice and illusion, of melodrama and music, but also of tough intellectual demands. It was also, as the work of both Manet and Degas insisted, the site of overt sexual commerce and thus possible compromise to a lady's reputation. Indeed most of the images in both high and popular culture of this period, in which a woman, a box at the theatre, and a pair of opera glasses appear, signify unequivocally the initiation of commercial sex between top-hatted gents and overdressed working-women or courtesans. In Renoir's

106

144

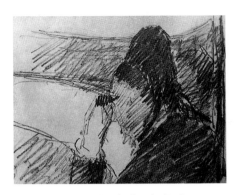

104 CASSATT Study for *At the Opera*
1878

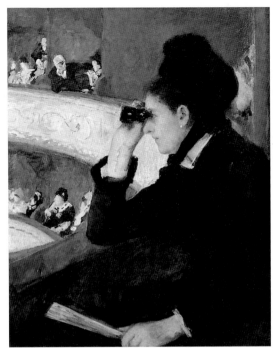

105 CASSATT *At the Opera* 1878

1874 treatment of *La Loge,* that suppressed the ogling and the anecdote to be found in Jean Béraud's chronicles of modern life, the beautifully painted "painted" lady becomes the spectacle at the spectacle. Degas alone had struggled with something more ominous and powerful in the image of the woman using a lorgnette to survey a public scene. Cassatt was clearly responding to Degas's repeated studies of what he found an almost too challenging figure, a woman looking in public, many of which are dated 1876–77, by painting self-confident New Women at the matinée.

Around 1878–82, Cassatt might have been rightly called a "painter of theatre scenes," for her studies of this modern venue form a suite of images, alternating between oil and pastel, functioning in opposing pairs that represent fashionable young women at evening performances. An oil painting shown at the 1879 exhibition focused on two young debutantes at the theatre, resumed in a later painting of 1882 where the young women are on show, sitting ramrod straight, awkwardly clutching a fan before a face or a bouquet of flowers held a little too tightly on the lap. They are being seen by the whole amphitheatre whose impersonal sea of gazes is reflected in the mirror behind them. Here, as in *Woman with a Pearl Necklace in a Loge* (1879), Cassatt continues her exploration of a mirror as a means to

100, 112

102

99,108

145

106 Poster for Théâtre Eldorado, Paris, c. 1895

refute the illusion of deep space by reminding us that we are looking at a flat, if reflective surface just behind the figure. It is certain that Manet took note of exactly this feature of Cassatt's work.

The complementary 1879 image in this pair shifts position to the interior, not of a balcony as with the Spanish subjects of the early 1870s, but of the thoroughly modern Parisian theatre box. The viewer, positioned as if in hidden in the depths of the protective box from which the young women intently watch the performance, thus looks at a picture about looking, about being enthralled, about cultural consumption in which the excitement and pleasures of the whole spectacle are perceived from the perspective of young, educated women, perhaps a Louisine Elder or Mary Ellison (her portrait was probably in the 1879 exhibition).

The alternation between "being seen" and "seeing," being on show and being absorbed in the show, is repeated in an 1879 pair of pastels of single figures. In the theatrical scenario Cassatt found a device for conjoining her fascination with the figure, notably of young women in smart day or evening clothes, with the need to situate them in a social setting—one of the ambiguous spaces of modernity which bourgeois femininity could occupy and contest. Without having to abandon the close viewpoint that produced both a modernist flattening of the picture's surface and a "feminist" intensity of psychological presence for the woman she represents, Cassatt could elaborate a significant setting. She used the interior views to compress space by drawing the curving sweep of the theatre's tiered boxes—*Woman in a Loge with Fan Gazing Right* shows how the color of the red velvet and the gilt, echoed in fan and dress, work in this radically flattened composition. In the views from outside the box, the artist incor-

114

113

146

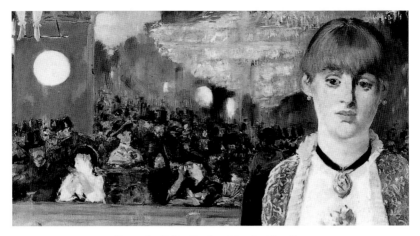

107 EDOUARD MANET *Bar at the Folies-Bergère* 1881–82 (detail)

porated a mirror to deny depth while also exploring the glittering and artificial illumination of the theatre. At this date, performances took place with the houselights up, brilliant illumination being provided by huge gas chandeliers. Charlotte Brontë incorporated her visit to the theatre in Brussels in her novel *Villette* (1853): "Pendant from the dome flamed the mass that dazzled me—a mass I thought of rock crystal, sparkling with facets, streaming with drops, ablaze with stars, gorgeously tinted with dews of gems dissolved, or fragments of rainbows shivered. It was only the chandelier, reader, but for me it seemed the work of eastern genii."

The theatre was the privileged site of Cassatt's debut with the Impressionist group. It shows how Cassatt took her place with the keenest artistic intellects of this new art world. Modernity could not be summed up in a single picture and would only be researched through series that focused repeatedly on paradigmatic scenes. During the later 1870s Cassatt would have watched Manet reworking paintings of the café and café-concert, experimenting with compositions, situations, and social types as he struggled to distill into a single painting the whole complexity of a modernity that was, in essence, a matter of unstable reflections and ambivalent identities in a world of commodities and public spectacle. *The Bar at the Folies-Bergère* (1881–82) seems to have achieved that vivid synthesis. It is highly significant, however, that in two details, Manet's solution reveals an artistic dialogue with Cassatt's work. Across the back of his painting stretches a mirror reflecting the auditorium and the audience, in which, in the form of a fashionably dressed woman holding opera glasses to her eyes, we can discern a deliberate quotation from Cassatt's painting of 1878 *At the Opera*.

147

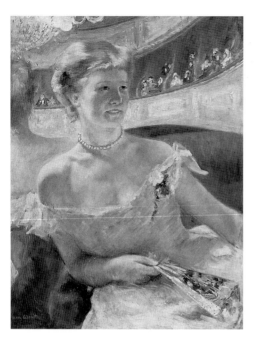

A selection of the paintings and pastels by Mary Cassatt shown at the Fourth Impressionist Exhibition in 1879

108 *Woman with a Pearl Necklace in a Loge* 1879

109 *Woman Reading* 1878

110 *Portrait of Moyse Dreyfus* 1879

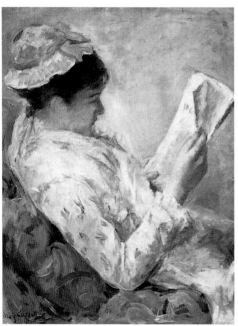

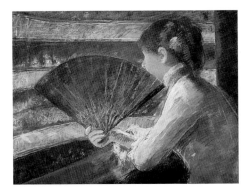

111 *In the Loge* 1879

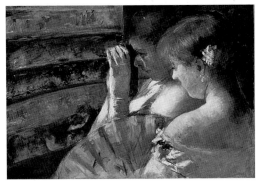

112 *In the Box c.* 1879

113 *Woman in a Loge with a Fan Gazing Right*
1879

114 *Miss Mary Ellison* 1879

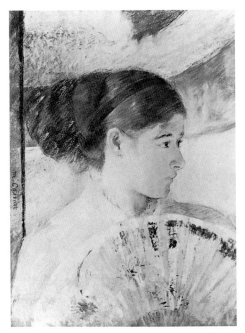

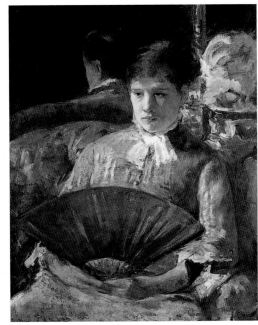

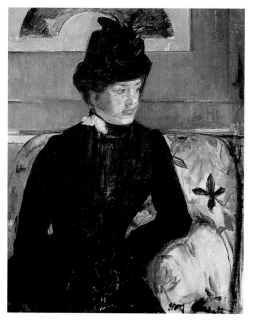

115 *Portrait of Madame J* 1879

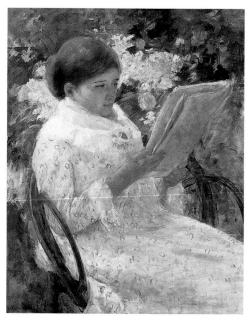

116 *Woman Reading in the Garden* 1880

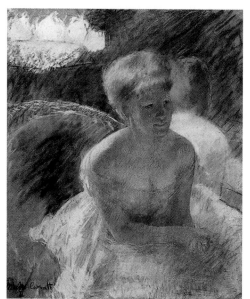

118 *Five O'Clock Tea* 1880

117 *At the Theatre* 1879

150

A selection of the paintings and prints by Mary Cassatt shown at the Fifth Impressionist Exhibition in 1880

119 *Lydia Reading Turned to the Right*
c. 1880

120 *Under the Lamp*, 3rd state, *c.* 1880

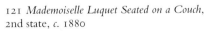

122 *Before the Fireplace c.* 1880

121 *Mademoiselle Luquet Seated on a Couch*,
2nd state, *c.* 1880

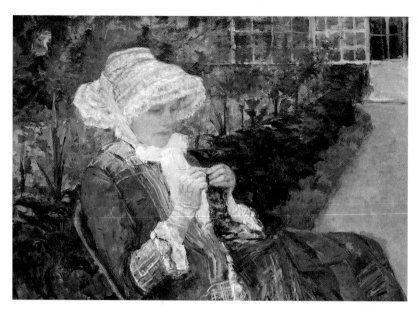

123 *Lydia Crocheting at Marly* 1880

A selection of the paintings and pastels by Mary Cassatt shown at the Sixth Impressionist Exhibition in 1881

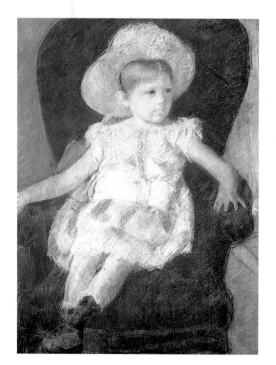

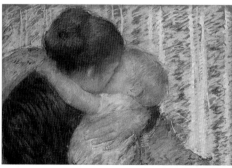

125 *A Goodnight Hug* 1880

124 *Elsie Cassatt in a Blue Armchair* 1880

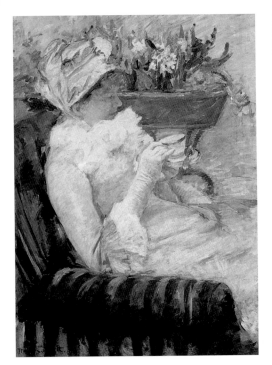

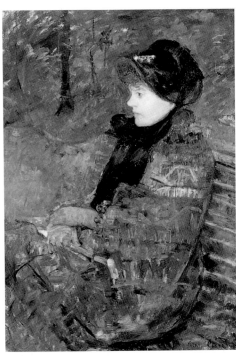

126 *The Cup of Tea* 1880

127 *Autumn* 1880

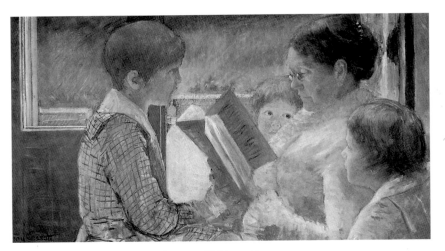

128 *Katherine Cassatt Reading to her Grandchildren* 1880

A selection of the paintings and pastels by Mary Cassatt shown at the Eighth and Last Impressionist Exhibition in 1886

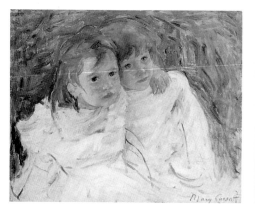

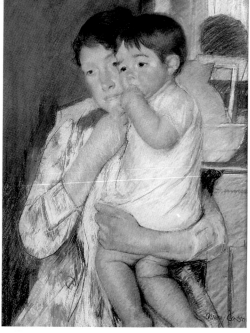

129 *Children in the Garden* 1885

130 *Mother and Child c.* 1886

131 *Girl Arranging her Hair* 1886

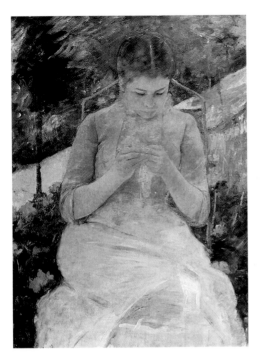

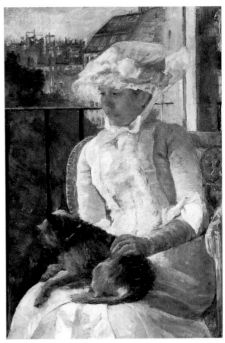

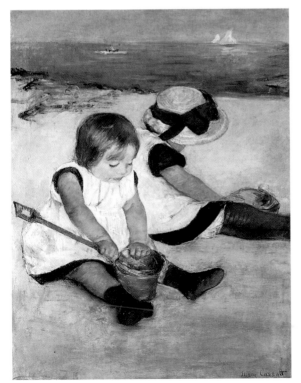

132 *Young Woman Sewing* 1883–86

133 *Susan on a Balcony* 1883

134 *Children Playing on a Beach* 1886

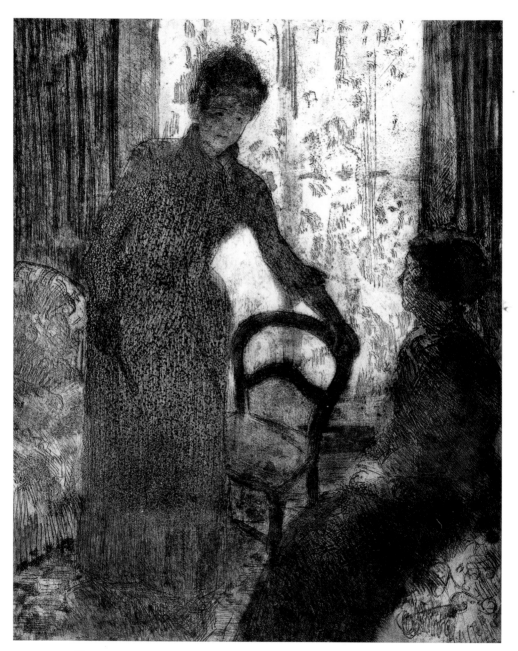

135 CASSATT *The Visitor*, 5th state, *c.* 1880

The Maid and the Mother in the Color Prints of 1891

It is absolutely necessary while what I saw yesterday at Miss Cassatt's is still fresh in my mind, to tell you about the colored prints she is to show at Durand-Ruel's at the same time as I. We open Saturday, the same day as the patriots who between the two of us, are going to be furious when they discover next to their exhibition a show of rare and exquisite works... the mat tone, subtle, delicate, without stains or smudges: adorable blues, fresh pinks. ...

<div align="right">

Camille Pissarro, letter to his son Lucien,

3 April 1891

</div>

Mary Cassatt was as renowned as an avant-garde printmaker as she was as a "new painter." In 1909 Frank Weitenkampf, curator of prints at the New York Public Library, praised Cassatt's etchings and drypoints for their "full appreciation (sensitive, notwithstanding a robustness often emphasized by the models used by her) of the nature of the medium, a recognition of its possibilities and its limits, its forceful technique, its firmness, its spontaneous vitality, its succint straightforward manner of statement, its judicious effective economy of line." In another article of 1916, however, Weitenkampf admitted that such robust prints might, at first, be "difficult" for viewers new to French modernism: "It is conceivable and a fact that well-intentioned people of taste may not be attracted at first sight by her drypoints." Their "vigor, their uncompromising directness" might inhibit immediate appreciation of the "discriminating and absolute truthfulness in these pictures of every-day plain women and ordinary babies." Cassatt's work is compelling, he argued, but "only after it has been sympathetically studied. ..."

There are very few extant drawings in Cassatt's oeuvre; many that exist are preparatory studies for prints. As a young artist Cassatt had been enthralled by paint and color, and pursued her education in the museums. When she became involved with the "new painters," after 1877, Cassatt began to carry a sketchbook to note contemporary scenes. These she translated into studies in color—indeed to the extent that she exhibited her paintings at the 1879 fourth group exhibition in painted, brightly colored frames. In Parma, Cassatt had studied with Carlo Raimondi, Professor of Printmaking at the Parma Academy and a highly reputed

engraver. There is no evidence, however, of an interest in the graphic arts in these early years.

Degas prompted Cassatt to participate in the major renaissance in printmaking that had begun in the 1850s–60s and was enthusiastically taken up by the Independents—Degas, of course, Manet, Bracquemond, Morisot, Pissarro and their younger followers such as Gauguin and Bernard. In 1879, after the closure of the fourth Impressionist exhibition, Degas proposed an avant-garde journal, *Le Jour et la nuit (Day and Night)*, whose publication would coincide with the next group exhibition in 1880. Degas was not ready in time, and the journal was never published. But Cassatt showed seven etchings in the 1880 exhibition, her first suite in black and white.

119–22

Since the death of Rembrandt the art of etching had fallen into disuse, with major exceptions of Goya and Piranesi. Line engraving reached its height in the nineteenth century, especially in reproductive steel and wood engraving. There was, however, a desire for a graphic medium that allowed a freer handling, a greater spontaneity of touch and directness of expression which etching alone could provide. Etching underwent a major revival in France between 1850 and 1880, anticipated by the founding of the Etching Club in Britain by Whistler's brother-in-law, Francis Seymour Hayden. When Whistler exhibited a suite of London river scenes at the Galerie Martinet in Paris in 1862, the poet-critic Charles Baudelaire, who would be a major advocate of the etching revival, declared: "Decidedly, etching is becoming *à la mode*." He praised Whistler's evocations of the Thames. They were "as subtle, and as lively as improvisation and inspiration . . . the profound intricate poetry of a vast capital." In 1862 the printers Cadart and Delâtre published an album of etchings dedicated to Baudelaire, and then produced another featuring work by Manet, Daubigny, and Jongkind, an event which led to the founding later that year of La Société des Aquafortistes. In 1867 Le Nouveau Illustration replaced the Société and produced yearly albums between 1874 and 1881.

Etching matched the aesthetics and poetics of an emergent modernism deeply entangled in the social experience of the city, public and private. It was, as Baudelaire wrote, "so subtle and superb, so naive and profound, so gay and severe, a technique which can paradoxically accommodate the most varied qualities and which is so admirably expressive of the personal character of the artist." Cassatt, who thought plastically in color, and worked with masses rather than line, rose to the challenge of black and white as another means to explore the poetics of the intimate social rituals and spaces of modernity. Her earliest experiments in the graphic arts were undertaken in close collaboration with Degas in his studio where he

experimented with new and unconventional combinations of procedures, softground, and aquatint, as well as etching. Over ninety impressions of Cassatt's prints from this period were found in his studio after his death, attesting to printmaking as the medium and the late 1870s as the moment of the most intense artistic conversations between these two artists. To appreciate Cassatt's contribution to modernist printmaking, a few technical details are required.

The principles of etching involve marking a copper plate and biting the markings into the plate with acid so that they carry ink in the printing process to produce a (reversed) image. In hardground etching a plate is covered with a hard, acid-proof coating into which a steel or diamond tool scratches the intended design, exposing the metal surface. Immersed in a bath of acid, these exposed areas are bitten away, lightness or darkness depending on how long the plate is left in the acid bath. Drypoint etching does not use immersion in acid, for the artist draws directly on to the copper plate with a needle, which throws up tiny furrows, known as burr, along the edges of the lines. The burr holds additional ink and thus creates a feathered-out, furry appearance to the printed image. In softground etching the plate is covered with a ground of hardground mixed with grease or tallow, melted slightly to cover the plate. The artist draws on paper placed over this sticky ground, and, where the pencil makes an impression through the paper, the ground will pull away from the plate, exposing the design for the acid. Aquatint works with tone rather than line, because aquatint is a ground applied to the plate made up of tiny particles of powdered resin, dusted, sifted or poured in a suspension of alcohol, leaving a porous surface. Areas that are to remain white are stopped out with resin. On immersion, the acid eats into the copper around each of the resin particles. Degas encouraged Cassatt to combine different processes in "the cuisine method."

Derived from the painting *Woman with a Pearl Necklace in a Loge* (1879), 99
In the Opera Box (c. 1880) combined softground, aquatint and etching. In 136
the final state, the linear shading of the first draft was overlaid by soft-ground to create considerable textural variation. The boldness of Cassatt's formal imagination is revealed by this translation into black and white of a painting showing the scintillating effects of gas illumination on powdered skin and the intense contrasts of deep red plush, pink satin, and blond hair. It was probably as much a revelation to her as it is to us. The print creates a taut compositional structure, playing off the tension between the slightly leaning, upright, seated figure; the bold semi-circular curves of the reflected balconies; and the flattening frontality of the opened and curving fan held in the bend of the woman's angular left arm.

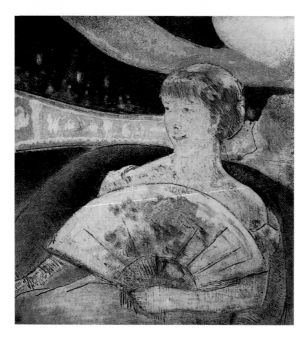

136 CASSATT
*In the Opera Box
No. 3, c.* 1880

137 CASSATT
The Map, 3rd state,
1889–90

135
84, 118
With its intimate interior setting and almost Jamesian scene of social interaction, *The Visitor* echoes the theme of *Five O'Clock Tea*, shown at the 1880 exhibition, and demonstrates Cassatt's confident experimentation with various print processes. The early states of the print are predominantly linear with diagonal hatching, while the final state incorporates a bold use of aquatint graininess and softground patterning. The variety of surface textures recreates the density of an interior space into which light breaks from the luminous area in the background, utterly reversing the traditional use of chiaroscuro which favored dark depths and luminous highlights.

After the period 1879–82, printmaking, like much else of her artistic practice, was constantly interrupted: by mourning for her sister Lydia, by the search for new homes, and by traveling with her ailing parents for their health. It was not until the end of the 1880s that Cassatt returned to printmaking, inspired by a renewed initiative among her colleagues that led to the founding in 1881 of a new exhibition society and a major exhibition at Durand-Ruel's gallery in January 1889 of La Société de Peintres-Graveurs (the Society of Painter-Engravers).

Cassatt had by then become interested in the most demanding of all etching processes, drypoint, in whose possibilities Marcellin Desboutin (1823–1902) was her new mentor. A severe economy characterizes her

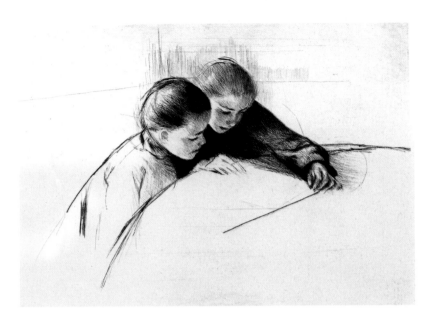

drypoints such as *The Map* (1889–90) and *Baby's Back* (1889–90). Freed from having to furnish the setting and supplementary details that a painting would demand, the artist focuses on the central motif, which is treated as a study of lines and voids, darks and lights, marked and blank paper. Drypoint allowed Cassatt to build up dense areas that inking would render velvety black. While the practice confirmed the formal and architectonic quality of Cassatt's compositions, the affecting character of the social situation is even more economically revealed.

In *Baby's Back* we see a woman holding a naked baby. Her face is 138 radically cut in half by the profile of the young child she holds who, however, looks directly across her eyeline, while the woman's arm bisects the child's legs which disappear into her barely indicated dress. This etching relates to a pastel of 1889, *At the Window*. At the Painter- 139 Engravers' exhibition of 1889 at Durand-Ruel, Cassatt exhibited a trio of images using different media: a pastel, a drypoint, and an etching, suggesting that she was exploring the related possibilities of these "drawing" media. Etching abjured all color, while pastel allowed the artist to *draw* with color, both forcing into view a more synthetic approach to her art: a distillation of subject joined to an economy of technique to produce a tough and demanding art work. Perhaps conversations with Degas had drawn Cassatt to an appreciation of drawing—in the traditional sense of

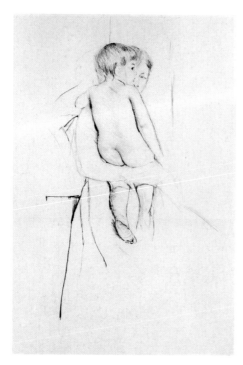

138 CASSATT *Baby's Back*,
3rd state, 1890

disegno—with which she had formerly had little sympathy. For Degas, drawing was not a means of recording what he saw; it was a means of *thinking*—a modernist thinking through the always disjunctive relationship between the world as we perceive it and its distillation into artistic representation. As Alfred de Lostalot commented in 1893: "Mary Cassatt learned from M. Degas the art of emphasizing the drawing, underscoring it in the right places, and ignoring everything that could dilute the effect and weaken the expression of the artist's plastic thought."

Cassatt perceived Degas as an artist of the museum. But he frequented rooms which she, the student of the painterly colorists Velázquez, Correggio, and Rubens, had not visited. Degas was the great admirer of Ingres (1780–1867), the passionately intellectual painter of a glacial eroticism. Degas introduced into the complex melting pot of early Parisian modernism the uncanny modernity of Ingres's unnatural drawing and defamiliarizing formalism. This discipline finally banished Cassatt's residual Romanticism that had surfaced in the 1860s and had been displaced in the late 1870s by the acute observation of immediate social situations and exchanges inspired by Manet's bold engagement with the awkwardness of modern urban life.

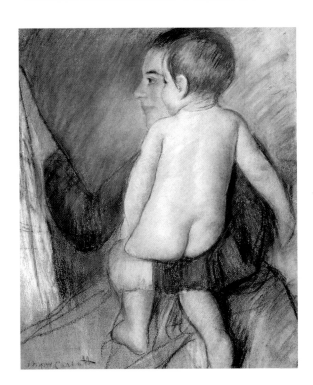

139 CASSATT
At the Window 1889

WOMEN AND CHILDREN

Cassatt's discovery of graphic media alone allowed her to engage with so heavily freighted a subject as women and children in a way that would allow it to become a long-term theme for formal research and compositional experimentation. Degas argued that an artist should take years to work out any one topic: "It is essential to do the same subject over again, ten times, a hundred times. Nothing in art must seem to be chance, not even movement." He thus encouraged both Cassatt and himself to focus on one subject, so rich in intellectual, social, and personal possibilities that an artist could concentrate for many years on the apparently formal problems the subject posed, knowing that the resulting work would never be empty. The subject would have to have a significant relation to modernity to sustain repeated investigation. The relations between women and children were for Cassatt what the dancer became for the late Degas: a means to think artistically.

Yet its thematic freight was clearly of a different order. What constantly distinguished Cassatt's work from Degas's was her focus on the psychological, enacted in every exchange between human subjects. As a new

territory typical of modernity, this subject of adult-child interaction would come into its own when Freud began to theorize the meanings and effects of the mundane intimacies of childhood in the formation of subjectivity in the bourgeois family.

From the painterly representations of the social spaces of modern femininity in the 1876–86 period, Cassatt moved in the 1890s on to a series of formal experiments and investigations of the child/adult relation, freeing it from the blight of being not too familiar, but too idealized, too iconic, and increasingly so sentimentalized that the very association with the subject at all later threatened to submerge everything else about Cassatt's complex artistic history and intensely intellectual preoccupations with art-making.

The child/adult couple appears in some paintings and pastels of the early 1880s, one of the most impressive being in fact the portrait of *Alexander Cassatt and His Son* (1884), where masculinity and its generations are the topic. An early pastel study for the child sprawling sleepily on its attendant's knee reveals Cassatt's growing interest in the nineteenth-century revival of pastel. Inspired by eighteenth-century Italian and French pastellists, both French and American artists of the late nineteenth century found new aesthetic possibilities in this medium. While Whistler used it to great effect in shorthand notations of cityscapes, Cassatt would share with Degas an experimental expansion of the possibilities of pastel to capture distinctive modern figures. Pastel could be used to build up forms by a dense weave of drawn, colored strokes; it could also be scraped into a powder, mixed with size or fixative and applied as a paste with brush or knife. Some of Cassatt's pastels of the mid 1890s exhibit this smooth, gouache-like quality, that alternates with an almost impasted build up of pastel-paste, given further texture by a stiff brush. Steaming further aids its malleability while incomplete mixing of pastel dust and size leaves a granular texture. In all of these procedures, however, the energy of the handling gives a strongly tactile effect to the bodies and faces in the finished work, while making pictorial space dense with vibrant color.

Cassatt's sustained investigation of the theme of women and children coincided with her renewed experiments with graphic media. The "robustness" of her media enabled the intensity of the subject matter to be explored in a thoroughly modern, formally self-conscious and intellectually impassioned manner. Writing in 1916, Frank Weitenkampf declared:

> Her work is entirely lacking in the smirking sentimentality so often connected with this subject.... Miss Cassatt tells no story in the sense that she is the dispenser of illustrated anecdote. She draws for us, in

140 CASSATT
*Alexander Cassatt and
his Son* 1884

dozens of *nuances*, women and babies just as she sees them. Not only
"just as *she* sees them," that is, with an implied absence of prettifying
touches and alluring frills, but also "just as she sees them," that is going
below the surface. Simple in effect, subtle in import. Subtle in percep-
tion, not with the subtlety of hyper-preciosity, of a painful seeking for
something apart.... I should even hesitate to attribute to her volitional
psychological analysis of her models. All the better, we get the thing
without the accompaniment of irritating intention. Suppose we
assume that our artist was concerned only with the depiction of what
was before her. Then we still have the difference between a soulless
setting down of obvious facts and the deepseeing sympathetic setting
forth of souls within bodies....

Commenting on the "suite of twelve" drypoints exhibited in 1890, which 10, 137,
included several studies of women and children, Weitenkampf concluded: 138
"It is an open question whether, in her own special sphere, she has ever
been surpassed."

After two years of exhibiting with the Painter-Engravers, Cassatt and
Camille Pissarro were unexpectedly excluded from the 1891 group show,

141 KITAGAWA UTAMARO *Midnight, the Hour of the Rat: Mother and Sleepy Child* from *Customs of Women in Twelve Hours* series, *c.* 1795

because they were not French-born. It was a blow because Cassatt had been developing a whole new suite of *colored* prints for the 1891 season. These were, none the less, shown at her solo exhibition at Durand-Ruel in April 1891 that so enthused Pissarro (see this chapter's epigraph). Cassatt's turn to color in her graphic work was inspired by a vast exhibition at the Beaux Arts in Paris in April 1890 of 725 Ukiyo-e Japanese woodcut prints, albums, and illustrated books by Utamaro, Hiroshige, and many others. The discovery of the popular Japanese art form by French artists and collectors had begun in the 1860s. Japanese prints offered a corresponding reflection of the social and sexual mores of an emerging urban bourgeois class fascinated with its own performances of leisure and pleasure, and with the performers—dancers, actors, and courtesans—who created the spectacle of their own modernity in public and private rituals. Correspondences of theme between the eighteenth and early nineteenth-century Japanese artists and Parisian modernists extended to a shared search for novel technical and adroit formal means to create what Japanese culture called "The Floating World," a phrase that recalls Marx's own analysis of Western capitalism and its world of commodities as a world in which "all that is solid melts into air."

On 15 April 1890, Cassatt wrote to her friend and artistic colleague Berthe Morisot about the show at the Beaux Arts:

Seriously, you must not miss that. You who want to make color prints you couldn't dream of anything more beautiful. I dream of it and don't

think of anything else but color on copper. Fantin [1836–1904] was there the 1st day I went and was in ecstasy. I saw Tissot [1836–1902] there who also is occupied with the problem of making color prints.... You *must* see the Japanese—*come as soon as you can.*

Cassatt knew of Japanese prints long before this major exhibition as she herself collected prints, porcelains, and decorative fans from Japan, being especially interested in the work of Utamaro. The exhibition, however, revealed in sheer quantity and quality of the impact of their intense color, tough and simplified line, and "other" ways of treating familiar Impressionist themes, like mothers and children, women at their toilette, visits and tea-drinking. What must have enthralled Cassatt was the possibility of reintroducing her passion for color and and a densely worked surface into her new-found interest in the simplified line and the reduced setting.

THE 1891 COLOR PRINTS: THE MAID

The 1891 suite of ten color prints offers a summary of Mary Cassatt's Impressionist period realized anew by experimental graphic techniques that she developed in 1890–91. *The Lamp* and *Afternoon Tea Party* resume 146, 147 the material of her first exhibitions with the Independents, showing social rituals of the haute-bourgeoise lady, in afternoon dress and bonnet or evening glamour. *The Letter* and *The Fitting* return to the woman privately 150, 151 absorbed in intellectual reflection or fashionable self-absorption in stylish presentation. Two prints deal with *la toilette* carried out by the working women of the bourgeois household: the striped *peignoir* of *Woman Bathing* 156 also appears on the nursemaid in the contemporaneous painting *The* 169 *Bath* (1891–92), and the washstand reoccurs from *Girl Arranging Her Hair* 8, 131 (1886). Three of the prints indicate a soon to be substantial artistic investment in the scenes of domestic work and social interaction associated with childcare. *In the Omnibus*, however, takes the viewer into the public 145 spaces of the modern city with a bourgeois woman, an overdressed bourgeois child, and its nursemaid.

As a subject, *In the Omnibus* recalls English genre painting, for instance William Maw Egley's *Omnibus Life in London* (1859). Cassatt's American compatriot in Paris, Henry Bacon also treated the theme at the Salon of 1889, and Nancy Mowll Mathews discovered a print from the Salon Illustré of 1887, *A Corner of the Omnibus* by Madame J. Delance-Feugard. The omnibus was the site of much artistic interest in the nineteenth century. Like the balcony and the theatre, it represented a hybrid space of seeing and being seen—a public space where people of several classes and

142 CHILDE HASSAM *At the Florist* 1889

143 EDOUARD MANET
Olympia 1863–65 (detail)

both sexes are thrown into confusing proximity and socially unregulated situations.

In a preliminary drawing for her plate, *In the Omnibus*, Cassatt seems to have been planning a genre scene about popular travel. The bourgeois lady, her child and the nanny are seated beside a top-hatted gentleman with cane; the outline of an elegant, standing woman's figure is just visible. The seated lady looks in the opposite direction from the gentleman, creating a compositional and psychological tension in their awkward public proximity. The gentleman and the standing lady were soon excised. The print focuses on three figures—the child could be a boy given the undifferentiated apparel of boys and girls at that age at that time. The nursemaid holds the child and seems to look towards it. Her dress, reminiscent of the outsized garment worn by the maid in Manet's *Olympia* (1863) provokes a formal comparison with Manet's painting. Cassatt's child in its frothy costume, set between two women, occupies the place of the bouquet in Manet's work. The maid and mistress also occurs in *At the Florist* (1889) by the American painter Childe Hassam. His more anecdotal genre treatment of the lady accompanied by her working-class maid on errands in the modern city underlines the aesthetic and ideological distillation of Cassatt's print from its preliminary drawing of a possible genre scene through several states to the final composition.

The maid and the child are connected by position and interlocking gestures. The lady may be the mother, but she and the child are not engaged

in any interaction. They both face in the same direction and there is more than a hint of family resemblance in their aligned profiles. Against the backdrop of the Paris of the Seine and its bridges, Cassatt has staged, with all the cryptic economy of the drypoint etched line and aquatint, a tiny incident of class. Cassatt's print is not an interior scene, but even outside the home, women occupied the spaces of the bourgeois family, which, of course, was always permeated by "an outside" in the person of servants. At the time promoters of the ideology of maternity in both France and the United States tried to naturalize the sexual division of labor, fixing the meanings of woman's gender to the maternal role in the family. The expanding iconography of *maternité* was widespread both in paintings at the Salons and among the Independents. Renoir led the way among Cassatt's associates with his grandiose images of nursing mothers and fleshy infants, while many women painters, such as Elizabeth Nourse or Virginie Demont-Breton, embraced the call for *l'art féminin*—whose key icon was the mother and child among the peasantry, the fisherwomen or the bourgeoisie. By contrast, Cassatt's print is social in character,

144 CASSATT Study for
In The Omnibus 1890–91

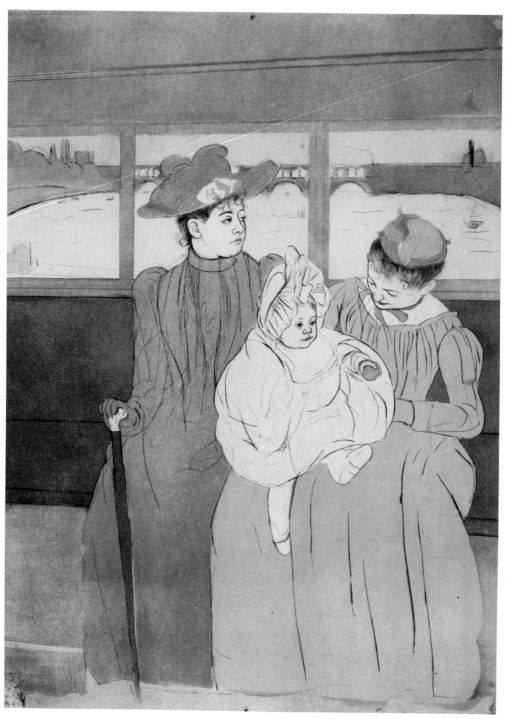

145 CASSATT *In The Omnibus*, 7th state, 1890–91

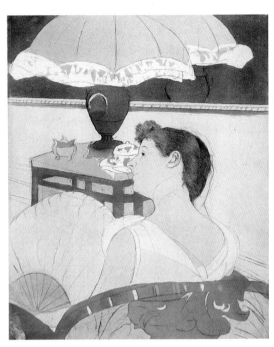

146 CASSATT *The Lamp*,
4th state, 1890–91

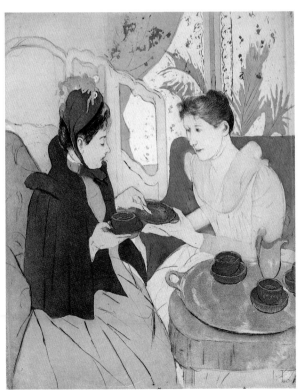

147 CASSATT *Afternoon Tea Party*,
5th state, 1890–91

psychological in its attention to the contingencies of social and personal relationships created not by nature but by *work* and money relations. Rather than presenting the mother and child as a state of being reflecting Woman's Nature, Cassatt's work discerns relationships between women and class caught up in sometimes intense and often uneasy negotiations. Social relations and difference are the core of this image. By means of the inventive etching techniques that Cassatt was investigating in 1891 the artist concentrates on the unexpectedly rich possibilities of this simple juxtaposition of modern, classed femininities in public space.

150 By contrast *The Letter* focuses on socially private and psychologically interior space, which calls to mind a painter not formerly acknowledged as one of the sources for Cassatt's distilled formality: Vermeer's *Lady Writing a Letter with Her Maid* (c. 1670). Set in the private domain, *The Letter*, none the less, implies a world beyond, that is represented in Vermeer's painting by the maid, the go-between, who looks out of the window into the social space that a working woman may traverse on behalf of her bourgeois employer. Servants function as liminal figures in nineteenth-century literature. In *Pot Bouille* (1882) Zola set up a cynical contrast between the bourgeois façade of respectability and its dirty underside, known to the servants who gossip in the darkened spaces of the well at the back of the fashionable apartments. This constructs the working class in the mold of the bourgeoisie's fantasied and abjected alter ego, its lower body as it were. In the Vermeer no such crude sexuality is implied. The maid as social Other comes to stand metaphorically for a

148 The Mary Cassatt Room in the Exhibition of Paintings and Drawings by Representative Modern Masters, Pennsylvania Academy of Fine Arts, 7 April–9 May, 1920

149 JAN VERMEER *Lady Writing a Letter with her Maid c.* 1670

knowledge of female sexuality that is at once denied to bourgeois women, yet passed between women across the boundaries of class.

In *The Fitting*, Cassatt studies another encounter between women of 151 different classes. The young bourgeoise turns towards the dressmaker kneeling to attend to her hem. We see both her profiles as she reflects upon herself in a selfconsciously elegant pose for the mirror. Her body is being dressed for its display; it is schooled in the choreography of bourgeois femininity. The radical moment of Cassatt's print is the crouching working woman, the dressmaker. Her pose conveys the concentration of her skillful work without exposing her face. Contrast Degas's milliners who were represented with his class and gender prejudices written upon faces he willfully caricatured. In Cassatt's print, the social relations of class became the opportunity for figuring the working women as a subject, rather than, as in masculine fantasy, an almost animal body on the margins of humanity and bestiality. Cassatt's use of *profil perdu* grants to the working women the dignity of her own working consciousness, which excludes the viewer.

Woman Bathing is one of two occasions—the other is the print *The* 156 *Coiffure*—on which Cassatt grappled with the subject of the partially 154 unclothed adult woman, first tackled in *Girl Arranging her Hair* (1886), 8, 131 which had been a riposte to Degas's caustic remarks about women artists' lack of style: the entire print series confirms her desire to confound this view. The body was historically the territory of the most ambitious and valued domain of artistic practice. Yet cultural prohibitions

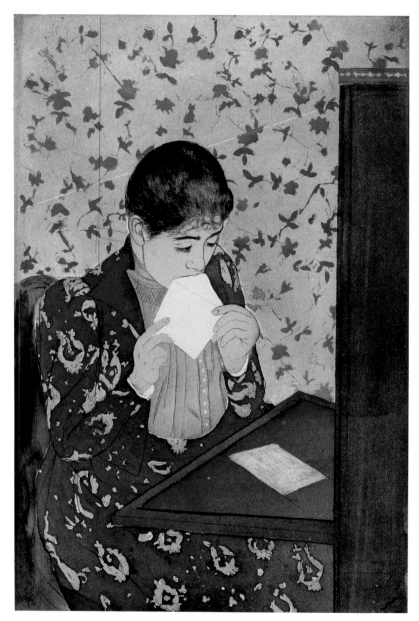

150 CASSATT *The Letter*, 4th state, 1890–91

151 CASSATT *The Fitting*, 7th state, 1890–91

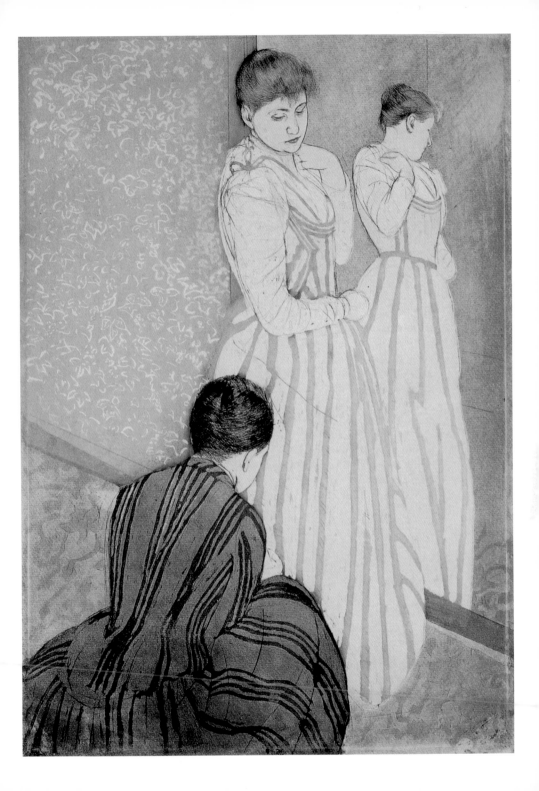

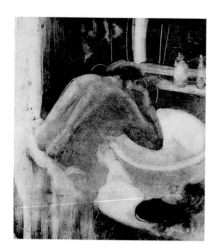

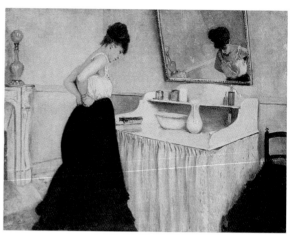

152 EDGAR DEGAS *The Washbasin*
1879–83

153 GUSTAVE CAILLEBOTTE *Woman at a Dressing Table*
c. 1873

and ideological reticence still inhibited women artists' untrammeled access to the nude. Degas had studied the private rituals of hygiene in both the notorious pastel suite of bathers exhibited in 1886, and in monotypes, like *The Washbasin* (1879–83), all of which involve the viewer in a fiction of clandestine, almost voyeuristic viewing. Gustave Caillebotte's *Woman at a Dressing Table, c.* 1873, anticipates similar scenes in Manet's work that either introduce an implied erotic narrative of undressing and revelation, or feed the masculine fantasy of discovered feminine self-absorption and reverie. Cassatt's frank reconstruction of a servant's bedroom seems very different in intention, effect, and the position offered to the viewer.

The space represented is not the eroticized space of masculinity in the city, the house that is not a home, in Linda Nochlin's phrase: a brothel. Nor is it the Turkish Bath where, according to Heather Dawkins, Degas paid to spy on women taking a bath. It is the studio mock up of the attic of the bourgeois house. In such a setting a working woman's body could be represented by a bourgeois woman artist. This body is not offered for sexual observation, despite the fact that the display of any female body cannot ever defend itself against those wishing to use it thus. Here the "Japanization" of the figure evokes the rhetoric of eroticism embedded in another culture's aesthetic forms, while stifling the corresponding erotic charge associated with Degas's debased prostitutes and a voyeuristic masculine sexuality.

Cassatt, the ardent admirer of Courbet's painting of female breasts, could never have *painted* a naked female torso; Courbet's art was the language of a heterosexual man. At that date art provided no comparably public rhetoric

176

for female sexualities. But in the clearly flagged artifice of the colored print, and by so obviously evoking the stylized elegance of her Japanese prototypes, Cassatt could engage with a politics of the female body in which this transaction between two women, artist and model, of different classes takes place.

As an ambitious member of this self-selecting artistic fraction, Cassatt would have had to take on the implications of Manet's defining modernist nude, *Olympia*, in which the modern female body was redefined as a sign of class and the site of money relations. But the way Cassatt could relate to the image of a working-class woman's nakedness would be ambivalent not only because of shared gender, but also because of the rigorous strictures that prevented women of the bourgeoisie having visual access to and knowledge of their own bodies. (In Catholic countries middle-class women were obliged to wear a shift when taking a bath). Typically, the bourgeois woman's body is *dressed* for its purposes; its femininity is the masquerade, as in *The Fitting*. The image of the working woman at her mundane toilette provided access for a bourgeois lady to a femininity beyond bourgeois censorship on middle-class women's experience of their own corporeality.

THE LOST MOTHER AND HER JOUISSANCE

The special character of Cassatt's color prints lies in her technical innovations within the rigorous discipline of etching that create a tight, formal dignity for many of the bodies in these images, dressed and unclothed. But then, as we turn to the prints of her relatively new subject matter, the woman and child in some intimate moment of work or play, a sudden release of almost palpable *jouissance* infuses the work. In *Mother's Kiss* there 157 is a joyous nakedness at the centre of the plate as the seemingly boneless flesh of the young infant straddles the mother's arms while she swoops the child up to her face to kiss it. Children enjoy the swift strong movement of such play. Mothers love to bury their faces in exquisitely soft, sweet-smelling infant flesh. The intensity of physical pleasure in this unlimited intimacy with another's body is almost shocking, reviving in the adult long-repressed sensations of her own infant pleasure in the maternal body. This print offers an image of passion reawakened in the mother and her recovered memories from childhood. The positions of the two heads are those of lovers about to kiss. The woman's eyes are closed as are those in the other print in the series, *Maternal Caress*. Here the mother hugs the 158 naked baby to her with an intensity that is almost painful. Its little face, by contrast, registers only joyous delight in being there.

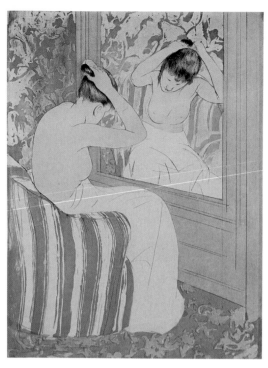

154 CASSATT *The Coiffure*,
5th state, 1890–91

155 CASSATT *The Bath*,
17th state, 1890–91

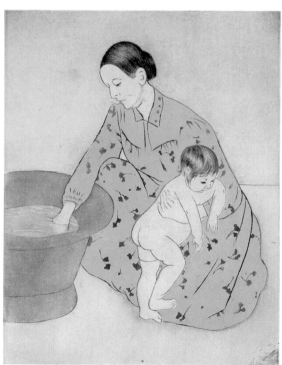

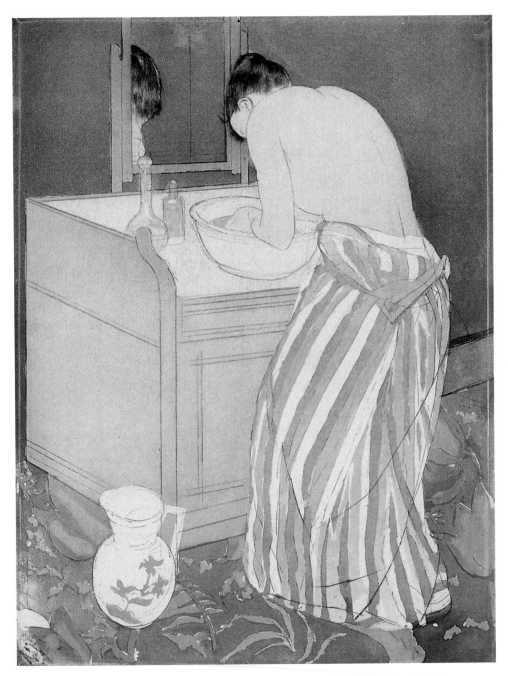

156 CASSATT *Woman Bathing*, 4th state, 1890–91

In her study (1989) of "the semiotics of the maternal metaphor" in nineteenth-century American literature and art, Jane Silverman van Buren reads Cassatt's work in the light of modern psychoanalytical theories of infant-caretaker relations in which good mothering equals happy, well-adjusted child. The French psychoanalyst Jacques Lacan (1901–81) rejected such views, seeing a far more tragic drama of irreparable loss and separation in the formation of human subjectivity and desire. Both mother and child, he argued, experience a pleasure so intense and unnameable it is almost akin to suffering. His term for this is *jouissance*, a sense of intensity the child imagines it once enjoyed, but from which it is forever separated by language and the law of culture. Much of our psychic organization aims to recover this apparently remembered pleasure. This lack produces "desire," an impossible search for some moment of total unity that is lost, a search that is doomed to failure, one that propels our being after we learn to speak, a process that severs us from the non-verbalized bodily sensations of earliest infancy. There is a gap between the experience we "imagine" we originally had, "remembered" as a fusion with the "mother," and the search to recover a lost proximity. In this psychic gap, experienced as something missing, there is, however, a commemorative, ineradicable trace of loss itself that makes us invest emotionally and psychologically in what was once part of this intimacy with the "mother": the voice, the touch and the gaze which once functioned as an enveloping, life-sustaining embrace.

At the cultural highpoint of European Christianity in the fifteenth and sixteenth centuries, the widespread image of the mother and the boy-child rehearsed both that sense of loss and the effort to recreate imaginatively, through repeated images, a recovery of the mother's monumental body. Such images, read psychoanalytically for the fantasies that underpin their religious iconography are not representations of a real, social relationship. Devotional images of Mother and Child are the pictorial realization of a fantasy about lost feelings, memories of an archaic space. In the nineteenth century, the ideological function of images of mothers with babies confused this important distinction. Images that supported a psychic fantasy appeared only to reflect the social roles of women in the real, sexual division of labor in society.

For the boy-child the Mother is both a desired place and an overwhelming presence from which he must escape so that he can find his way to a subjectivity in the world of language. Hence the role of the symbolic Father, who represents the Law and Society. For the boy, his passage through the Oedipus Complex is facilitated by his mistaking his physical similarity to his male parent for a sign of his identification with the Law that says he cannot be the partner of his mother who is already claimed by

the Father. By means of the Oedipus Complex, the boy can sever himself from the Mother, identify with the Father, and, using this gap, find himself as an empowered speaking being in society and language. The residue of this moment is a passionate fantasy about what has been lost. In art this fantasy persists in two forms: idealized images of the Mother, or aggressively punished, debased sexualized images of her antithesis, in modern times, the prostitute. From Manet to Picasso, we can see how these twin faces of masculine fantasy haunted the new art of modernism. Cassatt's work intervenes in this cultural and psychological field, realigning some of its meanings through her position as a feminine subject.

The feminine subject has a different relation to the lost Mother since the fantasy can be relived in becoming a/the mother. The Mother also functions symbolically for her daughters as a desired Other, and a figure of power rivalry who can be creatively used in cultural forms. Artists and writers of the later nineteenth century—the New Women, the daughters of women who educated them, and encouraged them in outgoing social activity—explored this possibility of drawing upon the creative aspects of the Mother without merely falling into a regressive nostalgia for fusion with her by a feminine idealization of the image of Mother and Child.

Cassatt's paintings and prints were produced at a moment of semiotic renovation—we call it the avant-garde—of European visual tradition in which the Madonna and Child and her secularized descendants had been so important an iconography. Masculine modernism was predominantly a radical displacement of the trope of Virgin and Son as a whole, reflected in the widespread interest in prostitutional images by rebel son-artists from Degas to Toulouse-Lautrec and later, Picasso and de Kooning. Cassatt, with Morisot, herself a mother, forced a covenant between the new art and what Kaja Silverman in *The Acoustic Mirror* (1989) named the necessary "representational support" for feminine desire. Framed both by unconscious desire for the lost Mother *and* a creative rivalry with her, their art explored a specifically feminine fantasy of loss and maternal *jouissance*. It is important to note that late nineteenth-century feminists embraced and valued a discourse on the mother. Through the values and lessons of motherhood lay women's specific role in social improvement. Many women artists devoted their ingenuity and creative inventiveness to the theme of working-class mothers subject to terrible oppressions and deprivations, while others used the maternal image to represent feminine pathos, tragedy, anger, as well as the contemplation of pleasure or access to a sexualized *jouissance*.

That is what appears on the face of the mother-figure in *The Maternal* 158
Caress, an exquisite moment of bliss experienced through the child,

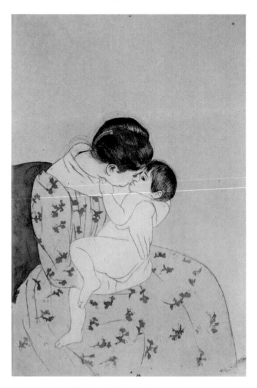

157 CASSATT *Mother's Kiss*, 5th state, 1890–91

whom she can also imagine to be herself. In the transitivity of psychic processes we can be both doer and done-to, active and passive, giver and receiver. As viewers of an image we can move between the positions offered through the both depicted figures in the relationship. By precise observation of gesture and expression, through which our repressed desires speak themselves by bodily signs rather than words, a figurative artist can invent an image through which to glimpse lost *jouissance*.

In 1893 Cassatt made two new color prints *The Banjo Lesson* and *Gathering Fruit*. Both were related to the 1893 mural, *Modern Woman*. Two more were produced in 1894–95 for her Durand-Ruel retrospective in New York: *Feeding the Ducks* and *Peasant Mother and Child*. Throughout the later 1890s up to 1904, a small quantity of new color prints and drypoints continued her technical experiments in an atmosphere of great critical interest in the graphic art of the avant-garde.

In the 1890s, through the possibilities of line and color in print-making, sustained by accompanying investigations of a textured space of

31

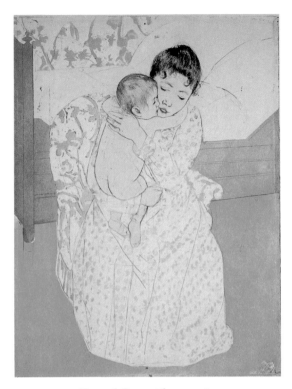

158 CASSATT *Maternal Caress*, 6th state, 1890–91

bodies and places in her pastels, a new formality combined with a new
intensity in Cassatt's work. The images of the relations between women
and children, staged in the mundane routines of the work of childcare
and education, between nursemaids, working-class women and their
own or other's children, link back to her commentary on the social spaces
of femininity and childrearing, while tracing deeper fantasies and desires
for which the "new" discourse of psychoanalysis would soon provide
a theoretical, explanatory vocabulary. In an engagement with graphic
media, the most demanding of artistic modernisms traversed the terri-
tories of the most controversial of psychological modernisms. Cassatt's
work opened up to fantasy and desire, and a displaced allusion to sexuality
the more it was structured in the intellectual rigors of its inventive
experiments with aquatint, drypoint, and pastel. It is in this conjunc-
tion of media that Cassatt's contribution to femininity and the spaces,
mentalities, and psychic fantasies of women of modernity may once again
be deciphered.

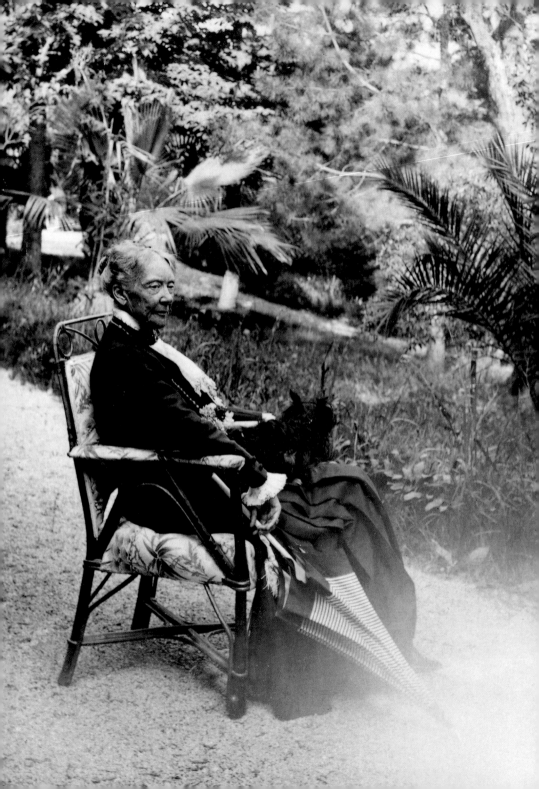

The Child of Modernity 1895–1915

With almost no exceptions...she painted only one subject: children, and the role she gave in the majority of the canvases to the mother of the baby was ordinarily a secondary role in order to define the emotional intention and to emphasize by means of dark or light touches of costume or by means of the justness of her movement the general, overall harmony.

Achille Segard, *Mary Cassatt,*
Un peintre des enfants and des mères, Paris, 1913

In 1881, Joris-Karl Huysmans wrote an enthusiastic review of Cassatt's contributions to the sixth Independent exhibition.

Oh, my Lord! those babies! How those portraits have made my flesh crawl, time and again!—A whole passel of English and French smearers has painted them in such stupid, pretentious poses! The moderns were still battening on the foolishness of dead painters.... For the first time, thanks to Mlle. Cassatt, I have seen effigies of enchanting tots, calm bourgeois scenes, painted with an utterly charming sort of delicate tenderness.

Such approval seems undone by his next sentence: "Besides, it must be repeated, only a woman is qualified to paint childhood." His sentiment appears to confirm the Irish writer on Impressionism, George Moore: "I have heard that some women hold that their mission of their sex extends beyond the boudoir and the nursery. It is certainly not within my province to discuss so important a question, but I think it is clear that all that is best in woman's art is done within the limits I have mentioned." (1893)

Cassatt's works—Huysmans is referring to the painting of her mother reading to the grandchildren and a "mother kissing her baby on the cheeks"—are "family life painted with distinction, with love." These are significant terms, which echo across the subsequent critical approbation heaped upon Cassatt's representation of children. In 1902, Camille Mauclair, the Symbolist writer called her a "Painter of Childhood," stating: "To paint an adult is to record a state of mind; to paint a child is to record the foreshadowing of a soul." After a lengthy explanation of this claim he concluded:

95, 128
125, 165

185

159 Mary Cassatt at Villa Angelotto, Grasse, 1913

Cassatt may be the only painter today to have given us an interpretation of childhood that is contained within the child itself. Faced with a being in process, she has not been anxious to divine its maturity. She stops her calm, sure contemplation at the very minute in which the creature she is studying appears before her…and that is all she needs to create a psychology that is new, fascinating and powerfully inspired by nature.

Writing in 1910, André Mellerio concurred:

She has captured the instinctual gestures of a life at its lisping beginning, opening its naive, astonished pupils to the light. Glimmers of intelligence, harbingers of the future, appear in those brilliantly shining eyes.…Already a being of a higher order is breaking through its purely animal grace, innocent shamelessness, and unreasoned movements.

This conjunction of a modern interest in psychological formation and the formal challenges of painting a child in order to distill its moments and find forms for its pictorial analysis developed slowly in the work of Cassatt and finally came to prevail as her subject only after the death of her mother in 1895.

IMAGES OF CHILDREN

During Cassatt's "Impressionist" years from 1877 to 1886, there are very few paintings or pastels of the subject that effectively became Cassatt's "signature" subject for the last two decades of her career. To *A Goodnight Hug* of 1880 we can attribute the situation that became *Mother's Kiss* and *Maternal Caress* in the series of color prints of 1891. The scene of generational transmission through reading from *Katherine Cassatt and her Grandchildren* (1880) repeats itself in the pastel *Nurse Reading to a Little Girl* (1895) and in the painting *Family Group Reading* (c. 1901).

Although Adelyn Breeskin identifies *Mother About to Wash her Sleepy Child* as having been exhibited in the fifth Impressionist exhibition in 1880, it does not correspond with any item listed in the catalogue or described by the critics. It seems strange that such a large and significant painting was not shown, since it was clearly done in the same setting and probably with the same models as appear in *A Goodnight Hug*. The painting was, however, shown in 1895 in New York at the galleries of Durand-Ruel, Cassatt's first substantial retrospective exhibition in the art capital of the United States, two years after she "arrived" with the mural of *Modern Woman*.

The 1895 exhibition received mixed responses from American critics, who appreciated the early, Impressionist treatments of child and adult, but

165

157, 158
95, 128
4

167

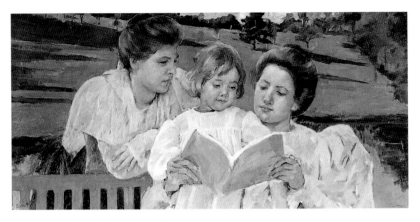

160 CASSATT *Family Group Reading c.* 1901

found the recent works of the early 1890s like *The Bath* (1891–92) "hard,
crude,...brutal...inharmonious...[and they] shock the eye." One com-
plained that "a rude strength, at times out of keeping with the subject, is
noticeable, and takes away in a measure from the charm of femininity."
Writing in *Scribner's Magazine,* William Walton discerned what he consid-
ered the real subject of these works: "The wonderful infinite motherly
yearning over the queer little unresponsive, responsive being of which she
knows so little. The mystery, real and fictitious, of these small, naked
infants counts for even more in the obsession of the painter than the
thorny technical problem of presenting their bodies—and she seems to
render it even more truly."

In the 1895 New York exhibition, the gradual development of Cassatt's
interest in this subject matter could be observed with historical hindsight.
It is critical to rely upon the evidence provided by exhibitions of her work
in order to track very carefully both the strategies of this artist's self-
presentation to the public and the public's perception of her work. The
retrospective would locate studies of women with young children within
a larger discourse on modern life, perceived through a modernist's distaste
for traditional beauties and easy subjects. This behoves us to stop before
these paintings. Rather than slipping them seamlessly into the stereotype
of "Mother and Child" or *maternité,* simply because a woman painted them,
we need to pose some questions. What are these paintings of? Mother-
hood or Childhood? Adult or Child? Family or Domestic Labor? Are they
psychological portraits? Whose position are we invited to adopt before
such paintings?

But even at this point, by discussing the work in such general terms, we are collapsing the critical distinctions between each work, or each related series, each artistic event or adventure, and losing sight of its making. Louise Havemeyer reports what Cassatt said about painting:

> I doubt if you know the effort to paint! The concentrations it requires to compose your picture, the difficulty of posing the models, of choosing the color scheme, of expressing the sentiment and telling your story! The trying and trying again and again, and oh, the failures, when you have to begin all over again! The long months spent in effort upon effort, making sketch after sketch.... After a time, you get keyed up and it "goes," you paint quickly and do more in a few weeks than in the preceding weary months. When I am *en train* nothing can stop me and it seems easy to paint, but I know very well it is the result of my previous efforts.

Cassatt was not a painter of the mother-and-child theme. She slowly came to find artistic and intellectual challenges in a variety of particular social situations. There can be no doubt that the actual scene of a mother washing her sleepy child, which gives rise to the specific character and meaning of the painting of 1880, will always evoke a deeper association that harks back to images that descend to us through archaeology from Neolithic times. The Mother and Child furthermore became a core image in the mediaeval and Renaissance period in the West as the visualization of the theology of Christianity, the Incarnation, which relied, as Leo Steinberg has suggested, on two key tropes: the exposed nakedness of the boy-child, and the gesture known as the "chin chuck." With the waning of Christianity's cultural hegemony, challenged by Enlightenment rationalism, this iconography underwent a radical translation. Its already heavily freighted imagery, stripped of its theological significance, lent its evocative power to the emergent ideology of the new bourgeoisies in which definitions, not of the nature of the divine made flesh, but of the nature of the human sexes, were to be determined by the function of reproduction. In the same ideological turn, Motherhood was invented, as was a new category, Childhood. The novel conception of Woman as synonymous with maternity, visualized through the trope of *maternité*— the mother breast-feeding the child, which Cassatt herself painted on several occasions—produced a paradox for the modernist. Any representation of a woman and a child could collapse into the trope, simply naturalizing the dominant ideology of Woman as Mother. Yet its very dominance made this situation, role and experience a viable and necessary subject for Realist re-examination in art—and for modernization.

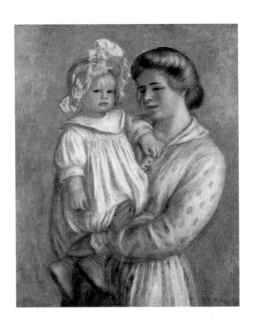

161 PIERRE-AUGUSTE RENOIR
Claude and Renée 1902–03

There is, therefore, nothing special about Cassatt painting women and children. It was so typical a subject that one can hardly find an artist in her group who did not contemplate his/her own familial situations or represent those of others. Few did it so consistently as Renoir. The culture these artists serviced raised both motherhood and childhood to a new kind of visibility. There was, as a consequence, a vast vocabulary on offer in both official and Independent art worlds ranging from the formal portrait of the well-heeled young to sentimental scenes of domestic tragedy or intimacy amongst the rural poor. We need to ask, therefore, what would make its treatment modern and what has it to do with New Women, so many of whom abjured domesticity and maternity?

Let us go back to the beginning. In 1878 Cassatt painted *The Nurse* (private collection, USA). Shown in New York in 1895, it is a rare outdoor scene, set in a park or garden, where a nurse knits while a baby sleeps in its pram and a toddler waters or picks the flowers. Experimental in its technique, the painting echoes Monet's similar scenes in the Parc Monceau. Such a composition was never tried again. In the 1881 painting, *Woman and Child Driving*, the artist's sister Lydia drives a buggy while a nervous but stoical child, Odile Fèvre, Degas's niece, sits beside her. There is no interaction, and the painting juxtaposes two moments of femininity: the still unformed girl-child and the mature woman competent in her journey through public space. The theme is generational and gives a naturalist form to the allegory of "ages of woman."

162

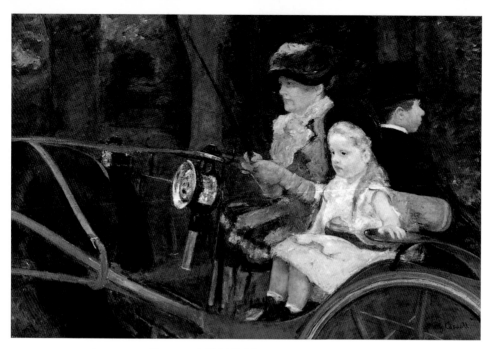

162 CASSATT *Woman and Child Driving* 1881

Between these completely different scenes that served entirely distinct artistic purposes, there are the intimate scenes of the young child's toilette and bedtime. The pastels of *A Goodnight Hug* and *Mother Feeding her Child* combine with *Mother About to Wash her Sleepy Child* in making the *interaction* between adult and child in the routines of childcare the momentary site for the representation of a psychological exchange. *A Goodnight Hug* is an extraordinary work, for both faces are obscured and the picture is carried entirely upon our recognition of the gesture's emotional intensity. Yet even here in an image of the kiss there is a critical displacement. On the one hand, the kiss is not an erotic exchange, but takes place between an adult woman and a child. Yet that domestic tenderness is represented with all the stark compositional simplicity of an adult embrace. Huysmans was right. Here is certainly no sentimentality, but, as the art historian, Harriet Scott Chessman has argued, a surprising encounter with a subliminal "female erotics." Take for instance the child about to be washed. A pastel study shows the artist exploring the child on its own. Its "sensuality" appears in the languorous pose, with open legs, head resting dreamily on its elbow while gazing, with drooping lids, at its caretaker, a pose associated with the Orientalist odalisque. In the painting, the child

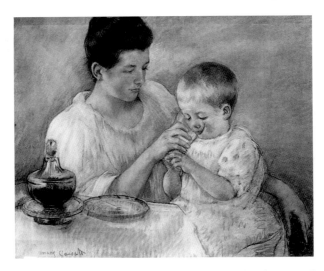

163 CASSATT
*Mother Feeding
her Child* 1898

is held within the woman's gaze and the relay between touching and looking—the psychological interaction that modern psychoanalytical theory recognizes in the pathway of the gaze—gives us the special character of Cassatt's painting. Rather than reducing scenes of childcare to merely modern-day settings for an emblematic icon of maternity, her work uses the space of domestic childcare to invent an image of the child as an emerging psychological entity.

This makes the child the subject of the painting; the maternal figure becomes a signifying element necessary to specify that child's psychological situation in the complex process of becoming a human subject, which takes places within the dynamic social situation of childcare that is both a workaday job and an emotional playground.

Cassatt does not produce modernist madonnas. No Madonna is shown working at her job: washing, bathing, feeding. There was an icon of the lactating Madonna whose body offered nourishment and that theme of the mythic maternal body was subsumed into nineteenth-century *maternité* paintings. But Cassatt shows adult women, often *employed* for these tasks, laboring with children, teaching them to read, or to feed themselves, as in the so-called pastel *Mother Feeding her Child* (1898) bought from the artist by her devoted collector James Stillman.

The child was a popular theme in late nineteenth-century painting and it can be instructive to use this subject to identify the convergences and the differences between two American artists, who as women, found themselves often compared and set up as rivals for the position as America's Leading Woman Artist. Cecilia Beaux was called by the New York painter of modern life, William Merritt Chase, not only "the greatest living

woman painter, but the best that has ever lived." Beaux also studied at the
Pennsylvania Academy of Fine Arts 1877–79, years during which Cassatt
exhibited at the Academy's annual shows. Between 1881 and 1883, Beaux
studied with William Sartain, father of Cassatt's companion in Parma,
Emily. *Les Derniers Jours d'Enfance* (*The Last Days of Childhood*) was begun
in 1883, a portrait of her sister Etta and her son. Exhibited at the American
Art Association in New York, it made Beaux's name when it also appeared
at the Paris Salon in 1887, the year in which she painted the portrait of a
young girl, *Fanny Travis Cochrane*. Beaux studied in Paris and traveled
throughout Europe from 1888 to 1899, the period during which Cassatt's
work was not much on public view in Paris. Also keenly interested in
Rembrandt and Velázquez, Beaux produced paintings which can be
compared with her older contemporary Cassatt, for instance *Ernesta and
her Nurse* (1894) and the brilliant "symphony in white," *New England
Woman* (1895). Beaux's circle included Margaret Lesley Bush-Brown
(1857–1944), Alice Barber Stephens (1858–1932), Susan Macdowell
Eakins (1851–1938) as well as Lilla Cabot Perry—a list of artists' names
which challenges the tendency to select only one woman as token artist
of her sex. These painters are a necessary frame within which to contemp-
late both the singularity of Cassatt's trajectory as an American in Paris,

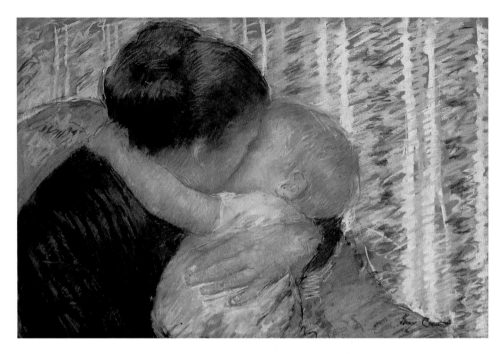

165 CASSATT *A Goodnight Hug* 1880

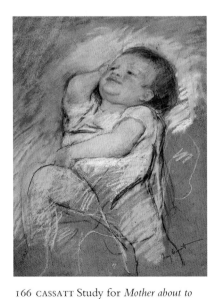

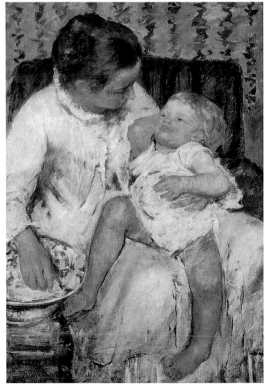

166 CASSATT Study for *Mother about to Wash her Sleepy Child* c. 1880

167 CASSATT *Mother about to Wash her Sleepy Child* c. 1880

and the coincidence of themes and issues amongst a group of artists whose formal or stylistic solutions drew on different resources to create diverse effects. The public and private moments of bourgeois femininity— coming out for social occasions, sewing or reading at home, conversing, growing up and growing old—all these topics can be found in the oeuvres of these women painters, who, like Cassatt, took note of the radical shifts in art made possible by Parisian modernism, mediated to them by Eakins, Sargent, Whistler, and of course, Cassatt.

 Les Derniers Jours d'Enfance is particularly interesting because the child sprawls on its mother's lap in the unexpectedly natural pose that Cassatt had dared to use in *Little Girl in a Blue Armchair* and again in *Mother About to Wash her Sleepy Child*. Beaux said that the core of her painting was the interlacing of hands at its centre—another correspondence with Cassatt for whom the gesture of hands was a fundamental signifying instrument. The sympathy between this painting and those of Cassatt was even more evident in later works, although Beaux's color schemes and, in particular, this painting's evident homage to Whistler and his portrait of his mother (exhibited in Philadelphia in 1881) puts Beaux's work in the frame of his emergent Symbolist aesthetic, through which lingering Romanticism found a still current form. What is so strikingly different from Cassatt's high-toned, energetically brushed Paris modernism, however, is Beaux's lack of the tight framing of figures in space, so characteristic of Cassatt's painting. It was not subject matter that distinguished Cassatt, but the formal and psychological effects of her radical suppression of pictorial space.

 Contrast Cassatt's *The Bath* of 1891–92, exhibited in Paris in 1893 and in New York in 1895, with a contemporary painting that appeared in the American section of the World's Columbian Exposition at Chicago in 1893 by Frederick A. Bridgman, *Fellahine and Child—The Bath, Cairo,* (*c.* 1892). Bridgman uses the Egyptian setting to sexualize the young mother and insinuate a playful association between popular Orientalist scenes of women bathing and this scene of exotic domestic intimacy. All such freight is banished by Cassatt's compositional rigor. Her painting focuses attention on the lightest area, the plump little girl's half-undressed body with its straight limbs, stocky legs, thick ankles, and square toes. At one end of the diagonal formed by her body, two heads incline toward each other in joint absorption with the task in hand, toward which their downward gaze directs the viewer's. The couple does not form an icon of unity, but indexes the social bond that, in the intimacy of trusting dependence, may engrave itself upon the fabric of the child's inner life.

 There was a considerable artistic challenge in painting the infant body, its fleshiness and singular anatomy, its characteristic gestures and non-

168 FREDERICK
BRIDGMAN *Fellahine
and Child—The Bath,
Cairo c.* 1892

adult poses, as artistically fascinating as the dancer's athleticism was to
Degas. During 1897 Cassatt worked with a child model, Anne, in oil and
pastel: *Anne Seated on the Grass with her Mother, Patty Cake* and *Breakfast in
Bed*. For all her blond curls, the child is not cute. Tracked down by diligent
artistic processing is the quality of childishness with its struggle to master
movements that adults execute with grace and ease, the unique propor-
tions and adjustment of the limbs of a childish body with tiny legs and
tensely upturned feet, ramrod-straight back, over-sized head and
exploratory hands. In *Breakfast in Bed*, the tight framing of the composi- 170
tion in its shallow space draws the viewer's attention across the patterns of
hands and the rhythm of the areas of painted flesh against the color-laden
whites of the bed-clothes. The reclining woman's curious gaze is a pictorial
echo of our own interest in the character of "the child," not the identity of
this child. In *Portrait of Olivia* (1911), a much later portrait by Lydia Emmett,
who also exhibited in the Woman's Building beneath Cassatt's mural, the
face is the luminous focus of the painting, creating an image of a childish
femininity that is at odds with Cassatt's studied revelation of the architec-
ture of the childish body and its resulting relation to the world, a topic
equally explored with a small but bulbous male body in *Baby Getting up
from his Nap* (c. 1899), and a series of paintings of a model named Jules. In
such later works, we can see what happens to the subject matter if any-
thing of the terse, tight compositional discipline slips and allows in
distracting associations. Degas unkindly complimented Cassatt for a *c.* 1899 172
painting of Jules, calling it the "Infant Jesus and his English Nurse."

195

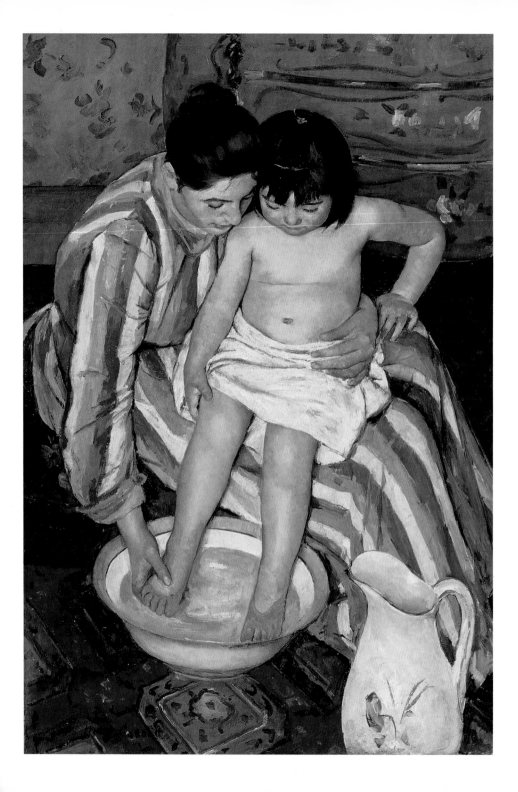

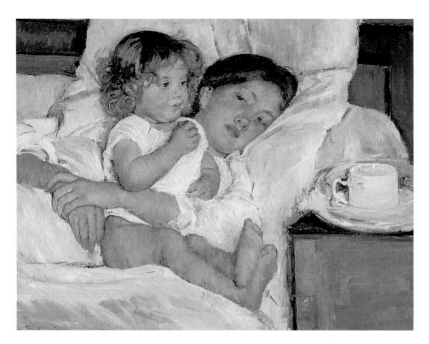

170 CASSATT
Breakfast in Bed 1897

171 CASSATT
The Caress 1902

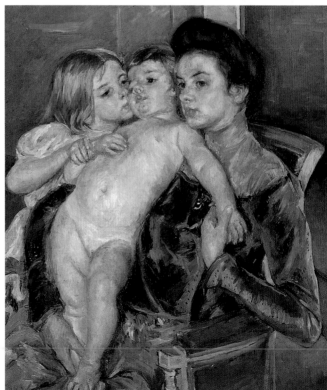

169 CASSATT
The Bath 1891–92

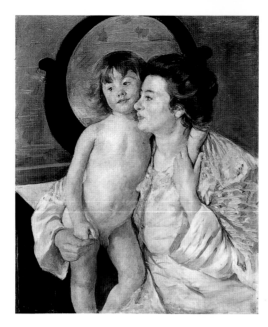

172 CASSATT *Mother and Child (The Oval Mirror) c.* 1899

To underline the general lack of sentimental involvement with her subject matter, one episode reported by Louisine Havemeyer reveals that in the search for the pose through which to study the difficulties and particularities of the infant nude, Cassatt was a demanding employer. On a visit to Cassatt at the Villa Angelotto in Grasse in March 1914, Louisine Havemeyer witnessed her working on a pastel *Mother and Sleeping Child.* She records the difficulties the artist, the mother, and the housekeeper were having in amusing a child who would not cooperate. The next day the whole composition had changed and the child now lay asleep, back to the artist, cradled in its mother's arms. This had only been achieved because Cassatt had chastised the child and it had cried itself to sleep. The anecdote reminds any viewer of the gap between the effects we may "read in" to the picture and the brute conditions of its extremely unsentimental production.

THE GESTURE AND THE GAZE

If the naked body of the child is one of the themes of Cassatt's work, there are at least two others of significance: the gesture and the gaze. *Emmie and her Child* (1889) was exhibited in New York in 1895. The painting had initiated a series of works stemming from the scene of the child's toilette that examine the "first contact." Mother and child do not look at each other,

174

but are linked pictorially by the physical bond created by the child's tiny hand casually resting on the mother's chin while her hand firmly grasps its small limb. The artist's presence as fabricator is inscribed into the painting through the loosely brushed area around the child's feet—a moment of aesthetic becoming that one is tempted to read for its association with the child's own incomplete emergence as a separate person.

The gesture that occurs here is made the central topic of a later pastel, *Baby's First Caress* (1891), in which Cassatt appears to distill as a single event 173 a rarely portrayed and prolonged process through which the child intuits its own separateness from the maternal body, gaze, voice, and space which have functioned as its life-sustaining prosthesis since birth. This is a modernist, psychologically informed interpretation of a gesture, that has, as Leo Steinberg has argued, an impressive antiquity. The "chin-chuck" comes down to us from Ancient Egypt, freighted with erotic or affectionate meanings, becoming a ritual gesture for erotic communion, either carnal or spiritual, within Christian art. The Christ Child's use of the chin-chuck towards his Mother in many a Madonna and Child image confirms Augustinian theology of the Infant Spouse. The apparent "naturalism" of its representation in art served to make visible the mystery of Incarnation. Iconography in art history invites us to recognize the many links in the chain of artistic tradition, but not every incidence of a gesture means the same. Modernization emptied the traditional sign, the chin-chuck, observed no doubt by Cassatt in her passionate studies of fifteenth-century Italian art, using it to signify a new sensibility about psychological relations. Cassatt has not merely naturalized the sacred. She has made this most long-lived and potent of iconographies the scene of a radicalization that, like Freud himself, makes us see the deep-seated Oedipal fantasies that nestled within the theological costumes of religious thought and art practice.

In *Baby's First Caress* the boy-child's gesture—it has to be boy-child for this particular intervention to work—makes the touch the outward and visible sign of an unconscious process in which the Mother becomes an object, an Other, who will force the child into self-awareness of its own, physically separated identity. Psychoanalysts examining and theorizing the coming of this crucial but painful rift between the child and its maternal envelope argue that the human subject's sense of self is dependent on two crucial moves. The child must develop a spatial awareness—here (I) and there (you/other)—and must experience its chaotic bodily and emotional experiences as confined within a boundary, within an image of the body as a closed container. The child has to the learn the limits of its own body, locate its own experiences within them and realize that there is a space between itself and the frontier of an Other. Jacques Lacan used the

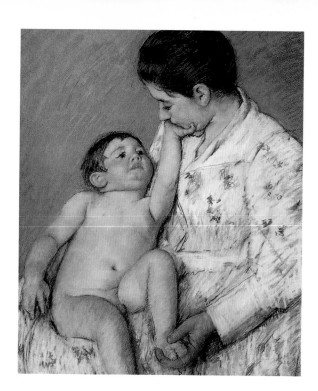

metaphor of a mirror—a framed fictive space like a picture in which the
lineaments of a boundaried, defined body image could be found and, in
fantasy, incorporated by the child as a kind of psychological skeleton
which its own subsequently developing ego would clothe with its partic-
ular sensations, memories, and meanings.

 Held in his infant dependency and physical immaturity on the broad
lap of his enveloping caretaker, his foot wholly cradled in her hand while
his hand rests upon her holding arm, the baby boy holds the woman's chin
and appears to reflect upon that gesture as he gazes into her returned
look. The pastel offers several images of locking hands and looks that bind
the two figures in an intimacy. The child's gesture intimates an severance
that hand and eye with all their developing erotic and emotional freight
will try to bridge. This image can only be a synthesis of many observations
of passing moments, of many sketches and failed attempts to distill the
precise configuration that will reveal the hitherto unknown significance
of the semiotics of child-adult relations. Continuously fascinated by
this "moment," Cassatt painted it in oil but with a new translation—the
child is a girl in both *Child's Caress* (1891, Honolulu) and *Maternal Caress*
(1896, Philadelphia). These titles reveal how misled we may be by later,

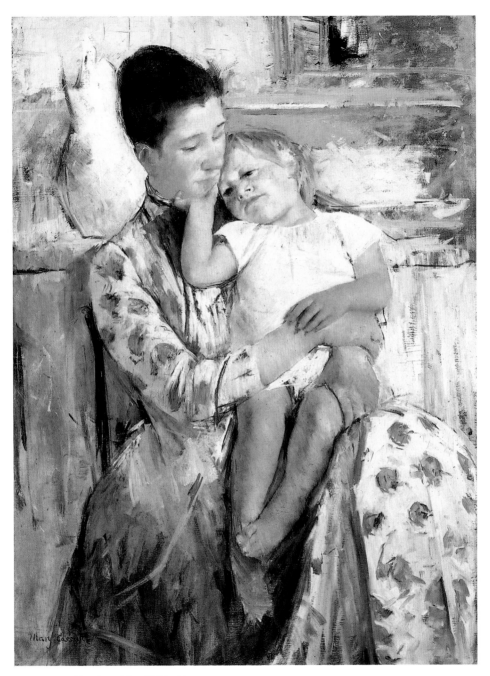

174 CASSATT *Emmie and her Child* 1889

apparently descriptive, titles given to paintings that do not illustrate or refer, but study a psychological knot in the history of subjectivity.

If the gesture both breaks the unity of adult and child and reforges it at the level of a social act, the look which passes between two figures also signals a gap, a spacing between two subjectivities that speaks both of separation and the desire to cover it over with a sign. The presence and the absence of the maternal gaze will be equally significant. In a series of pastels based on a little boy called Thomas, the nursemaid introduces an anxious child to the world. In an unfinished sketch for the pastel exhibited in New York in 1895, *Mother Looking Down at Thomas*, the woman's face is almost obscured. The sketch reveals the heart of the work, what the artist was trying to work out with this composition. Pale infant flesh nestles against vibrant orange, setting off the continuity between the child's dark hair and that of the tending woman. So striking is the evocation of childish reverie or even disquiet, that the untoward obscuring of the adult's face does not immediately strike us. But the same juxtaposition
177 in a pastel of 1897 makes the artist's compositional daring more obvious, and revealing. The *profil perdu* of the nursemaid—reminiscent of that of
151 the milliner in *The Fitting*—ensures that this fragment functions as a screen for an imaginary figure, a memory. Not a person in time, space, and place, though the model surely was, what is imaged is a psychically charged *"fetish"*—a commemoration of absence that equally tries to disavow that loss. The lost face is a fetish for a feminine presence for which the child then looks somewhere else in her reverie. Symbolist critics who hailed Cassatt's work in the early decades of this century recognized this: that Cassatt's pastels are not "naturalist" studies of the real, but are calculated representations of the psychological; not documenting this child and its nurse, but the sensations of childhood that unconsciously evoked echoes in the artist herself.

177 The two faces touch, providing another study of the maternal kiss, the adult woman's pleasure in the child's skin and person. But the child, whose little arms and hands rest on the woman's shoulders in a gesture of unthinking tenderness and trust, is the pictorial site for a subjectivity. Couched in this child's face and body, Woman can be made to think and dream about some of life's mysteries without collapsing into the trope of Woman-as-mystery which waylaid so many paintings of women by women, as much as by men. Any deviance from modernism's demanding commitment to the prosaic would allow back the Romantic drift of a more decadent Symbolism.

176 In a pastel of 1896–97 known as *Pensive Marie Looking up at her Nurse*, looking becomes a form of gesture, materialized in the indeterminacy of

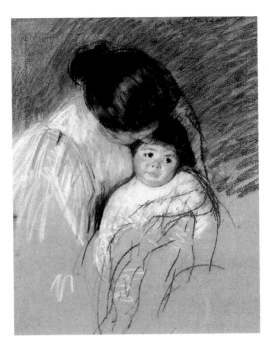

175 CASSATT *Mother Looking Down at Thomas* c.1893

the pastel out of which both figures are formed. The adult woman as body and gaze physically envelops the child in a visual embrace made almost palpable through its pictorial representation in the materiality of the pastel, whose smudged effects undo the boundaries between the adult and the child lodged within a sweep of the woman's body and fashionable costume. Yet against this almost "choric" image of the feminine body—the Greek word *chora,* meaning a container, has been used by Julia Kristeva to evoke an infantile fantasy of the mother as a space that contains the child—the imminent sense of separation is equally signified by the child's look. Thus the exchange of glances both suggests partition and offers vision as a bridge by which to compensate for loss of unity through building an affective bond called Love. How often, in Cassatt's oeuvre is the young female child represented, like the older woman, in the pose of melancholic thought? The girl-child becomes a young, feminine Sphinx questioning the curious paradox of humanity: "Who am I and What am I in relation to an Other?" Choosing to explore this dimension of child-hood self-discovery through the image of a girl-child and an adult woman, ensures that the question of human subjectivity does not collapse into the question of sexual difference that is mythically represented by the legend of Oedipus in which Man was the answer to the riddle of the monstrous feminine Sphinx. Cassatt uses the figure of the girl-child as the means to

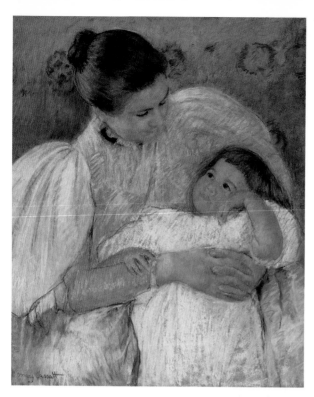

176 CASSATT *Nurse and Child (Pensive Marie Looking up at her Nurse)* 1896–97

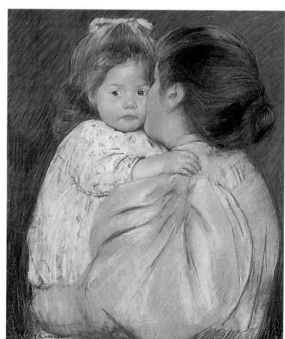

177 CASSATT *Maternal Kiss (Pensive Marie Kissed by her Nurse)* 1897

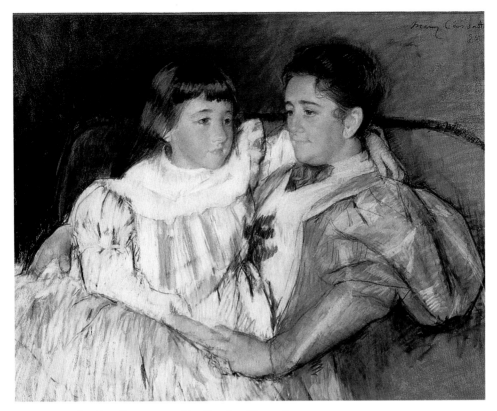

178 CASSATT *Louisine Havemeyer and her Daughter Electra* 1895

pose questions about identity and subjectivity that were central to the
project of late nineteenth-century feminism and came to the fore in the
generation after 1915. The girl-child, born into a world of change, looks
to the generation that came before her and asks: "What is to become of me,
'in the feminine'?" A girl-child looked up to the fruit picker in the mural
Modern Woman and received the gift of an older generation's campaigns for
the fruits of knowledge, the pleasures of ambition, and the joys of creativity.
These little girls are the questioning faces of that historic moment when
women were remaking their own history and their own futures.

Most of Cassatt's paintings of so-called mother and child are, therefore,
nothing of the sort. Some, of course, are about childcare. But the point of
view is not that of the woman as mother. Cassatt was never a mother.
The place from which the paintings were made and thus the place of our
identification in her work is that of the daughter. Her paintings may be

22

read as the figurations of a daughter's relation to the mother and of a changing femininity developing in this historically transformed relation of women to their society. The femininity explored in Cassatt's pictures worked *against the grain of,* while also *being creatively conditioned by* the character of her own mother's role in her life.

The significant relation of Cassatt's adult life was with her mother and her loss nearly destroyed her. Plunged into depression, Cassatt was com-forted by a visit in the summer of 1895 of her friend Louisine Havemeyer, travelling with her own daughters, Electra and Adaline. In a pastel portrait of Louisine Havemeyer and her daughter Electra made during this trip, the seven-year-old Electra is seated on her mother's knee, one arm draped over her mother's shoulder, while the other, on her own knee, is partially sheathed by her mother's hand. This sequence of gestures and positions creates a circle within which the child is held. Mother and daughter appear intimately connected, bonded, but in ways that suggest a signifi-cant historical difference from an earlier self-portrait by Elisabeth Vigée-Lebrun with her daughter Julie (1789), that stands, historically, at the beginning of the movement to promote motherhood as both sensuously gratifying and psychologically fulfilling. Vigée-Lebrun's formal solution to the bonding of two figures was found in the classical perfection and harmony of a pyramidal composition coupled with overt sensuality. No such physicality and sensuality pervades the late nineteenth-century image by Cassatt, whose figures are stiffly encased in the costume of a decorporealized femininity typical of the late nineteenth-century haute-bourgeoisie. While the circle of hands and arms entwines the two bodies, it is broken by the clashing direction of their looks. The woman and the child neither look at each other nor directly out towards the spectator. Such a configuration might seem to resemble the dissonant images of the family by Degas: *Portrait of the Belleli Family* (1858–67), a scene of severe marital discord, and the lesser-known *Portrait of Giovanna and Giulia Belleli* (1865–66), where the two sisters have been positioned at a sharp angle to each other. This divergence creates a powerful dynamic, pushing against the frame of the represented space and seeming to insist upon the fracture of any relationship between the two sitters.

Cassatt's pastel of Louisine and Electra is quite different, however. There is indeed a managed pictorial tension. The bodies, central to the painting's space, curve round each other in gestures of casual intimacy while the faces suggest psychological detachment. Although the direction of the figures' gazes cuts across each other and the picture's central core, the implied movement of these looks expands the space. The two women are at different stages of their lives, and the painting accentuates their

178

difference rather than their identity as women without implying conflict. Furthermore the mother-daughter relation does not to belong simply to a state of being, an automatic connection which was so much the ideological aim of contemporary propaganda about motherhood. In Cassatt's painting, the mother-daughter relation is a frame, a space within which two beings coexist, at ease, yet their thoughts are unknown to each other. Almost all the pastels provide a supplement of sensuous pleasure and an evocation of the tactile—as well as of the artist's actual, graphic, mark-making touch. The intensities of color in clothes and settings and the delicate luminosity in the flesh passages (Cassatt's fulfilled debt to Courbet and Rubens) carry an emotional charge disciplined by the terseness of the compositions in confined and shallow space. Of all her media, pastel allowed Cassatt to work on the cusp of her own making processes, producing forms that constantly hovered undecided at the boundaries between separate bodies and discrete beings. There was no necessity to work harder to make the hands of Electra and Louisine Havemeyer more distinct and realized. The unfinished state, however, becomes a transformative borderspace shared between two femininities that marks the distinctive character of Cassatt's treatment of women and the family.

Like Cassatt, Louisine Havemeyer was a feminist, but she was also an active suffragist. After the death of her husband in 1907, Louisine Havemeyer had risen to prominence in the National Women's Party, becoming one of the most prominent campaigners for women's right to vote in the United States. The relations between art and activism were made concrete in the exhibitions of art Louisine Havemeyer organized as benefits for the suffrage cause at Knoedler's Gallery in New York in 1912 and 1915. In 1915, works by Degas, Cassatt, and selected Dutch Old Masters shared one exhibition space. It was the last exhibition of Cassatt's career as an active painter, and it is highly significant that it took place in New York and was a benefit for what she called "the cause," in the presence of works by Degas and the Old Masters. Louisine wrote:

> It goes without saying that my art collection had also to take part in the suffrage campaign. The only time I ever allowed my pictures to be exhibited collectively was for the suffrage cause.... Furthermore, the only time I ever spoke upon art matters was for one of these exhibitions.... I spoke upon the art of Degas and Miss Cassatt, whose work was for the first time creditably exhibited in America and formed about half of the exhibition, while the other half was made up of an unusually interesting collection of Old Masters. To contrast the old with the modern gave me a most attractive programme; but nevertheless,

180

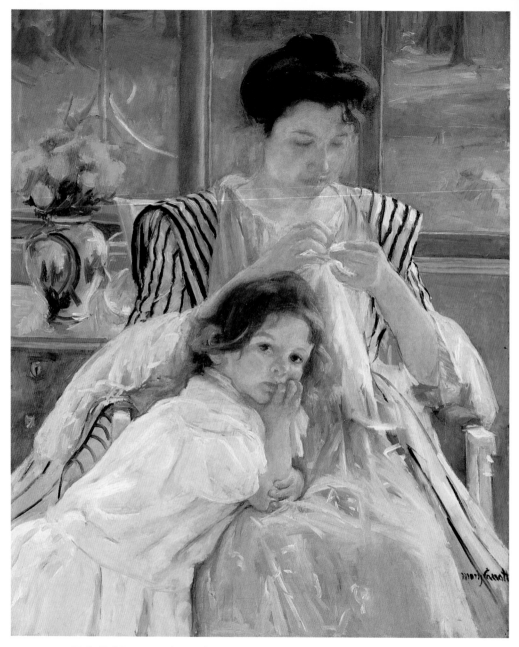

179 CASSATT *Little Girl Leaning on her Mother's Knee (Young Mother Sewing) c.* 1901

probably on account of the enthusiasm it excited and the wide publicity the exhibition received, I was very much frightened at this new venture into a new field of oratory so different from anything I had attempted before. It was an easy thing to talk about the emancipation of women, but art was a very different and difficult subject.

In Knoedler's galleries viewers would enter into an artistic framework conceived by Cassatt, an American artist, whose engagement with the modern in French art, represented at its cutting edge by Degas, was shaped by an equally strong study of selected historical periods of European art during her lengthy apprenticeship.

Prominent in the 1915 exhibition, among the many paintings of the child with its adult caretaker dating from the years 1900 to 1915, was Cassatt's *Little Girl Leaning on her Mother's Knee,* bought by the Havemeyers from Durand-Ruel in Paris in 1901. The painting creates a soft, domestic space within which the child resides, so simply connected by physical proximity and contact to the woman's body that the child casually but absolutely claims as a prop. The child confronts the viewer in a childish evocation of the iconography of the thinker. That intent look breaches the pictorial space and questions the viewer whose own, returning gaze is invoked by the directness of the child's regard. Her look pierces the ideological seams of that space to project a space not so much beyond its frame as in front of it where there once was another person. At the point of production, which is so often commemorated in the work that Cassatt produced, that Other was the artist, who thus inscribes herself into her work as the painted child's imaginary interlocutor.

There is an implied reminder of the artist whose looking and working the child regarded while she was being painted. The critical core of the painting is the young girl, represented both in her "being with her mother" (the mature woman through identification with whom she will make her contradictory way to her own adult femininity) and in her "separate being," a difference which she must acknowledge in order to become an independent creative femininity like the artist at work she sees before her. The artist was different from her mother and yet comparable to her because both adult women are busy and absorbed (the sewing woman recalls images of Cassatt's sister Lydia and her domestic creativity). The triad the painting generates is not an Oedipal triangle with the determining Other as the Father, who comes between Mother and Child to facilitate the child's separation from the Mother. Instead a creative artist who is a woman functions as the lure of this early twentieth-century girl-child's reflective gaze.

180 Installation view of Loan Exhibition of Masterpieces of Old and Modern Painters, Knoedler and Co. Galleries, New York 6-24 April 1915

At a glance the installation photograph of the Suffrage Benefit Exhibition of 1915 reveals that Louisine loved Cassatt's late paintings of young children and their caretakers, with their intense coloration and evocation, in modernist translation, of the compositional richness of Renaissance Italian art. The interrogating look of the young girl is visible in these gallery photographs, breaking the rhythms of the compositions which flow from a very recent and highly colored pastel of a woman in a kerchief with a naked baby (1914) to the earlier monumental painting of *Mother and Child* (1905) in which a naked little girl contemplates her tiny image in a hand-held mirror. From closer observation, this child's look at the spectator would also become visible, mirrored out from the picture's space by the witty use of the hand mirror in which Venus more often contemplates her sexual beauty and invites the viewer to share her narcissistic pleasure. The play with mirrors in this painting harks back to 1878 when Cassatt used such reflections in the portrait of her mother *Reading "Le Figaro"* and in theatre scenes. The fashionably garbed woman signals a social destiny, and a socially privileged femininity. The naked child, with its round belly and straddling legs is momentarily translated into that ideal by the body-image that is formed by the mirror (the face) and the double clasp of hands around its stem (the body). The direction of the girl's and woman's gestures moves ineluctably towards that tiny face captured in the mirror's magic pool, where the child's *profil perdu* looks back at us with some perplexity. Here is her image, her prospective femininity repre-

181

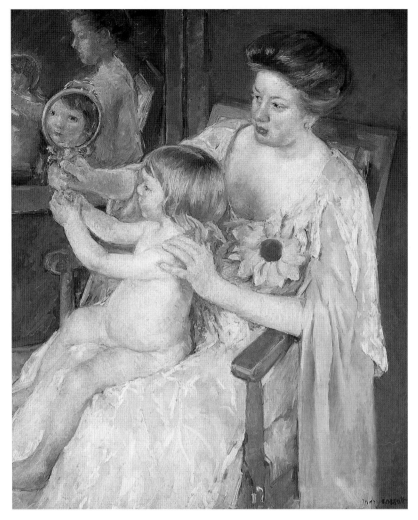

181 CASSATT *Mother and Child (Mother Wearing a Sunflower on her Dress)* 1905

sented as image, but this feminine ideal is being questioned once again by its passage through the girl-child, in its nakedness outside the rules and costumes of the adult masquerade of fashionable femininity.

The hanging of the 1915 exhibition in New York presents the possibility of a historical space in which "Degas" did not negate "Cassatt," in which these two worlds of bourgeois modernity—the sexualized spaces of masculinity and the intimate spaces of femininity—could, as it seems

they did in Paris, coexist and converse. What Cassatt and Degas shared was a museum culture, a sense that you make art by working through art's resources and traditions. But what I have been also trying to suggest is that Cassatt could also take on Degas's—and Manet's and Courbet's—subjects through a different perspective than that from which their subjects had been produced. Degas showed working-class women posing in his grimy Paris studio as if dancing, ironing, selling hats, washing themselves in brothels. These scenes, drawn from the social worlds which Cassatt, a bourgeois woman, could only indirectly glimpse, provided images in relation to which her representations of children and their mothers or nurses were revealed to have an equally social and historical take on modernity.

Had the 1915 Suffrage Exhibition displayed the 1891 color prints on the wall opposite the exhibit of Degas's paintings and pastels we would have had no problem in seeing an interesting dialogue in which social and sexual difference would operate to make plain the difference between the world's bourgeois men and women, showing how Cassatt negotiated that difference productively. The problem arises because instead of that set of prints about social difference and maternal *jouissance*, the walls of Knoedler's offered images of wholesome children of varied ages with an equally healthy adult, set in sun-filled landscapes, painted with modernist color in classicizing simplicity or Baroque compositional counterpoint. Yet in the bold portrait *Lady at a Tea Table* (1883–85), also shown in the 1915 exhibition at Knoedler's, we find a trace of Cassatt's studies in the 1880s of modern women of various ages. The sitter's relatives had rejected this portrait for its frankness about age, social station, and character that was so at odds with the elegance and mystique of femininity provided by Whistler, Sargent, or, later, Cecilia Beaux. Between the single images of the 1880s with their frank attention to the specificity of body, face, and personal style, and the later paintings of child and adult after 1890, we can discern the patterns of continuity and common interest in Cassatt's overall project. What the pictures of children attend to repeatedly is the borderline of the difference between two beings, two stages in the formation of femininity. Her fascination with bonding and separation can only become visible in a sequence of representations, however, when we trace across many paintings the carefully calibrated observations of different moments in social interactions that are also psychologically formative.

The novelty of Cassatt's later works was her representation of the curious and thoughtful daughter, like the one who grasps the mirror so firmly to question us indirectly as her reflected face is turned outward to meet our gaze in *Mother and Child* (1905). That daughter is also present, however, in the allusion to the artist herself in the painting *Little Girl*

181
179

212

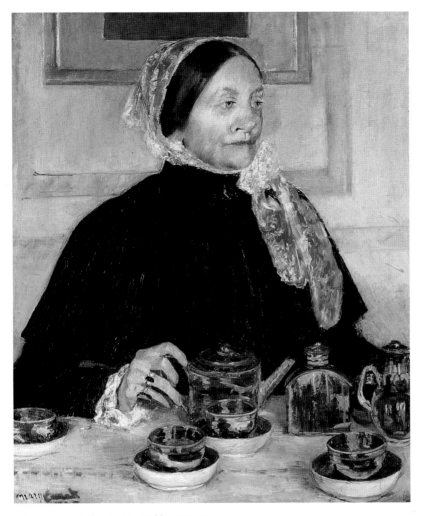

182 CASSATT *Lady at a Tea Table* 1883–85

Leaning on her Mother's Knee. It was the artist and her work whom the little
girl's direct gaze confronted then and commemorates now. The woman
artist, the intellectual, the painter, the feminist, the daughter, the sister,
the friend, the curator, Cassatt is for us now "the Other woman" who
belonged to a historical moment of feminism whose archaeology is of
such value to contemporary feminism, while her modernism is crucial in
grasping the creative intersection of Modern Art and Modern Woman.

213

Epilogue

With the advantage of hindsight, Mary Cassatt emerges as a vigorous influence upon the increasing sophistication of the American eye.

 Anne D'Harnoncourt, Introduction to Adelyn Breeskin's
 Mary Cassatt: A Catalogue Raisonné, 1970

Mary Cassatt did not make the crossing to see the Suffrage Benefit Exhibition in New York in 1915, the year that has since been assigned critical significance by American cultural historians. In that summer a group of men and women from New York's Greenwich Village founded the Provincetown Players—a small gesture of hope amidst the horror of a war in which thirteen million would die. This group signalled the convergence of a "new" consciousness, or rather a consciousness of the American role in the New, playing itself out across advanced American culture, though with a New Politics, a New Psychology, a New Art, a New Theatre, and a New Woman. Sigmund Freud lectured in the United States in 1909, offering a more complex model of human personality than that which divided human subjects between rational and emotional, spiritual and sexual, masculine and feminine. Woodrow Wilson and Theodore Roosevelt set out new political agendas for the United States both nationally and internationally. The Armory Show in 1913 exposed the American public to the works of Cézanne and Van Gogh, to Cubism and Fauvism that radically challenged the still prevalent taste for sentimental Realism or rural genre painting. Economic and social transformations in the conditions of working-class and bourgeois, black and white women generalized the aspirations of the New Women of the 1880s–1910s and opened the way to a new exploration of sexuality and life-styles.

Cassatt's last exhibition as an active painter coincided with this "cultural moment" that would mark the historical division between the beginnings of modernism and that which it had spawned. Such a coincidence within the historical time-frame has led some art historians to lament the fact that Cassatt did not acknowledge Picasso and Matisse as her group's successors. This is typical of modernist art history which sees modernism following an unquestioned logic of development. The very

183 Mary Cassatt at Château Beaufresne, Mesnil-Théribus, 1925

conditions for any widespread American understanding of what was in the Armory show lay in the creation of audiences and publics for the earlier modernism of Cassatt's generation. Understanding even those artistic strategies involved grasping the fundamental issues of modernism's double relation to the musealized histories of its own practices as art and to the shifting socio-economic conditions of modern urban-industrial capitalism, grasped both as in Marxist theory as a political economy, and as a radical alteration of consciousness, language, meaning, and identity.

Like her former colleague Monet, Cassatt lived into the 1920s. She died on 14 June 1926 at the age of eighty-two in the Château Beaufresne at Mesnil-Théribus, an estate that both her father's legacy and her own financial success with sales of pastels, paintings, and prints in the early 1890s had enabled her to purchase. One last photograph, one last monument detains us. The picture of Mary Cassatt at Beaufresne shows us a

very old woman, almost blind, peering at us through disfiguringly thick and ineffective spectacles. She had outlived all her immediate family and would not travel to the States to visit the next generations because of her dread of seasickness. For almost ten years she was unable to work and almost unable to see. What pain such incarceration in a dragging half-life must have been for an artist whose entire adult life had been spent in the regular discipline of eight hours' painting every day. Two years after her 181 *Mother and Child* (1905), Picasso painted *Les Demoiselles d'Avignon* (1907), heralding another radical shift in European painting and its imaginary, fed by pillaged treasures from Africa and two decades of prostitutional modernism. Mary Cassatt would have nothing to do with Cubism or the Fauves, expressing hardly suppressed anti-Semitism in her dismissal of the enthusiasm for such work by two members of a subsequent generation of Americans in Paris, Gertrude and Leo Stein.

Yet in Picasso's grand portrait of Gertrude Stein, an American modernist who would fashion her own singular take on the avant-garde's possibilities through language rather than painting, there is an uncanny evocation of the very brutal, powerful, eye-shocking, monumental modernism of Cassatt's subject paintings that critics had decried at her exhibition in New York in 1895. There can be no doubt that Cassatt was a highly significant and influential figure in the making of both European and American modernism. Her oeuvre reveals its consistency over many decades in the modernizing examination of lives of women she knew, sustained by its radical discoveries of the possibilities of modernization through the potentialities of graphic media—printmaking and pastel. Both these aspects left their traces in a variety of works by her American and European contemporaries. While we can note intriguing parallels in topic and theme between her work and that of her contemporaries Eakins, Whistler, and Sargent, or of her successors like Beaux, Cabot Perry, and Ellen Hale (1855–1940), these Americans' work tended to remain within that late nineteenth-century moment when would-be modernists had just discovered the seventeenth century and represented the artifice and elegance of their social worlds with the facture of Velázquez, the verve of Hals, or the formality of Vermeer. "Cassatt"—the body of work unified by that author name, rather than by the historical person—allows us to watch an artist grappling with the testing problematics of a more stringent modernist discipline. She had learned her art through the academic tradition while absorbing new theories and new moves. Her own study of Old Masters would enable her to integrate them as the basis for a new practice. She had dared to leap from skillful virtuosity in exotic genre painting into "the new painting" of Paris's tiny

184 PABLO PICASSO
Portrait of Gertrude Stein 1906

independent avant-garde. Working always at the process of making art itself, "Cassatt" also exemplifies the finely calibrated relations between medium and message. Through the discipline and the materiality of her graphic media, the subject of the child in its adult environment would be tackled in a way that led Achille Segard in the first monograph on the artist to identify her as "a painter of children" and only then "of mothers." As the historical moment in which that compliment and its subtle insight was lodged gave way under the ghastly historical forces which ravaged Europe during World War I, the meaning of Segard's accolade faded before the rampant sexism that ruled the world of art history until the 1970s. For a generation or two, Cassatt's modernism became invisible, veiled by the exclusive and stereotypically denigrating perception of her gender that produced dismissive readings of her painting as typically "feminine": "tea, clothes and nursery." Cassatt's work awaited a renewed feminist revaluation of the spaces and sentiments of nineteenth-century femininity for its intervention to become legible once again.

Now to be able to see "Cassatt" in Manet's epochal *Bar at the Folies-Bergère*, and citations from Manet's *Olympia* in her print *In the Omnibus*, and to find the painting of the artist's educated mother haunting Picasso's portrait of the great modernist intellectual Gertrude Stein, is to begin to understand Mary Cassatt's place in the histories of modernism as "the Painter of Modern Women."

Select Bibliography and Sources

General

Breeskin, Adelyn, *Mary Cassatt: A Catalogue Raisonné of Oils, Pastels, Watercolors and Drawings*, Washington D.C., 1970; Breeskin, A., *The Graphic Work of Mary Cassatt: A Catalogue Raisonné*, New York, 1948; Breuning, Margaret, *Mary Cassatt*, New York, 1944; Carson, Julia, *Mary Cassatt*, New York, 1966; Hale, Nancy, *Mary Cassatt*, New York, 1975; Mathews, Nancy Mowll, *Mary Cassatt and the "Modern Madonna" of the Nineteenth Century*, New York University, Ph.D. Dissertation, 1980; Mathews, N. M., *Mary Cassatt and Edgar Degas*, San Jose, 1982; Mathews, N. M., ed., *Cassatt and Her Circle: Selected Letters*, New York, 1984; Mathews, N. M., *Mary Cassatt*, New York, 1987; Mathews, N. M., *Mary Cassatt: A Life*, New York, 1994; Mathews, N. M., ed., *Cassatt: A Retrospective*, New York, 1996; Pollock, Griselda, *Mary Cassatt*, London and New York, 1980; Pollock, G., "Modernity and the Spaces of Femininity," *Vision and Difference*, London, 1988; Pollock, G., "The Gaze and the Look: Women with Binoculars—A Question of Difference," *Dealing with Degas: Representations of Women and the Politics of Vision*, ed. R. Kendall and G. Pollock, London, 1992; Pollock, G., "The View from Elsewhere," in *Twelve Views of Manet's Bar*, ed. Bradford Collins, Princeton, 1996; Pollock, G., "Critical Critics On *Reading Le Figaro* by Mary Cassatt," *University of Leeds Review*, 36, 1993/4 and in Pollock, G., *Looking Back to the Future: Essays from the 1990s*, New York, 1998; Pollock, G., *Differencing the Canon: Feminist Desire and the Writing of Art's Histories*, London, 1999; Segard, Achille, *Mary Cassatt: Un Peintre des enfants et des mères*, Paris, 1913; Sweet, Frederick, *Mary Cassatt: Impressionist from Pennsylvania*, Norman, Oklahoma, 1966; Valerio, Edith, *Mary Cassatt*, Paris, 1930.

Introduction

Biddle, George, "Some Memories of Mary Cassatt," *The Arts*, 10/2, 1926; Bilyeu, Elizabeth, *Gender Issues in the Artistic Reputation of Mary Cassatt*, Washington University, M.A. Thesis, 1995; Burns, Sarah, *Inventing the Modern Artists: Art and Culture in Gilded Age America*, New Haven and London, 1996; Geffroy, Gustave, "Mary Cassatt," *La Vie Artistique*, series 3, 1893; Mauclair, Camille, "Un Peintre d'enfance: Mlle. Mary Cassatt," *L'Art Décoratif*, August 1902; Mellerio, André, "Mary Cassatt," *L'Art et les Artistes*, 12, November 1910; Richardson, Edgar, "Sophisticates and Innocents Abroad," *Art News*, April 1954; Smith-Rosenberg, Carroll, "The Female World of Love and Ritual," *Disorderly Conduct: Visions of Gender in Victorian America*, New York and Oxford, 1985; Rubinstein, Charlotte Streifer, *American Women Artists, from Early Indian Times to the Present*, Boston Mass., 1982; Walton, William, "Miss Mary Cassatt," *Scribner's Magazine*, 19/3, 1896; Watson, Forbes, "Philadelphia Pays Tribute to Mary Cassatt," *The Arts*, 11/6, June 1927

1 Painter of *Modern Woman*, 1893

In This Academy: The Pennsylvania Academy of Fine Arts 1805–1976, Philadelphia, 1976; Bashkirtseff, Marie, *The Journals of Marie Bashkirtseff*, ed. Mathilda Blind, introd. by Rozsika Parker and Griselda Pollock, London, 1985; Carr, Carolyn Kinder, and Webster, Sally, "Mary Cassatt and Mary Fairchild MacMonnies: The Search for the 1893 Murals," *American Art*, 8, 1994; Elliott, Maud Howe, *Art and Handicraft in the Women's Building of the World's Columbian Exposition, Chicago, 1893*, New York and Paris, 1893; Fiddell Beaufort, Madeleine, "Elizabeth Gardner Bouguereau: A Parisian Artist from New Hampshire," *American Art Journal*, 24–25, 1984–85; Stanton, Elizabeth Cady, *The Woman's Bible*, New York, 1895; Havemeyer, Louisine W., *Sixteen to Sixty: Memoirs of a Collector*, New York, 1930 and 1993; Geerdts, William, *Women Artists of America 1707–1964*, Newark, 1965; Kysela, John D., "Mary Cassatt's Mystery Mural," *Art Quarterly*, 29/2, 1966; Mellerio, André, *Exposition Mary Cassatt*, Paris, 1893; Monroe, Lucy, "Chicago Letter," *The Critic*, 23, 18 November 1893; de Lostalot, Alfred, "Exposition des Oeuvres de Miss Mary Cassatt," *La Chronique des arts et de la curiosité*, 9, December 1893; Simon, Marie, *Fashion in Art: The Second Empire and Impressionism*, Paris and London, 1995; *Lilly Martin Spencer 1822–1902: The Joys of Sentiment*, Washington D.C., 1973; Sund, Judy, "Columbus and Columbia in Chicago: Men of Genius meet Generic Woman," *Art Bulletin*, 75/3, 1993; Ten Eyck Gardner, Albert, "A Century of Women," *Metropolitan Museum of Art Bulletin*, December 1948; Weimann, Jeanne, *Fair Women*, Chicago, 1981; Welter, Barbara, "The Cult of True Womanhood 1820–1860," *American Quarterly*, 18, 1966; Wattenmaker, Richard, *Puvis de Chavannes and the Modern Tradition*, Toronto, 1976; Wharton, Edith, *The House of Mirth*, London and New York, 1905.

2 Americans At Home and Abroad

Akerman, Gerald, "Thomas Eakins and His Parisian Masters: Gérôme and Bonnat," *Gazette des Beaux Arts*, ser. 6, 73, April 1969; Bacon, Henry, *A Parisian Year*, Boston, 1882; Baudelaire, Charles, *The Painter of Modern Life and Other Essays*, trans. Jonathan Mayne, London, 1964; Ellet, Elizabeth, *Women Artists in All Ages and Countries*, London and New York, 1859; Fink, Lois, *American Art at the Nineteenth-Century Paris Salons*, Cambridge and Washington D.C., 1990; Geerdts, William, *Lasting Impressions: American Painters in France 1865–1915*, Evanston, 1992; Harris, Neil, *The Artist in American Society: The Formative Years 1790–1860*, Chicago, 1966; Johns, Elizabeth, *Thomas Eakins: The Heroism of Modern Life*, Princeton, 1983; Huber Jones, Christine, *The Pennsylvania Academy and its Women 1850–*

1920, Philadelphia, 1974; Legrange, Léon, "Woman's Position in Art," *The Crayon*, 8, 1861; Lindsay, Suzanne, *Mary Cassatt and Philadelphia*, Philadelphia, 1985; Nochlin, Linda, *Realism and Tradition 1848–1900*, Englewood Cliffs, N.J., 1966; Quick, Michael, *American Expatriate Painters of the Late Nineteenth Century*, Dayton, 1976; Thoré, Théophile, "Salon de 1863," in *Salons de W. Bürger, 1861–68*, vol. i, Paris 1870; Weinberg, Barbara, *The Lure of Paris: American Painters and Their French Teachers*, New York, 1991; Zola, Emile, "Edouard Manet," *L'Artiste: Revue du XIXe siècle*, Paris, 1867.

3 Cassatt's Choices 1870–77

Alcott, Louisa May, "Diana and Persis," in *Alternative Alcott*, ed. Elaine Showalter, Brunswick, N.J., 1989; Boone, M. Elizabeth, "Bullfights and Balconies: Flirtation and Majaism in Mary Cassatt's Spanish Paintings 1872–3," *American Art*, 9/1, 1995; Cary, Elisabeth Luther, "The Scrip: Recent Acquisitions of Modern Art in the Wilstach Collection," *International Studio*, 35/137, July 1908; Duranty, Edmond, *La Nouvelle Peinture: à propos du groupe d'artistes qui expose dans les galeries Durand-Ruel*, Paris, 1876; Gautier, Théophile, *Voyage en Espagne*, Paris, 1843; Hawthorne, Nathaniel, *The Marble Faun*, Boston, 1860; James, Henry, "A Roman Holiday," in *Transatlantic Sketches*, 1875, in *Henry James: The Art of Travel*, ed. M.D. Zabel, New York, 1958; Nieriker, Mary Alcott, *Studying Art Abroad, and How to Do it Cheaply*, Boston, 1879; Tennyson, Alfred, "The Princess: A Medley," [1848] in *Tennyson: Poems and Plays*, ed. Herbert Warren, London 1971.

4 Modern Women—Modern Spaces

Clark, T.J., *The Painting of Modern Life: Paris in the Art of Manet and His Followers*, New York, 1984; London 1985. Garb, Tamar, *Sisters of the Brush: Women's Artistic Culture in Late Nineteenth-Century Paris*, London and New Haven, 1994; Garb, T., *Women Impressionists*, Oxford, 1986; Hemmings, Frederick, *The Theatre Industry in Nineteenth-Century France*, Cambridge, 1993; James, Henry, *Parisian Sketches: Letters to the New York Tribune 1875–76*, London, 1958; Martindale, Meredith, *Lilla Cabot Perry: American Impressionist*, Washington D.C., 1990; Moffett, Charles, *The New Painting: Impressionism 1874–1886*, Oxford, 1986; Rouart, Denis, ed., *The Correspondence of Berthe Morisot*, introd. Tamar Garb and Katherine Adler, London, 1986; Nochlin, Linda, "Impressionist Portraits and the Construction of Modern Identity," in Colin B. Bailey, *Renoir's Portraits*, Ottawa, 1997; Roger-Marx, Claude, "Les Femmes-Peintres de l'Impressionisme," *Gazette des Beaux Arts*, December 1907; Sparrow, Walter, ed., *Women Painters of the World*, London, 1905; Shapiro, Barbara Stern, *Mary Cassatt at Home*, Boston Mass., 1978.

5 The Color Prints of 1891

Betterton, Rosemary, "Mother Figures: The Maternal Nude in the work of Käthe Kollwitz

and Paula Modersohn Becker," in *Generations and Geographies in the Visual Arts: Feminist Readings*, ed. Griselda Pollock, London, 1996; Bolger, Doreen, *American Pastels 1880–1930*, New York, 1989; Buetther, Stuart, "Images of Modern Motherhood in the Art of Morisot, Cassatt, Modersohn Becker and Kollwitz," *Women's Art Journal*, 7, 1987; Chesneau, Erneste, "Le Japon à Paris," *Gazette des Beaux Arts*, Sept. 1878; Crighton, R.A., *The Floating World: Japanese Popular Prints 1700–1900*, London, 1973; Fénéon, Félix, *Oeuvres plus que complètes*, ed. Joan Halperin, Geneva, 1970; Fuller, Sue, "Mary Cassatt's Use of Softground Etching," *Magazine of Art*, 43, 1950; Ives, Colta Feller, *The Great Wave: The Influence of Japanese Woodcuts in French Prints*, New York, 1974; Kristeva, Julia, "Motherhood According to Bellini," in *Desire in Language*, trans. Leon Roudiez, New York, 1980; Melot, Michel, *L'Estampe Impressioniste*, Paris, 1974; Mathews, Nancy Mowll, and Shapiro, Barbara Stern, *Mary Cassatt: the Color Prints*, New York, 1989; Peet, Phyllis, *American Women of the Etching Revival*, Atlanta, 1988; Pissarro, Camille, *Letters to His Son*, ed. John Rewald, Santa Barbara, 1981; Chessman, Harriett Scott, "Mary Cassatt and the Maternal Body," in *American Iconology: New Approaches to Nineteenth-Century Art and Literature*, ed. David Miller, London and New Haven, 1993; Schneider, Rona, "The American Etching Revival: Its French Sources and Early Years," *American Art*, 14, 1982; Silverman, Kaja, *The Acoustic Mirror*, Bloomington, Indiana, 1989; Silverman van Buren, Jane, *The Modernist Madonna: Semiotics of the Maternal Metaphor*, Bloomington, 1989; Weitenkampf, Frank, "Some Women Etchers," *Scribner's Magazine*, 45/6, Dec. 1909; Weitenkampf, F., "The Drypoints of Mary Cassatt," *Print Collector's Quarterly*, 6, 1916

6 The Child of Modernity, 1895–1915

Alexandre, Arsène, "La Collection Havemeyer et Miss Cassatt," *La Renaissance de l'Art*, 13 Feb. 1930; Beaux, Cecilia, *Background with Figures*, Boston and Newport P.A., 1930; Frelinghuysen, Alice Cooney, et al., *Splendid Legacy: The Havemeyer Collection*, New York, 1993; Havemeyer, Louisine, *Remarks on Edgar Degas and Mary Cassatt*, New York, 1915; Havemeyer, L., "The Cassatt Exhibition," *Pennsylvania Museum of Art Bulletin*, May 1927; Heller, Adele, and Rudnick, Lois, *1915: The Cultural Moment: The New Politics, The New Woman . . . in America*, New Brunswick, N.J., 1991; Huysmans, Joris-Karl, "L'Exposition des Indépendants en 1881," in Huysmans, *L'Art Moderne*, Paris, 1883; Steinberg, Leo, *The Sexuality of Christ*, London, rev. edn, 1996; Teall, Gardner, "Mother and Child: The Theme Developed in the Art of Mary Cassatt," *Good Housekeeping Magazine*, 50/2, Feb. 1910; Tufts, Eleanor, *American Women Artists, 1830–1930*, Washington, 1987; Weitzenhoffer, Frances, *The Havemeyers: Impressionism Comes to America*, New York, 1986; Weinberg, Barbara, et al., *American Impressionism and Realism: The Painting of Modern Life 1885–1915*, New York, 1994

List of Illustrations

33 Cassatt, Central panel of *Modern Woman* 1893 (detail). Photograph courtesy of the Chicago Historical Society
34 Cassatt *Young Women Picking Fruit* 1891. Oil on canvas 130.8 x 90 (51 ½ x 35 ½). The Carnegie Museum of Art, Pittsburgh. Patrons Art Fund
35 Berthe Morisot *The Cherry Tree* 1891–92. Oil on canvas 136 x 89 (53 ½ x 35). Private collection
36 Cassatt *Baby Reaching for an Apple* 1893. Oil on canvas 100.3 x 65.4 (39 ½ x 25 ¾). Virginia Museum of Fine Arts, Richmond. Gift of Ivor and Anne Massey. Photo © Virginia Museum of Fine Art/Grace Wen Hwa T'sao
37 Gustave Courbet *The Painter's Studio: A Real Allegory Summing up Seven Years of my Artistic Life* 1855. Oil on canvas 360.7 x 599.4 (142 x 236). Musée d'Orsay, Paris
38 Cassatt *The Boating Party* 1893–94. Oil on canvas 90 x 117.3 (35 ½ x 64 ¼). © 1997 Board of Trustees, National Gallery of Art, Washington D.C. Chester Dale Collection
39 Mary Cassatt in Paris, *c.* 1867. Private collection
40 *Pieter Baumgaertner Robert Cassatt and His Children* 1854, Mary standing centre. Private collection
41 . Cassatt *Robert Cassatt on Horseback* 1884–86. Pastel on paper 91.4 x 71 (36 x 28). Private collection
42 The modeling class at the Pennsylvania Academy of the Fine Arts, 1862, Eliza Haldeman and Mary Cassatt on the right (detail). Photo by Gihon and Rixon. Albumen photograph with hand colouring 18.6 x 13.5 (7 ⅜ x 5 ⅜). Pennsylvania Academy of the Fine Arts, Archives
43 Mary Cassatt in 1863. Private collection
44 Gilbert Stuart *Mrs Richard Yates* 1793–94. Oil on canvas 77 x 63 (30 ¼ x 25). © 1997 Board of Trustees, National Gallery of Art, Washington D.C. Andrew W. Mellon Collection
45 Winslow Homer *Art Students and Copyists in the Louvre Gallery, Paris*, from *Harper's Weekly*, January, 1868
46 Jean-Léon Gérôme *The Cock Fight* 1846. Oil on canvas 143 x 204 (56 ¼ x 80 ¼). Musée du Louvre, Paris
47 Painting class of Charles Chaplin, with Mary Cassatt top left, Paris 1866 (detail). Location unknown
48 Charles Chaplin *The Pearl Necklace*, undated. Oil on canvas 103.5 x 76 (40 ¾ x 29 ⅞). Nationalmuseum, Stockholm
49 Paul Soyer *The Dead Bird* 1866. Oil on canvas 67.3 x 55.9 (26 ½ x 22). Photo © Glasgow Museums, Art Gallery and Museum, Kelvingrove
50 Cassatt *The Mandolin Player* 1868. Oil on canvas 92 x 73.6 (36 ¼ x 29). Private collection
51 Jean François Millet *The Spinner: Goat Girl of Auvergne* 1868–69. Oil on canvas 92.5 x 73.5 (36 ½ x 29). Musée d'Orsay, Paris. © Photo RMN
52 Edouard Manet *The Spanish Singer* 1860. Oil on canvas 147.3 x 114.3 (58 x 45). The Metropolitan Museum of Art, New York. Gift of William Church Osborn, 1949 (49.58.2). All Rights Reserved

53 Cassatt *The Young Bride c.* 1869. Oil on canvas 88.2 x 69.8 (34 ¾ x 27 ½). The Montclair Art Museum, Montclair, New Jersey. Gift of the Max Kade Foundation
54 Anonymous, formerly attributed to Guido Reni *Beatrice Cenci*, early 17th century. Oil on canvas 75 x 50 (29 ½ x 19 ⅝). Galleria Nazionale, Rome. Photo Alinari
55 Cassatt *Portrait of a Woman* 1872. Oil on canvas 59 x 50 (23 ¼ x 19 ⅝). The Dayton Art Institute. Gift of Mr. Robert Badenhop, 1955.67
56 Antonio Correggio *Il Giorno* 1527–28 (detail). Oil on panel 200 x 139.7 (78 ¾ x 55). Galleria Nazionale, Parma
57 Cassatt in Parma, Italy *c.* 1872. Photograph by Baroni and Gardelli. Courtesy of the Pennsylvania Academy of the Fine Arts, Philadelphia, Archives
58 Cassatt *Two Women Throwing Flowers During the Carnival* 1872. Oil on canvas 63.5 x 54.6 (25 x 21 ½). Private collection
59 Edouard Manet *The Balcony* 1868–69. Oil on canvas 170 x 124.5 (66 ⅞ x 49). Musée d'Orsay, Paris. © Photo RMN
60 Cassatt *The Bacchante* 1872. Oil on canvas 61 x 50.5 (24 x 19 ⅞). Courtesy of the Pennsylvania Academy of the Fine Arts, Philadelphia. Gift of John Frederick Lewis
61 Cassatt *The Musical Party c.* 1874. Oil on canvas 96.5 x 66 (38 x 26). Musée du Petit Palais, Paris. © Phototèque de la Ville de Paris
62 Mariano Fortuny *A Spaniard Lighting a Cigarette c.* 1860s. Oil on panel 24 x 18 (9 ½ x 7⅛). Private Collection. Photo Phillips, London
63 Raimondo de Madrazo *Gypsy Girl c.* 1870s Oil on canvas 65 x 49 (25 ⅝ x 19 ¼. Museo del Prado, Madrid. Photo Mas
64 John Phillip *The Balcony* 1857. Oil on canvas 60.9 x 48.3 (24 x 19). Leicester City Museums
65 Cassatt *On the Balcony* 1873. Oil on canvas 101 x 82.6 (39 ¾ x 32 ½). Philadelphia Museum of Art. W. P. Wilstach Collection
66 John Phillip *La Bomba* 1863. Oil on canvas 91.9 x 114.2 (36 ⅛ x 45). City of Aberdeen Art Gallery and Museums Collections
67 Cassatt *Spanish Dancer in a Lace Mantilla* 1873. Oil on canvas 65 x 49.5 (25 ⅝ x 19 ½). National Museum of American Art, Washington D.C. Photograph Art Resource, New York
68 Cassatt *Toreador Smoking* 1873. Oil on canvas 81.6 x 64.1 (32 ⅛ x 25 ¼). The Art Institute of Chicago. All Rights Reserved. Gift of Mrs. Sterling Morton, 1969.332
69 Cassatt *Young Lady Offering the Panal to the Toreador* 1873. Oil on canvas 100.6 x 85.1 (39 ⅝ x 33 ½). © Photo Sterling and Francine Clark Art Institute, Williamstown, Massachusetts, USA
70 Cassatt *Portrait of a Lady of Seville* 1873. Oil on canvas 95.9 x 77 (37 ¾ x 30 ¼). Private collection
71 Cassatt *Katherine Kelso Cassatt* 1873. Oil on wood 62.2 x 57.2 (24 ½ x 22 ½). Private collection
72 Cassatt *Ida* 1874. Oil on canvas 57.5 x 45 (22 ⅝ x 17 ¾). Private collection

73 Edouard Manet *Gare St. Lazare* 1872–73. Oil on canvas 93.3 x 111.5 (36 ¾ x 43 ⅞). © 1997 Board of Trustees, National Gallery of Art, Washington D.C. Gift of Horace Havemeyer in memory of his mother, Louisine W. Havemeyer
74 Edgar Degas *The Ballet Rehearsal c.* 1875. Pastel and gouache over monotype 55.2 x 68 (21 ¾ x 26 ¾). The Nelson-Atkins Museum of Art, Kansas City, Missouri. Acquired through the Kenneth A. and Helen F. Spencer Foundation Acquisition Fund
75 Draner (Jules Renard) *Chez MM. les peintres indépendants* from *Le Charivari* 23 April 1879
76 Edgar Degas *Mary Cassatt c.* 1880–84. Oil on canvas 71.4 x 58.7 (28 ⅛ x 23 ⅛). National Portrait Gallery, Smithsonian Institution, Washington D.C. Gift of the Morris and Gwendolyn Cafritz Foundation and the Regents Major Acquisitions Fund
77 Cassatt *Self Portrait c.* 1880. Watercolor on paper 33 x 24.4 (13 x 9 ⅝). National Portrait Gallery, Smithsonian Institution. Photo Art Resource, New York
78 Photograph by Theodate Pope of Mary Cassatt reading a newspaper, Château-Beaufresne, Mesnil-Théribus, *c.* 1905. The Hill-Stead Museum, Farmington, CT
79 John Singer Sargent *Lady Agnew* 1892–93. Oil on canvas 125.7 x 100.3 (49 ½ x 39 ½). National Galleries of Scotland, Edinburgh
80 Elizabeth Gardner *Two Mothers* 1888. Whereabouts unknown
81 William Merritt Chase *A Friendly Call* 1895. Oil on canvas 76.5 x 122.5 (30 ⅛ x 48 ¼). © 1997 Board of Trustees, National Gallery of Washington D.C. Chester Dale Collection
82 James McNeill Whistler *Arrangement in Black No.8: Mrs. Alexander Cassatt* 1883–85. Oil on canvas 191 x 90.8 (75 ¼ x 35 ¾). Private collection
83 Cassatt *Lois Cassatt at a Tapestry Frame* 1888. Pastel 81.3 x 63.5 (32 x 25). Private collection
84 Cassatt *Five O'Clock Tea* 1880. Oil on canvas 64.8 x 92.1 (25 ½ x 36 ¼). Courtesy, Museum of Fine Arts, Boston. M. Theresa B. Hopkins Fund
85 Photograph by Theodate Pope of Mary Cassatt drinking tea, Château-Beaufresne, Mesnil-Théribus, *c.* 1905. The Hill-Stead Museum, Farmington, CT
86 Cassatt *Little Girl in a Blue Armchair* 1878. Oil on canvas 89.5 x 129.8 (35 ¼ x 51 ⅛). © 1997 Board of Trustees, National Gallery of Art, Washington. Collection of Mr. and Mrs. Paul Mellon
87 Cassatt *Girl in a Straw Hat* 1886. Oil on canvas 65.3 x 49.2 (25 ¾ x 19 ⅜). © 1997 Board of Trustees, National Gallery of Art. Collection of Mr. and Mrs. Paul Mellon
88 Cassatt *Ellen Mary Cassatt in a White Coat* 1896. Oil on canvas 81.9 x 61 (32 ¼ x 24). Courtesy, Museum of Fine Arts, Boston. Anonymous Fractional Gift in Honor of Ellen Mary Cassatt
89 Cassatt *Young Woman Reading* 1875. Oil on panel 34.9 x 26.6 (13 ¾ x 10 ½). Courtesy Museum of Fine Arts, Boston. Bequest of John T. Spaulding

90 Cassatt *The Reader* 1877. Oil on canvas 81.2 x 64.7 (32 x 25 ½). Private collection. Photograph courtesy of Gerald Peters Gallery, New York
91 Cassatt *Reading "Le Figaro"* 1877–78. Oil on canvas 101 x 81.2 (39 ¾ x 32). Private Collection, Washington D.C.
92 Paul Cézanne *Portrait of Louis-Auguste Cézanne Reading "L'Evénement"* 1866. Oil on canvas 198.5 x 119.3 (78 ⅛ x 47). © 1997 Board of Trustees, National Gallery of Art, Washington D.C. Collection of Mr. and Mrs. Paul Mellon
93 James McNeill Whistler *Arrangement in Gray and Black: The Artist's Mother* 1871. Oil on canvas 144.3 x 162.5 (56 ⅞ x 64). Musée du Louvre, Paris
94 Lilly Martin Spencer *War Spirit at Home* 1866. Oil on canvas 76.2 x 83.2 (30 x 32 ¾). Collection of The Newark Museum. Purchase 1944 Wallace M. Scudder Bequest Fund. Photo Art Resource, New York
95 Cassatt *Katherine Cassatt Reading to her Grandchildren* 1880. Oil on canvas 55.9 x 100.3 (22 x 39 ½). Private collection
96 Cassatt *Portrait of Katherine Kelso Cassatt* 1889. Oil on canvas 96.5 x 68.5 (38 x 27). The Fine Arts Museums of San Francisco. The William H. Noble Bequest Fund
97 Cassatt *Lydia Crocheting at Marly* 1880. Oil on canvas 66 x 94 (26 x 37). The Metropolitan Museum of Art, New York. Gift of Mrs. Gardner Cassatt, 1965 (65.184). Photograph © 1993 The Metropolitan Museum of Art
98 Cassatt *Lydia at a Tapestry Frame* 1881. Oil on canvas 65 x 92.4 (25 ⅝ x 36 ⅜). Courtesy of the Flint Institute of Arts. Gift of the Whiting Foundation
99 Cassatt *Woman with a Pearl Necklace in a Loge* 1879. Oil on canvas 80.3 x 58.4 (31 ⅝ x 23). Philadelphia Museum of Art. Bequest of Charlotte Dorrance Wright
100 Cassatt *In the Box c.* 1879. Oil on canvas 43 x 61 (16 ⅞ x 24). Private collection. Photo Christie's Images, London
101 Cassatt *At the Theatre* 1879. Pastel on paper 55.4 x 46.1 (21 ⅞ x 18 ¼). The Nelson-Atkins Museum of Art, Kansas City, Missouri. Acquired through the generosity of an anonymous donor
102 Cassatt *The Loge* 1882. Oil on canvas 111.1 x 95.3 (43 ¾ x 37 ½). © 1997 Board of Trustees, National Gallery of Art, Washington D.C. Chester Dale Collection
103 Cassatt *Dressed for the Matinée* 1878. Oil on canvas 100.3 x 80.7 (39 ½ x 31 ¾). Private collection
104 Cassatt, Study for *At the Opera* 1878. Pencil 9.8 x 14.6 (3 ⅞ x 5 ¾). Private collection
105 Cassatt *At the Opera* 1878. Oil on canvas 80 x 64.8 (31 ½ x 25 ½). Courtesy, Museum of Fine Arts, Boston. Charles Henry Hayden Fund
106 Poster for Théâtre Eldorado, Paris *c.* 1895. Private collection
107 Edouard Manet *Bar at the Folies-Bergère* 1881–82 (detail). Oil on canvas 96 x 130 (37 ¾ x 51 ⅛). Courtauld Institute Galleries, London
108 Cassatt *Woman with a Pearl Necklace in a Loge* 1877. Oil on canvas 80.3 x 58.4

(31 ⅝ x 23). Philadelphia Museum of Art. Bequest of Charlotte Dorrance Wright
109 Cassatt *Woman Reading* 1878. Oil on canvas 81.2 x 59.6 (32 x 23 ½). Joslyn Art Museum, Omaha, Nebraska
110 Cassatt *Portrait of Moyse Dreyfus* 1879. Pastel on paper mounted on canvas 81.3 x 65 (32 x 25 ⅝). Musée du Petit Palais, Paris. Gift of Justin Mayer in the name of Mme. Moyse Dreyfus, in memory of Moyse Dreyfus. Photo © Photothèque des Musées de la Ville de Paris
111 Cassatt *In the Loge* 1879. Pastel and metallic paint on canvas 68 x 82.5 (26 ¾ x 32 ½). Philadelphia Museum of Art. Given by Margaret Sargent McKean
112 Cassatt *In the Box c.* 1879. Oil on canvas 43 x 61 (16 ⅞ x 24). Private collection. Photo Christie's Images, London
113 Cassatt *Woman in a Loge with a Fan Facing Right* 1879. Pastel on gouache 64.6 x 54.5 (25 ½ x 21 ½). Private collection
114 Cassatt *Miss Mary Ellison* 1879. Oil on canvas 85.5 x 65.1 (33 ¾ x 25 ⅝). © Board of Trustees, National Gallery of Art, Washington D.C. Chester Dale Collection
115 Cassatt *Portrait of Madame J* 1879. Oil on canvas 80.8 x 64.8 (31 ¾ x 25 ½). The Peabody Institute of the City of Baltimore, on extended loan to The Baltimore Museum of Art
116 Cassatt *Woman Reading in the Garden* 1880. Oil on canvas 90 ⅛ x 65 (35 ½ x 25 ⅝). Photograph © 1997 The Art Institute of Chicago. All Rights Reserved. Gift of Mrs. Albert J. Beveridge in memory of her aunt, Delia Spencer Field, 1938.18
117 Cassatt *At the Theatre* 1879. Pastel on paper 55 x 45 (21 ⅝ x 17 ¾). The Nelson-Atkins Museum of Art, Kansas City. Nelson Fund
118 Cassatt *Five O'Clock Tea* 1880. Oil on canvas 64.8 x 92.1 (25 ½ x 36 ¼). Courtesy, Museum of Fine Arts, Boston. M. Theresa B. Hopkins Fund
119 Cassatt *Lydia Reading Turned to the Right c.* 1880. Drypoint and aquatint 18 x 11 (7 ¼ x 4 ⅜). The Library of Congress, Washington D.C.
120 Cassatt *Under the Lamp*, 3rd state, *c.* 1880. Drypoint and aquatint 19.6 x 21.2 (7 ¾ x 8 ⅜). S.P. Avery Collection. Miriam and Ira D. Wallach Division of Art, Prints and Photographs. The New York Public Library. Astor, Lenox and Tilden Foundations
121 Cassatt *Mademoiselle Luquet Seated on a Couch*, 2nd state, *c.* 1880. Drypoint and aquatint 21.9 x 14.2 (8 ½ x 5 ⅝). S.P. Avery Collection. Miriam and Ira D. Wallach Division of Art, Prints and Photographs. The New York Public Library. Astor, Lenox and Tilden Foundations
122 Cassatt *Before the Fireplace c.* 1880. Drypoint and aquatint 16.3 x 20.5 (6 ½ x 8 ⅛). © 1997 Board of Trustees, National Gallery of Art, Washington D.C. The Rosenwald Collection
123 Cassatt *Lydia Crocheting at Marly* 1880. Oil on canvas 66 x 94 (26 x 37). The Metropolitan Museum of Art, New York. Gift of Mrs. Gardner Cassatt, 1965 (65.184). Photograph © 1993 The Metropolitan Museum of Art
124 Cassatt *Elsie Cassatt in a Blue Armchair* 1880. Pastel 88.9 x 63.5 (35 x 25). Private collection

125 Cassatt *A Goodnight Hug* 1880. Pastel on paper 42 x 61 (16 ½ x 24). Private collection. Photo Christie's Images, London
126 Cassatt *The Cup of Tea* 1880. Oil on canvas 92.4 x 65.4 (36 ⅜ x 25 ¾). The Metropolitan Museum of Art, New York. From the collection of James Stillman, Gift of Dr. Ernest G. Stillman, 1922 (22.16.17). Photograph © 1983 The Metropolitan Museum of Art
127 Cassatt *Autumn* 1880. Oil on canvas 93 x 65 (36 ⅝ x 25 ⅝). Musée du Petit Palais, Paris. Photo © Photothèque des Musées de la Ville de Paris
128 Cassatt *Katherine Cassatt Reading to her Grandchildren* 1880. Oil on canvas 55.9 x 100.3 (22 x 39 ½). Private collection
129 Cassatt *Children in the Garden* 1885. Oil on canvas 48.2 x 57 (19 x 22 ½). Photo © Glasgow Museums, Art Gallery and Museum, Kelvingrove
130 Cassatt *Mother and Child c.* 1886. Pastel on paper 63.5 x 48.2. (25 x 19). Musée du Louvre, Paris. © Photo RMN
131 Cassatt *Girl Arranging her Hair* 1886. Oil on canvas 75.1 x 62.5 (29 ⅝ x 24 ⅝). © 1997 Board of Trustees, National Gallery of Art, Washington D.C. Chester Dale Collection
132 Cassatt *Young Woman Sewing* 1883–86. Oil on canvas 91.4 x 64.7 (36 x 25 ½). Musée d'Orsay, Paris. © Photo RMN
133 Cassatt *Susan on a Balcony* 1883. Oil on canvas 100.3 x 64.7 (39 ½ x 25 ½). Corcoran Gallery of Art, Museum Purchase, Gallery Fund, Washington D.C.
134 Cassatt *Children Playing on a Beach* 1886. Oil on canvas 85.5 x 65.1 (33 ¾ x 25 ⅝). © 1997 Board of Trustees, National Gallery of Art, Washington D.C. Ailsa Mellon Bruce Collection
135 Cassatt *The Visitor*, 5th state, *c.* 1880. Drypoint and aquatint 52.1 x 39.7 (20 ½ x 15 ⅝). © 1997 Board of Trustees, National Gallery of Art, Washington D.C. Rosenwald Collection
136 Cassatt *In the Opera Box No. 3 c.* 1880. Drypoint and aquatint 20.4 x 18.7 (8 ⅛ x 7 ⅜). © 1997 Board of Trustees, National Gallery of Art, Washington D.C. Rosenwald Collection
137 Cassatt *The Map*, 3rd state, 1889–90. Drypoint 15.7 x 23.3 (6 ¼ x 9 ¼). S.P. Avery Collection. Miriam and Ira D. Wallach Division of Art, Prints and Photographs. The New York Public Library. Astor, Lenox and Tilden Foundations
138 Cassatt *Baby's Back*, 3rd state, 1890. Drypoint 23.4 x 16.5 (9 ¼ x 6 ½). The Metropolitan Museum of Art, New York. H. O. Havemeyer Collection. Bequest of Mrs. H. O. Havemeyer, 1929 (29.107.91). All Rights Reserved
139 Cassatt *At the Window* 1889. Pastel and charcoal on paper 75.5 x 62.2 (29 ¾ x 24 ½). Musée du Louvre, Paris. © Photo RMN
140 Cassatt *Alexander Cassatt and his Son* 1884. Oil on canvas 100 x 81.2 (39 ⅜ x 32). Philadelphia Museum of Art. Purchased with the W. P. Wilstach fund and funds contributed by Mrs. William Coxe Wright

141 Kitagawa Utamaro *Midnight, the Hours of the Rat: Mother and Sleepy Child* from *Customs of Women in Twelve Hours* series, *c.* 1795. 36.4 x 24.5 (14 ⅜ x 9 ⅝). The Metropolitan Museum of Modern Art, New York. Rogers Fund, 1922 (JP 1278). All Rights Reserved

142 Childe Hassam *At the Florist* 1889. Oil on canvas 92.7 x 136.5 (36 ½ x 53 ¾). The Chrysler Museum of Art, Norfolk, VA. Gift of Walter P. Chrysler, Jr., 71.500

143 Edouard Manet *Olympia* 1863–65 (detail). Oil on canvas 130.5 x 190 (51 ⅜ x 74 ⅞). Musée d'Orsay, Paris

144 Cassatt, *Study for In The Omnibus* 1890–91. Black chalk and graphite on wove paper 37.9 x 27.1 (14 ⅞ x 10 ¾). © 1997 Board of Trustees, National Gallery of Art, Washington D.C. Rosenwald Collection

145 Cassatt *In The Omnibus*, 7th state, 1890–91. Drypoint and aquatint 43 x 30 (16 ⅞ x 11 ¾). Photograph © 1997 The Art Institute of Chicago. All Rights Reserved. Mr. and Mrs. Martin A. Ryerson Collection, 1932.1289

146 Cassatt *The Lamp*, 4th state, 1890–91. Drypoint and aquatint 43.8 x 30 (17 ¼ x 11 ¾). Worcester Art Museum, Bequest of Mrs. Kingsmill Marrs, 1926

147 Cassatt *Afternoon Tea Party*, 5th state, 1890–91. Drypoint and aquatint 42.5 x 31.1 (16 ¾ x 12 ¼). © 1998 Board of Trustees, National Gallery of Art, Washington D.C. Chester Dale Collection

148 The Mary Cassatt room in the Exhibition of Paintings and Drawings by Representative Modern Masters, Pennsylvania Academy of the Fine Arts, 7 April–9 May 1920. The Pennsylvania Academy of the Fine Arts, Philadelphia, Archives

149 Jan Vermeer *Lady Writing a Letter with her Maid c.* 1670. Oil on canvas 71.1 x 38.4 (28 x 15 ⅛). National Gallery of Ireland, Dublin

150 Cassatt *The Letter*, 4th state, 1890–91. Drypoint and aquatint 43.7 x 29.7 (17 ⅛ x 11 ¾). Photograph © 1997 The Art Institute of Chicago. All Rights Reserved. Martin A. Ryerson Collection, 1932.1282

151 Cassatt *The Fitting*, 7th state, 1890–91. Drypoint and aquatint 42.1 x 30.6 (16 ½ x 12 ⅛). Worcester Art Museum, Bequest of Mrs. Kingsmill Marrs, 1926

152 Edgar Degas *The Washbasin* 1879–83. Monotype 31.1 x 27.3 (12 ¼ x 10 ¾). Photo © Sterling and Francine Clark Art Institute, Williamstown, Massachusetts, USA

153 Gustave Caillebotte *Woman at a Dressing Table c.* 1873. Oil on canvas 65 x 81 (25 ⅝ x 31 ⅞). Private collection

154 Cassatt *The Coiffure* 5th state, 1890–91. Drypoint and aquatint 43.2 x 30.5 (17 x 12). © 1997 Board of Trustees, National Gallery of Art, Washington D.C. Rosenwald Collection

155 Cassatt *The Bath*, 17th state, 1890–91. Drypoint and aquatint 29.5 x 24.8 (11 ⅝ x 9 ¾). The Metropolitan Museum of Art, New York.

Gift of Paul J. Sachs, 1917 (16.2.7). Photograph © 1988 The Metropolitan Museum of Art

156 Cassatt *Woman Bathing*, 4th state, 1890–91. Drypoint and aquatint 43.5 x 29.9 (17 ⅛ x 11 ¾). Worcester Art Museum, Bequest of Mrs. Kingsmill Marrs, 1926

157 Cassatt *Mother's Kiss*, 5th state, 1890–91. Drypoint and aquatint 43.5 x 30 (17 ⅛ x 11 ⅞). Worcester Art Museum, Bequest of Mrs. Kingsmill Marrs, 1926

158 Cassatt *Maternal Caress*, 6th state, 1890–91. Drypoint and aquatint 43.2 x 29.8 (17 x 11 ¾). Worcester Art Museum, Bequest of Mrs. Kingsmill Marrs, 1926

159 Cassatt at Villa Angelotto, Grasse, 1913. The Hill-Stead Museum, Farmington, CT

160 Cassatt *Family Group Reading c.* 1901. Oil on canvas 56.2 x 112.4 (22 ¼ x 44 ¼). Philadelphia Museum of Art. Gift of Mr. and Mrs. J. Watson Webb

161 Pierre-Auguste Renoir *Claude and Renée* 1902–03. Oil on canvas 78.7 x 63.5 (31 x 25). National Gallery of Canada, Ottawa

162 Cassatt *Woman and Child Driving* 1881. Oil on canvas 89.5 x 130.8 (35 ¼ x 51 ½). Philadelphia Museum of Art. W. P. Wilstach Collection

163 Cassatt *Mother Feeding her Child* 1898. Pastel on paper 64.7 x 81.3 (25 ½ x 32). The Metropolitan Museum of Art, New York. From the collection of James Stillman, Gift of Dr. Ernest G. Stillman, 1922. (22.16.22). All Rights Reserved

164 Cecilia Beaux *Les Derniers Jours d'Enfance* 1883–84. Oil on canvas 116.8 x 137.2 (46 x 54). Courtesy of the Pennsylvania Academy of the Fine Arts. Gift of Cecilia Drinker Saltonstall

165 Cassatt *A Goodnight Hug* 1880. Pastel on paper 42 x 61 (16 ½ x 24). Private collection. Photo Christie's Images, London

166 Cassatt, *Study for Mother about to Wash her Sleepy Child c.* 1880. Pastel on paper 61 x 40.6 (24 x 16). Private collection

167 Cassatt *Mother about to Wash her Sleepy Child c.* 1880. Oil on canvas 100.3 x 65.8 (39 ½ x 26). Los Angeles County Museum of Art. Mrs. Fred Hathaway Bixby Bequest

168 Frederick Bridgman *Fellahine and Child —the Bath, Cairo c.* 1892. Oil on canvas 60.3 x 80.9 (23 ¾ x 31 ⅞). Private collection. Photo Christie's Images, London

169 Cassatt *The Bath* 1891–92. Oil on canvas 100.3 x 66 (39 ½ x 26). Photograph © 1997 The Art Institute of Chicago. All Rights Reserved. Robert A. Waller Fund, 1910.2

170 Cassatt *Breakfast in Bed* 1897. Oil on canvas 58.4 x 73.6 (23 x 29). Courtesy of the Huntingdon Library, Art Collections and Botanical Gardens, San Marino, CA. Gift of the Virginia Steele Scott Foundation

171 Cassatt *The Caress* 1902. Oil on canvas 83.5 x 70.8 (32 ⅞ x 27 ⅞). National Museum of American Art, Smithsonian Institution, Washington D.C. Gift of William T. Evans

172 Cassatt *Mother and Child (The Oval Mirror) c.* 1899. Oil on canvas 81.6 x 65.7 (32 ⅛ x 25 ⅞). The Metropolitan Museum of Art, New York. Bequest of H.O. Havemeyer, 1929. The H.O. Havemeyer Collection (29.100.47). All Rights Reserved

173 Cassatt *Baby's First Caress* 1891. Pastel on paper 76.2 x 61 (30 x 24). New Britain Museum of American Art. Harriet Russell Stanley Fund

174 Cassatt *Emmie and her Child* 1889. Oil on canvas 89.8 x 64.4 (35 ⅜ x 25 ⅜). Wichita Art Museum. The Roland P. Murdock Collection

175 Cassatt *Mother Looking Down at Thomas c.* 1893. Pastel on paper 68.5 x 57 (27 x 22 ½). Collection of Jacqueline and Matt Friedlander; on extended loan to the High Museum of Art, Atlanta

176 Cassatt *Nurse and Child (Pensive Marie Looking up at her Nurse)* 1896–97. Pastel on paper 80 x 66.7 (31 ½ x 26 ¼). The Metropolitan Museum of Art, New York. Gift of Mrs. Ralph J. Hines, 1960. (60.181). Photograph © 1984 The Metropolitan Museum of Art, New York

177 Cassatt *Maternal Kiss (Pensive Marie Kissed by her Nurse)* 1897. Pastel on paper 55.8 x 46.3 (22 x 18 ¼). Philadelphia Museum of Art. Bequest of Anne Hinchman

178 Cassatt *Louisine Havemeyer and her Daughter Electra* 1895. Pastel on paper 61 x 77.5 (24 x 30 ½). Shelburne Museum, Shelburne, Vermont. Photograph by Ken Burris

179 Cassatt *Little Girl Leaning on her Mother's Knee (Young Mother Sewing) c.* 1901. Oil on canvas 92.4 x 73.7 (36 ⅜ x 29). The Metropolitan Museum of Art, New York. H.O. Havemeyer collection Bequest of Mrs. H.O. Havemeyer, 1929 (29.100.48). Photograph © 1997 The Metropolitan Museum of Art

180 Installation view of Loan Exhibition of Masterpieces of Old and Modern Painters, Knoedler and Co. Galleries, New York 6–24 April 1915. Photograph courtesy of Knoedler & Company, New York

181 Cassatt *Mother and Child (Mother Wearing a Sunflower on her Dress)* 1905. Oil on canvas 92.1 x 73.7 (36 ¼ x 29). © 1997 Board of Trustees, National Gallery of Art, Washington D.C. Chester Dale Collection

182 Cassatt *Lady at a Tea Table* 1883–85. Oil on canvas 73.4 x 61 (29 x 24). The Metropolitan Museum of Art, New York. Gift of the artist, 1923 (23.101). Photograph © 1994 The Metropolitan Museum of Art

183 Mary Cassatt at Château Beaufresne, Mesnil-Théribus, 1925. Photograph courtesy of the Archives of American Art, Smithsonian Institution, Washington D.C. The Frederick A. Sweet Papers

184 Pablo Picasso *Portrait of Gertrude Stein* 1906. Oil on canvas 99.7 x 81.3 (39 ¼ x 32). The Metropolitan Museum of Art, New York. Bequest of Gertrude Stein, 1946 (47 106). All Rights Reserved

222

Index